Business and Entrepreneurship for Filmmakers

This practical guide teaches readers the skills and business acumen required to build a career in the film industry from the ground up.

While countless books and classes teach newcomers the creative aspects of the film industry, many fail to properly prepare readers for the reality of how to navigate a freelance film career today. From creating a business model, dealing with taxes and funding, finding and managing clients, networking, investing, cashflow, and planning for the long-term, *Business and Entrepreneurship for Filmmakers* provides real-world, pragmatic advice on navigating a freelance film career, whether you're a recent film school graduate looking to take the next step or a seasoned professional hoping to start a production company. Moreover, the skills taught here apply across the industry, from corporate media and commercials to music videos and feature films.

Interviews with filmmakers, innovators, and business experts are included throughout the book to offer further expertise and examples.

Charles Haine is a filmmaker and entrepreneur who has worked in the motion picture industry since 1999. Haine founded the production company Dirty Robber in 2008, which has gone on to success in feature films and shorts, as well as commercials and music videos. Haine is an assistant professor at the Feirstein Graduate School of Cinema at Brooklyn College, and was formerly an associate professor at Los Angeles City College. In 2011, Haine published his first book, *The Urban Cyclist's Handbook*, and currently is the tech editor at NoFilmSchool.com.

Business and Entrepreneurship for Filmmakers

Making a Living as a Creative Artist in the Film Industry

Charles Haine

Routledge
Taylor & Francis Group

NEW YORK AND LONDON

First published 2020
by Routledge
52 Vanderbilt Avenue, New York, NY 10017

and by Routledge
2 Park Square, Milton Park, Abingdon, Oxon, OX14 4RN

Routledge is an imprint of the Taylor & Francis Group, an informa business

© 2020 Taylor & Francis

Library of Congress Cataloging-in-Publication Data
Names: Haine, Charles, author.
Title: Business and entrepreneurship for filmmakers : making a living as a creative artist in the film industry / Charles Haine.
Description: New York : Routledge, 2020. |
Identifiers: LCCN 2019020450 | ISBN 9780367140076 (paperback) | ISBN 9780367140069 (hardback) | ISBN 9780429029714 (ebook)
Subjects: LCSH: Motion pictures—Production and direction. | Motion picture industry.
Classification: LCC PN1995.9.P7 H345 2020 | DDC 791.4302/32—dc23
LC record available at https://lccn.loc.gov/2019020450

ISBN: 978-0-367-14006-9 (hbk)
ISBN: 978-0-367-14007-6 (pbk)
ISBN: 978-0-429-02971-4 (ebk)

Typeset in Times New Roman
by Swales & Willis Ltd, Exeter, Devon, UK

Contents

Introduction

There's an old book, *What They Don't Teach You at Harvard Business School* by Mark McCormack (Collins, 1984), from a businessperson who set out to tell the real-world lessons they felt were missed in schools. You can think of this book as "What they don't teach you at film school," since for some reason many film schools skip teaching the nuts and bolts of business skills that are going to be vital if you want to have a career in the industry.

While there are occasional "film business" classes that include discussions of the machinations of the large studios, that information is mostly useful 20 years after graduation when you've clawed your way up the ladder. Basically, no one is walking straight out of film school into pitching a studio, and even fewer are getting in that studio pitch session without years of prep first. The realities of what it's actually like to walk into the film industry and launch a career from scratch, with no family connections, pre-existing relationships, or massive cash reserve, is almost never discussed anywhere. Maybe people don't want to face how difficult it is to get going in motion pictures. For whatever reason, it's seldom talked about.

This is unfortunate since it is honestly easier than ever before to have a career in motion picture creation. We are in the middle of a content explosion and there are tons of jobs for hungry filmmakers looking to climb the ladder in the industry. You just need to accept that film is overwhelmingly a freelance industry and to learn some basic business skills in order to learn to manage your career as a business.

You can't avoid business in film; those "stable" jobs with regular paychecks where we are protected from the realities of how business operates seldom exist for anyone anymore, but they are especially rare in the world of making films for a living. As a filmmaker you'll be a freelancer, and a freelancer is effectively running the business of their own career.

This book is about the business skills vital to survival because so many filmmakers have the hope that there is a way to avoid having to learn all of this, that it's "distasteful" or "hard." They dream of being so successful that they won't have to worry about money, cashflow, client acquisition, and all the other nasty parts of business and they'll just have it "made." This doesn't exist. Friends of

mine have had multi-season arcs on hit soap operas (when that was a thing) and were back to waiting tables after having "made it." This is true in all arenas (authors of books you have read, that defined decades, later go on to law school to get a real income after their follow up books fail to attract the same audience), but it's especially true in film. You've got to learn some business skills to survive; no one has ever "made it" so thoroughly that they don't need to know this stuff.

This is especially true if your parents weren't in film, since most people look to their parents for career advice, and film isn't like anything else. If your parents had one of those stable careers (teacher, accountant, parole officer, lawyer, doctor, etc.) that provided the basis for a childhood where we could explore our creative selves and dream of making movies, they might be able to help somewhat, but fundamental aspects of their lives are different from what yours will look like. Thus our parents often can't guide us through navigating a freelance, small business, movie-making life, no matter how much they might want to.

Strangely, it's sometimes considered shameful or gauche to talk about money and business with anyone other than our parents, which leaves filmmakers in a conundrum and operating without a lot of good guidance. We need to look outside the traditional areas we go for information to find out how to navigate running a small business, which is what our careers will be.

It's a little bit understandable that film schools don't dive deeply into this; part of the point of film school is avoiding having to think about the reality of the world for a while and dive more deeply into our craft. That's a wonderful thing, while it lasts, and is vital to the process of finding your actual artistic voice and getting in touch with what it is you want to say outside of the pressures of commerce. Growing as an artist and exploring your muse are much harder to do when you are back to the grind of worrying about payroll. It serves an important function, that period away from commerce, but you'll be back in the field eventually and it's better to be prepared.

All of that high-level information about negotiating studio mergers, streaming contracts, and deciding when it's time to leave your agent is fascinating, and might be useful. For a small slice of the industry that will be actionable information (there are probably more senators than there are studio level filmmakers, for instance), but I want to focus here on having a long, sustainable, robust career whether you ever end up in a studio pitch meeting or not. "Making it," over and over and over again, not having "made it."

If you want to have a career while doing creative work, making movies, and telling stories, you need to understand some things about how the business world operates. Most of the people I know in film are involved in either a directly media-related business (the production companies, post houses, scene shops, and crew collectives) or have developed another business in order to finance their career (an acquaintance of mine is an actor with a high-end home theater installation business to smooth out the irregularities of acting income; another acquaintance who has been in three movies nominated for best picture Oscars still runs his side business).

These other jobs are usually far from normal, if for no other reason than because the stable jobs with the regular paychecks take so much of our valuable time that we can't keep going with our creative work. That's what they are paying you for; with a big guaranteed salary you get stability in exchange for a large volume of your time, but, as an artist, you want to be able to control your own schedule. So you have to find a way to carve out a "day job" that allows you the freedom to keep doing your own work.

Business is a human activity as old as civilization, probably older, with wisdom, knowledge, myths and legends passed down through schools, books, and word of mouth that is designed to make life easier for each successive wave of business people.

I personally graduated from a prestigious film school that covered basically none of the material in this book, leaving me completely unprepared for managing life as a creative freelancer. I learned most of this the hard way, through expensive mistakes, reading an MBA's worth of business books, and picking the brain of every entrepreneur I met for information. I ended up starting a production company which produced countless branded spots, music videos, book trailers, and eventually an Oscar-nominated short film and several feature films, including one I directed, making countless mistakes in the process of figuring out how to survive while moving towards the goal of creativity all the time.

I now teach at another film school and have developed a course on preparing for launching a career as a filmmaker. This book grows out of those lessons I learned in the real world that I try to pass on to my students.

This book is designed to be the first business book a filmmaker should read, when thinking about working in movies, or getting out of film school, or a few years into a career and struggling, to help them navigate how business operates.

Good luck. It's a blast making a living in film.

Chapter 1

Taking Care of Yourself for Long Term Survival

Getting to the place where you are making a sustainable, and healthy, living in entertainment can be a long road. There are a variety of strategies that help directly, but there are also indirect strategies you can implement to help you survive and not lose your mind as you pursue your goals in movies.

This probably seems like an odd chapter to start with, since if you yourself are currently about to move into motion pictures it's easy to think "I'll worry about meditation and eating breakfast every day once I'm in the third season of a streaming show," but I would argue that it's the right place to start. Right now, as you launch into a career, you have a goal (directing, writing, cinematography, etc.) and you need to figure out how to get from here to there. This book is built around the idea of making smart business decisions about your cashflow job(s) while working on pursuing that goal.

One of the elements that makes a cashflow job "smart" is that it doesn't emotionally or physically burn you out so thoroughly that you leave the film industry altogether. This requires knowing yourself well enough to know what your capabilities are and then choosing to direct your energy in the arena that is available to you that most sustainably keeps you in the game and moving towards the bigger goal.

At this moment it might not feel like you have a choice at all. You need money, after all, and when we need money and the account balance runs low we'll do whatever it is we can do to get it. Someone knows of a PA job you can get that works 70-hr weeks? Sure, why not, take it, replenish your cash reserve, but, when you can, you want to start making short-term decisions that involve your long-term strategy.

Remember, this is a decision. It might not feel like it, it might feel like you have no choice at all and you will do "whatever" to keep the pantry full while working on your goal, but you do in fact have some choices.

While this all might feel hopeless, you should also know that even having a goal at all (directing, writing, etc.) puts you ahead of the curve in life. Many people don't know what they want to do. You do (which is how you ended up reading this book), but the thing you have to figure out is not "what do you want to do," because you know that already: you want to direct movies! Or

edit movies, or shoot movies, or produce movies; you know the end game. The trick is to figure out how you maintain cashflow as you pursue that ambition. The most important decision you will be making at this point is the "cashflow" job to pursue while you work on pursuing your long-term ambition.

This book assumes the "ambition" job for most of you is "directing movies." Almost all of the advice also applies to writers, producers, editors, and cinematographers, but the difference there is that those careers have more easily defined "paths" to follow, though you'll still want to understand some basics while you do that. Directing is different since the path is less clear. Some people seem to figure out how to get movies made right away, and some take a while. The "paths" to directing are many, but three common ones are to start as a writer, start as a producer, or start as a cinematographer. Of course, all three of those jobs are almost as difficult to "break into" as directing, but they all also offer some version of a "climbing the ladder" cashflow job while you work.

Many filmmakers want a cashflow job that keeps them close to set. However, that only works for certain ambition jobs. If you want to be a Director of Photography (DP), you should absolutely right now get working as a camera Production Assistant (PA) or 2nd Assistant Cameraperson (AC). You can make money while learning your craft and developing relationships. If you want to be an editor, get in an edit suite as the post PA or assistant editor right away. It's a no brainer.

However, if your ambition is directing or writing, set jobs might not make sense. While I do know writers who wrote their first projects while working on set as a sound mixer (with the laptop open on the sound cart right above the mixer, writing in between takes), that takes a lot of discipline.

The problem with set work is that you work very long hours for many days at a time, and that might take you away from writing. To be a director or writer, you need to be writing something, since the vast majority of directors get their first feature made through writing the script for it. There are exceptions of course, DPs who turn to directing and independently wealthy folks who develop a script with a writer, but the more common path is for directors to launch their careers on a script they wrote.

Before discussing options, it's important for you to take a look at yourself and take stock of your actual ability to keep working on your long-term ambition. There are some who really can work a 60-hour office job and still write for 2–3 hours in the morning before work. If you are one such, you should consider going the "desk" route, pursuing a job as an assistant to an established producer, writer, manager, or agent. These jobs often start in the mailroom.

The benefit of the "desk" job is that you learn a tremendous amount about how the development and producing side of the industry works, and if you do create that magic script by writing in the morning, you have someone to give it to who can do things with it. That is an amazingly useful thing. This will accelerate your career.

However, as with set hours being long, so "desk" hours are long too. The benefit is that they tend to start at the same time every day (8 or 9, or sometimes even 10), but they end "when the day is done," and a 50-hour week is not uncommon, meaning being in the office 9–7 Monday through Friday. For some this still allows writing time. For others, it doesn't. You have to make that judgment call for yourself.

If that gets in the way of your writing, then you should look at a non-industry "day job," as it were. This is a job outside film, wherever that is, that allows you to write. There is no shame in this.

The poet T.S. Eliot never quit his day job. He worked at a bank, then at a publisher, and wrote in his spare time. William Carlos Williams was a doctor until he was 60. This gave him a solid base of cashflow income to work from and the freedom to write what he pleased. Philip Glass was a plumber into his 40s.

A day job that gives you the money to pay your bills while also giving you the time to do your work is invaluable. This might not be in your chosen field. The key is to find a day job that allows you to actually do your creative work.

Entry-level jobs in film tend to be too all-consuming for you to make movies on your own time. Their hours are usually too long. The energy they take from you is too much. Even if you do have time off, you are usually recovering from the tremendous effort you undertook at work and you aren't willing or able to dive into your own projects.

Sometimes it's less about time than the similarity of the task; it burns out your bandwidth if your day job is in your field. I was a bike courier for a while, and after 50 hours a week in the saddle, I didn't want to bike on weekends: I needed to do anything else other than bike. Many of my friends who edit for a living have personal projects needing editing that they can't bring themselves to face on a Saturday since they spend all week editing other projects already.

If your day job isn't in your field that's OK. Often, it's better. The key is that the day job allows you time to work on your ambition projects. Later in your career the same thing will apply, where you have to balance cashflow jobs with ambition jobs. Only now your cashflow job might be at a bank or managing a restaurant. Most "entry-level" jobs in film are massive time consumers; production companies and movie sets work long hours. What it benefits you in meeting people from your field it can often cost you in lost time when you could be working on your own projects.

One of the greatest enemies of long-term ambition is short-term comfort.

Waking up that hour before work every day to work on your own project takes effort, it takes energy and discipline. But if you lose track of your ambition, years could slip by without you creating what you actually set out to create.

Try to keep your overhead low while working your day job. Keep the old car (if it's not so old its repair expenses start to outweigh its savings in car payments). Keep the small apartment. Accumulate some real savings.

If the time comes to leave the day job (and it comes to many, but not to all), those savings will form a good buffer. And you'll be used to low overhead living, making life in the unpredictable freelance world easier to manage.

If you've gotten the house and have to give it up for your dream you'll resent it. But if you never had the house, you won't miss it, and you'll often have more savings in the bank to help you smooth out slow months with no sales.

Learn to cook, even if only one or two dishes. Many filmmakers never do this, getting used to catered meals on set and eating out after wrap, but it saves you both money and time, since you can cook while working and you are less likely to leave where you are writing to get lunch, which wastes time. I have a little standing desk I can move around the apartment and set up in the kitchen when I'm making lunch, so I can stand by the skillet while browning broccoli and keep writing.

Learn to fix your own things. If you are handy enough to set up a light stand and build a camera you are likely handy enough to fix the brakes on your bicycle or replace the seal on your toilet.

The most important part in this phase in your career is making sure you are spending 1–2 hours every single day on your ambition: writing your independent feature you want to direct, or writing the spec script you want to sell or you want to use to get hired, or directing projects with your friends on the weekends that you edit in those morning sessions. If you lose track of ambition nothing else matters. It's slightly better to have a "cashflow" job in film, but only if you are confident you can keep up your ambition work. If you can't, find a bartending gig that keeps your lights on while you write all morning.

The drawback to the bar job is that you won't have as many relationships and infrastructure available to you when the project is ready to go. If you truly believe you can focus on the long-term goals while doing this, it's often smart to consider joining or launching your own production company. This might be a group of you, it might be you solo, but creating a "film business" that is within the industry will help you build relationships and develop infrastructure (gear, post, offices, etc.) that will help when it comes time to make things.

Production Companies

If you have the patience, building a business for cashflow is one of the moves you can make since it will allow you a greater degree of freedom than working for someone else, while also developing filmmaking relationships. This could be a business built around a single person (if you edit for a living with multiple clients you are an "editing company," whether you feel like it or not), and almost all of the advice hereafter applies to sole proprietorships just as much as it does when you create a company with others.

The majority of the people I have seen manage to climb the ladder, the ones who did it without going "on a desk," are the ones who started a company of some sort. Because having a company gives you leverage. You will eventually have infrastructure, you will have support, you'll have a trained

team of people able to help. This might be a post house, a stage, a prop house, or a production company.

Starting a production company is a very smart, but very hard, cashflow job for those who want to make things. You'll not only be building relationships with others who make things, you'll be in a position to give yourself opportunities to make things. The hard part of a production company is how irregular the cashflow is. Some months you'll have three jobs and feel flush, then four months go by without a single job. Irregular cashflow makes running production companies nearly impossible. Every single month you have to eat and pay rent, but jobs might not come with that regularity.

This is why many production companies have some other "side-hustle." The production company that wants to do features might do commercials, if it can. Another will do post-production work. The beauty of post, and why you hear it discussed so often in this book, is that the money is much more regular.

With production, you might write 30 music video treatments and not only not book any of the jobs but, in the end, none of the videos might even get made. So many production jobs go out for bidding and then just never happen. Or, if they do happen, for some reason don't get finished, or if they get finished, get locked up in a vault and not released.

Post is easier since by the time a job goes out for post bidding, it's way way more likely to actually need the work. So, if you are used to writing 30 music video treatments to book a single job, you might be surprised to find in post you are booking one job for every ten bids you write, which is a more sustainable business model. After all, writing bids takes time.

If you look at the credits of most major motion pictures, the vast majority of the work now takes place in post. It also goes on for longer, and often in a pleasant climate-controlled office. Thus most "climbing the ladder" filmmakers develop at least one skill, usually in post, so they are "bringing something to the table."

The trick is that to develop a new skill takes time. If you decide you want to start a post house, production company, or develop a new skill like color grading for "cashflow," you need to devote yourself full time to that skill for a period of time until it generates income. It's very hard to spend an hour or two every weekend learning sound design and grow enough to earn real money in that arena if you are also writing in the morning and bartending at night. When trying to create a new "cashflow" skill it has to be your "ambition" skill for a while, which means putting your true long-term ambition on a hopefully brief hold.

But then once you get your cashflow job going, you quit bartending and get working as a freelance editor, you need to immediately get back to the grindstone of working on your long-term ambition.

Join or Form a Club

A lot of the information in this book I learned the hard way. I set out with a company, made mistakes, engaged in negotiations, managed cashflow, and

had lessons forced on me by experience. However, as I went along I realized the value in hearing from others who had already been through it, to learn from them the cost-saving and life-changing techniques that I could implement without having to learn them the hard way. Asking advice to take advantage of the painful processes others had learned on their own and implementing them in my own business before things became a problem.

In truth, business changes too quickly to be able to keep up alone. If your business is thriving, or even if you are working full-time on cashflow while editing in the mornings, you'll be too busy to constantly stay on top of changes; working 50 hours a week you won't want to spent your Sunday reading up on new accounting software or a new post-production workflow. One of the best options that exists is to find, or form, a club of fellow entrepreneurs where you can discuss dilemmas, find out new information, and hear others' experiences of applying it.

Everything in this book I have tested. Nothing is passed on if I haven't personally put it into practice or worked closely with someone who did. But often the first time it was introduced to me was not in a personal insight, or a business class or book, but sitting around a coffee table or on a phone call with another filmmaker, generally in a similar business. The information you gain from others needs to be tested. Even if it was true five years ago, it might not be true today. But getting information from others can save you a tremendous amount of time, and pain.

There are likely already "entrepreneur" clubs in your city, but you'll likely find them frustrating unless they are specifically targeted at filmmakers. Most "business" clubs are either built around long-established industries (organizations like the chamber of commerce) where the pace of technological change isn't as rapid, or they are clubs for start-up founders with big tech ideas designed to disrupt society and make billions to hang out, talk business plans, look for investors, and try to find developers.

If you are lucky, you'll be able to find a dedicated organization for your slice of the film industry. They do exist. Often, they take the form of online groups, and they can be vital methods for finding out information. Some of these groups even do market research, surveying members for rates and other valuable information that will help you operate, know how to price yourself, and know how to grow.

However, the best possible group is a smaller, targeted group of four–ten people who meet regularly in person for conversations. Because, it can never be said enough, breaking the stigma of talking about money, honestly and without fear or shame, is really tough. It can take a long time to get to know a group well enough to honestly talk through financial decisions and implications without fear of judgment. It helps to have a whole group who meet together or that you have otherwise gotten to know well enough that you can talk through these things.

It is likely you will have to be the person to organize this.

For me, this has taken many forms over the years, but one of my favorites is breakfast since it's the most reliable. Almost no one has to cancel an 8 a.m. meeting because they are "stuck at the office." You simply don't make any work meetings before 10 a.m. that day, and most people can make it. Business dinners are fine, but it's hard to get a regular rhythm going since, honestly, it's too likely that work will run late and people will cancel. But a weekday breakfast – nobody has any excuse not to make that.

Having lived in New York and Los Angeles, geography is key. I have mostly participated in these types of clubs and meetings with entrepreneurs that were in the same neighborhood or the next one over, since convenience is a factor in sustainability. It's only after a few years of regularly meeting that some of the deepest knowledge comes out, because it's only after a while that people trust each other enough to ask the toughest questions. "What do you do when payroll is tight?" involves admitting to strangers that payroll is sometimes tight. That's hard for a lot of people to do.

The closer to the same field you can find, the better, but they don't have to be your competitors. Sometimes it's hard to ask your direct competitors questions. When I had a production company doing a lot of music video and commercial work, the other entrepreneurs I talked to mostly ran production companies that did corporate video and EPKs; similar, but not directly competing, markets.

You will learn from these groups countless ways to make your business more fun and less painful. New vendors, new workflows, new freelancers, solutions others have figured out can roll over to your business more easily if you are hearing about it over a cup of coffee and a bagel. When there is something you can't solve, and none of your group can solve it, at least you get the shared commiseration that everyone deals with the same particular frustration, and maybe you'll even realize that there might be a business opportunity in solving it for others.

There are also an increasing number of online platforms offering this kind of community support, though nothing is quite as useful as in-person chats.

Advice

Asking for advice can be terrifying.

It's easier when you are younger, because you are more in touch with what you don't know.

But as you go along, it gets harder and harder, since you start to know some things, and others start asking you for advice about those things you know, and the trap of "well, I know some things so I must know a lot of things" becomes very dangerous.

There is a tremendous power in acknowledging what you don't know and asking for help, for advice, for introductions.

And it never ever goes away. There is not a single person in any industry who knows everything. Ever.

So, when you realize you don't know something, ask.

My career stalled for a few years, and the primary reason why is that I stopped asking for help. I stopped acknowledging to myself and others that there were things worth knowing that I didn't know. The world became divided into the territories of "things I know," and "things I don't know and never will."

This is doom.

Even if, somehow, you managed to know today every single thing you needed to do to do your job, tomorrow the world would have changed and you'll still need more advice. More information.

The final decision is always your own. You have to trust your own internal instincts and follow your own path and trust yourself. You can't let others make your decisions for you.

But you can pursue information and experience with gusto.

If you find yourself saying "One thing I really don't understand is X," then it's time to dive into X, if it's relevant to you moving ahead in your career.

People love being asked for advice.

One guaranteed way to ruin a connection is to argue strenuously with their advice when they far outrank you in experience. Peers sitting around the coffee table having a chat argue constantly with each other about advice. But if you have gotten the chance to sit down with someone several ranks above you on the ladder, and they give you their thoughts, strenuous argument doesn't serve you.

Most professionals understand that advice is just an outside opinion, a different perspective. Thus, when we hear it, we don't argue with it; if we disagree, we just ignore it. If we give it, we don't really expect strenuous argument. For some reason, many people early in their careers really struggle with this. The number of times I've been asked my opinion on something, then given a piece of input or advice, only to get a strenuous counter argument (usually using an appeal to authority, such as "I saw this famous person talk and they said something mildly different") is surprising, since, honestly, what is the point?

I've given my opinion based on my own experience. You'll get many, many opinions throughout your career. It's up to you to choose which one to listen to, which one to ignore, and how to use your own experience to evaluate which is which.

Arguing with the advice giver is a guaranteed way to ensure that they no longer want to give you advice, which is counterproductive. Your goal is to build a relationship with people. To get in a situation where they can be delivering real, concrete information, nuggets of wisdom, to you on a regular basis. You do that by being a receptive listener. I can't tell you the number of times I've watched a student chatting with an industry professional after an event, building a connection, only to argue back so viciously about advice, typically advice the student didn't want to hear, only to watch the professional politely move on to the next student.

This does not mean you have to follow that advice. You are free to ignore it. It might be out of date to current practices, built on exceptionally different

life experience (if someone got famous at 18 their life has been a bit different from yours), or otherwise useless to you.

But arguing strenuously with the giver of the advice sets you up as an adversary and makes them less likely to want to help you.

In truth, everyone really enjoys helping other people. It's hard-wired in most people to want to give away the information they have learned, to share their life stories, and to help the entire community grow.

You want to tap into as much of that free-flowing golden information as possible. You want dozens of people you can go for a quick coffee with to talk over a problem. You want to build the biggest network possible of people that have the vital information you need.

Within that, is there room for exploratory questions? Can you follow up with "Oh, I always heard something more like X, but you are saying Y, can you talk further about why you think Y because I think I see it?" Absolutely. That is very validating to the advice giver, and will likely set you up for an engaging conversation.

Is It Too Late?

Many of my students and peers worry that it's too late to be pursuing film. Orson Welles made *Citizen Kane* at 26, after all. Is 29 too old to be pursuing a career as a director, they worry? With them I usually have a discussion about a great book called *Old Masters and Young Geniuses* by David Galenson (Princeton University Press, 2007).

Galenson is an economist at the University of Chicago who hadn't published at 35. He looked around at his friends, who had published, and started to get a little worried: why have they published and I haven't? Was I not meant to be doing this? Am I in the wrong field?

First off, isn't it nice to know that other people worry about this too? It's not just filmmakers. Economists also feel the ticking of the clock.

Galenson decided to go out and study at what age most people create their important works. He eventually came up with "the Galenson curves," two curves that describe the arc of most careers. Galenson 1 goes up rapidly in your 20s, peaks around 26, then drops off over time. Think of Orson Welles.

Galenson 2 is a gentle peak from 35 to 55. Think Ridley Scott.

Every field has an outlier or two. Spielberg in movies. Picasso in painting. They go up early and stay up. It does happen, so going up early doesn't doom your career. It's just a different arc.

But other than that, the vast majority of people are one of those two curves. About 40% of artists are Galenson 1 and 60% are Galenson 2.

For a variety of reasons, Galenson 1s tend to get more press. It makes an amazing story, the 25-year-old wunderkind or enfant terrible.

This can be very disheartening if you are a Galenson 2.

Remember, there are more 2s than 1s.

Your journey as an artist involves accepting who you are, not fighting it. If you're a 2, you're a 2. That's great too. The trick to being a 2 is to keep pushing yourself, keep learning, keep growing, keep making things. Never ever stop.

Mental Health

Another thing that comes up all the time when talking to my students is mental health. Small business is stressful on mental health.

Film is stressful to mental health.

Combine the two and you are likely to find yourself in a difficult situation.

There are a variety of tools our society has developed in order to manage our mental well being. Therapy. Church. Meditation. Volunteering. Cardio.

If you are going to survive you can't have a meltdown.

How you do it is outside the scope of this book.

But take care of yourself. This industry is a doozy, and you absolutely have to take care of yourself if you want to be in it for the long run. Find a way to take at least a full day off once a week. I realized, three years into my production company, that not only had I not taken a vacation since the company started, I had also worked roughly seven days a week every week for three years. This is a recipe to burn yourself out.

Find a way to build something resembling work/life balance for yourself into the sustainable system of your business.

One of the biggest ways to do this is to charge people overtime. As soon as you have anywhere near the power to do so, be sure that your initial contract lays out overtime. Clients will work you as hard as they can for as long as they can. But if it starts getting expensive, if they can feel the clock ticking as the hours go by, the number of 16-hour days will decrease.

You likely feel desperate, trying to figure out how to break into an industry that is so notoriously difficult to enter.

Desperation is a funny thing.

Napoleon Hill, in his book *Think and Grow Rich* (TarcherPerigee, 2005), argues that you need to burn your boats behind you. Put yourself in a position where there is no turning back, no option for you to survive than to go forward. To success.

This seems to be true. I've seen it. When in a completely desperate moment visions, ideas, solutions to problems appear. All of your attention, every faculty at your disposal, is placed on the problem at hand.

Which is often when the breakthrough comes. When you start producing work that is good enough to make a living. When you find the answer to the tricky creative dilemma. When you go out and hustle to find new clients. Because you have to.

The flip side is that desperation isn't attractive. Clients can smell fear. And it's a turn off. Clients and collaborators want to know that, while you might not know everything, you know enough to deliver on their needs.

The key is to get into a desperate situation while remaining in complete faith that you will figure it out. You will break through. You will land that client. Or solve the problem.

Then desperation, the all-encompassing need, gives you focus and energy, while faith lets you move forward and lets others help you along the way.

Somehow, when a client can tell you need a job or you won't survive, you never seem to get it.

It's when you have total faith in yourself that you will do amazing work on the job, but that you'll also survive just fine without it, that it comes.

It's an annoying balancing act, to keep the faith in yourself through a crisis. But we've all got to learn how to do it.

Partnerships

Should you partner with friends?

Ideally, no.

Most businesses are started among friends, and this is especially true in film. The vast majority of my students want to start a production company, rental house, or post house with their best friends from film school as a way of sticking together. Many go ahead and do it.

Most of those friends aren't friends anymore.

If you start a business together, you are going to be spending at minimum 40 hours a week together, which is more than most romantic couples ever spend together when not on vacation. But that's a low estimate; the start-up years often demand much longer hours than that, and bleed into nights and weekends.

You'll be going out together, but it won't be friendly anymore, it'll be work, you'll be with clients or potential clients or vendors or employees.

There will be periods where you have ten phone calls a day to each other working out the thousands of decisions a small business faces every day.

It is very very unlikely you'll feel like getting together for a leisurely drink over the weekend, or to shoot hoops or hit a few balls at the driving range. You will have seen enough of each other.

Additionally, you will have gotten intimately acquainted with all of each other's weaknesses, faults, shortcomings, and failures. Good business partners understand that the other partner is only human, and there is forgiveness, but it's hard to be a confidant for someone's relationship ups and downs over a beer when you are simultaneously frustrated at how they failed to deliver on a project on schedule, or when you are sick of how they undermine you with employees.

A good business partner is someone you should be friendly with and there needs to be trust, but it's probably best if they aren't your best friend, and good too if your best friendships can be protected from the stresses of business.

There are exceptions, of course, but not many.

This is true even on a freelance level. Once you start hiring a friend for freelance gigs, the dynamic changes. You start talking about business, and it's

hard to pivot to having a normal conversation. When it doesn't go well, it's often harder to give them feedback as to why. It's also harder to evaluate their actual skills, and if they fit well, since they are friends.

When deciding "do I want to go into business with this person?" evaluate, really, if you are actually willing to give up their friendship. Because there are a lot of business partners out there in the world, but a true friend is hard to find.

The other thing my students are constantly proposing is not just that their friend group start a business, but that they start a "collective."

"Collectives" don't seem to last.

It's a common idea. "We are four directors who like similar movies, let's form a collective!" It comes up all the time.

There are a ton of examples in the non-profit space of collectives that survive, and there are a lot of "art" collectives that thrive for long periods of time.

That's fine.

But if you need to make a living doing this, if you need this to pay rent and college loans and put food on the table, "collectives" don't seem to be the best model.

The biggest reason I have observed is the lack of clarity about who does what. A "collective" of four directors often leaves no one to edit the projects, no one doing sales, and no one making sure the business's rent check makes it to the landlord.

If one of those four directors really learns to sell, they are likely to want to keep all those jobs themselves. If of those four directors one is booking all the jobs and making sure the rent is paid and growing the business, they quickly realize they don't need the other seven collective members.

The "collective" urge is a normal one, especially when young, but is seldom sustainable. Do an art collective, do a non-profit collective, live in a housing collective.

To make a living, do a business. Figure out who is going to do what, and make sure that there is some discussion of the really difficult aspects of business, especially how profits, if they come, are going to be used. With a collective there is the idea that "we all share alike," which is great, but it doesn't work for a business. A business needs to find ways to reward people who are bringing in more work, managing more projects. A business needs to keep its balance sheet healthy. It needs to have a cash reserve in the bank. There's nothing wrong with calling it a business.

Aiming at the Center of the Target

For some reason, many people in the arts aim towards the side of the target. They want to act, so they get into voice-over work. They want to direct, so they pursue cinematography. Or they want to direct features so they pursue commercials.

None of these things are inherently bad. Many times aiming slightly to the side of the target leads to the amazing discovery that they actually really enjoy whatever they land on.

However, for most people, somewhere in the darkness of your soul, you hope that by aiming at the target at all, but just to the side, you might accidentally hit the center. This almost never happens, of course, but it's the secret hope.

Far better to aim at the center, and if you land a bit off to the side, be happy. But to never aim at your target at all is a waste.

You want to direct features? That's your goal? Aim at it with everything you've got, and choose a cashflow job that allows you to keep moving towards it, and doesn't get in the way of it.

With every action you do, ask yourself the question, "Is it the best use of my time to be doing this?"

Your goal is to focus all of your attention on the work only you can do. No one else. If you want to make it to your big ambition goal, you need to be ruthless with your time. You need to only be doing things that nobody else can do, and you need to evaluate everything you do with that in mind. Nobody else can do that for you.

If you bill your work at $500/day, and it takes you a day that you could spend working on client work to do your taxes, is it the best use of your time to spend a day doing your own taxes when you could pay someone else $300 to do it for you? Or are you effectively wasting $200 by doing it yourself?

You need to set a value for your own time, then rigorously prioritize that time towards your goals.

I have a good friend in real estate. He makes around a million dollars a year. Assuming a 40-hour work week (he works more, but let's keep the math easy), that's 2,000 work hours a year, or about $500/hr. That's how he values his time.

Living in Los Angeles, he's often in his car, and while driving he can't respond to emails, he can't post to social media, he can't do contracts. He can do calls, but even those he can't focus on entirely since he's driving and that deserves proper attention.

So he hired a driver. It's $25/hr. At first it felt ridiculous. He grew up poor in England and he felt like it was an indulgent, posh thing to do. But we talked it through and effectively if he doesn't pay someone else to do it, he's basically paying himself $500/hr to drive himself around. That's what his time is worth. He's actually saving himself $475/hr by hiring the driver, so he can sit in the car and work while someone else drives for him.

Because he's English he can't bring himself to sit in the backseat, but that's another set of issues altogether.

As soon as you can, you want to pay others to do things for you that allow you to focus on what you actually want to be doing.

This is true both when you have a day job and if you've left it.

If you really and truly want to pursue your long-term goals, you need to be ruthless with your time management, and that often means paying others to do things that technically you could do yourself, once you are in a position to afford it.

When you can't afford it, you need to learn how to do your own publicity, your own marketing, social media, and traditionally your own taxes.

But once you start earning enough to make it worth it, outsource it all.

It's very, very hard to stay disciplined about pursuing the ambition goal.

It helps a lot to have our work be the only thing on our to-do list.

Some use all the administrative tasks of their career as a massive set of distractions to avoid doing the work that they feel driven towards and afraid of.

Don't.

Be ruthless.

If you can let it go, let it go. Maybe you don't need to redo your filing right now, maybe it can wait awhile.

Maybe you can find someone to clean the studio regularly so you don't have its mess weighing on you.

Whatever it is, you need to be conscious of how you spend your time, and prioritize what matters to you most.

As you make the decision about what "cashflow" job or skillset to develop while working on the long-term ambition, you need to really look clearly at yourself.

Science tells us that no one is at full capacity all day. We all have peaks and valleys in our energy, our focus, our creativity.

While it changes as we age, most people seem to either be best in the morning or at night. You're either a morning lark or a night owl.

The first thing to do is figure out which you are.

I knew in college. I would rather wake up early the day a paper was due and write it before class than stay up all night writing it the night before. By 19 I knew that my best hours were largely before noon, and after that I just wasn't as sharp.

If you ask yourself, you probably already know when you would rather work.

From there, the next step is to protect that time with every method at your disposal.

As a morning lark myself, I don't check email in the morning. I don't make plans in the morning. My business meetings don't start until lunch or the afternoon. I don't teach morning classes. These precious hours before noon are my time that I give to my writing.

I put my phone on "do not disturb." I have a website blocker installed on my computer that blocks all distracting websites (news is my vice, but I've been known to get lost in a Wikipedia hole from time to time as well).

These website blockers allow you to schedule what you block when. I block some things all the time (I never need to read Huffpost again), most things during the "work day" (how I miss you, the *Guardian*, but you ate up too much time), then literally everything during my peak work hours.

Before I did this, I lost too many good writing mornings to responding to some "emergency" that showed up in my email that wasn't actually an emergency at all, that really could have waited until later.

Napoleon had a policy of never answering a request letter from a subordinate until the second time it was asked. He assumed that most things worked themselves out on their own, and he only really needed to deal with issues that were so tricky people would bring them to him twice.

You'll be surprised at how little the world needs you during those peak productive hours.

Dedicate them to your art.

While you are starting out, push all the other tasks, publicity, marketing, filing, book keeping, to the rest of the day.

Once you are making enough, you can play video games and surf the rest of the day. Until then, that is the time for your "cashflow" work that keeps your stomach full.

Do not give your most productive hours to your cashflow job, or you will never hit your ambition goal.

Most of us are constantly trying to minimize the work required for cashflow jobs so that we can spend all of our time on ambition jobs. This means getting so good at our cashflow job we can do the same work in less time. We can be "masters" of our cashflow job.

Unfortunately it doesn't seem to work like that. When you think you've figured it out, you've lost it.

As far as I can tell, there is never a moment where you've finally figured it out. There is simply a series of breakthroughs, of moments where you move up a level, where you gain new understanding and insight into how your chosen field operates.

But each new level comes with a new level of complications, new information you didn't realize you needed, new problems to solve.

This never ends.

The biggest danger to your career is when you think you've "figured it out." When you feel like "you've got it."

Doing this work requires continually stretching yourself just a little bit beyond your comfort zone, at all times.

My whole life authority figures were always saying "If you think this is hard, wait until you get to X, that's hard." High school, college, graduate school, it was always about to get "hard."

Only, it never really did.

Until I started companies and trying to make movies.

Doing both is really hard.

Because you are interacting with the fundamental forces of how the world works. You need to know how commercial leases work, how to negotiate with clients, how to keep cash flowing. How to hold an audience's attention. What the current look is. How to pull off a truly surprising twist.

There is a never-ending volume of things you need to learn.

But it's also what makes business exciting, since it fully engages all of your senses.

Business almost never runs on auto-pilot. A business that isn't actively managed or directed fails. Even if it works perfectly, the market it's trying to serve moves, leaving it out of sync with reality. You can't write a computer program that generates money.

Art is the same way. Taste is constantly evolving. Aesthetics are moving. You can see an ad and generally know what decade it came from. If your cashflow commercial work is all from ten years ago, it will look hopelessly out of date. Seven to twelve years seems to be the "ugliest" age for art: more years pass and we are able to see it fresh again, appreciate its retro charm. But recent just-out-of-fashion work is almost never engaging. You've got to keep growing.

If you find this thought exhausting, you're right. It is very tiring.

Whatever you find for your "cashflow" job can almost never stay on auto pilot. If you decide to edit for cashflow, you still need to develop new editing skills, take workshops, watch tutorials, adapt to new software. If you don't, your editing cashflow will slowly dry up. Which is fine if your directing cashflow has started, but not fine if it hasn't. It's a lot to do.

But it's also incredibly exciting.

All of my regrets in business are jobs to which I should have said no.

You should say yes a lot. There will be jobs that make you nervous, that stretch you to your limit, and you absolutely, positively must say yes to them even though they scare you.

It's vital.

But no is powerful too. The most powerful people I've collaborated with are masters of saying no with speed. They zealously protect their own bandwidth and will absolutely not, under no circumstances, ever agree to do anything that gets in the way of their goals.

One-itis

Another major danger for pursuing your long-term goals is to focus too heavily only on one singular ambition project.

I spent several years trying to get one project made. That was it. If I was in a meeting or at a party and someone asked me "what are you working on," I had only one movie. And I was going to make THAT, or make nothing at all.

It fell apart in spectacular fashion. A producer came on board, we hired a casting director, the producer pulled out, and it turned into an epic fiasco. Then, months later, a major European director submitted a film to Cannes with the same exact, and honestly somewhat obscure, plot. It flopped. My film was done.

I had nothing else cooking.

My buddy, over breakfast, heard the situation and said "oh, man, you got a bad case of one-itis!" I hadn't heard the term and he explained "you decided that one project was it. That's one-itis. The belief, without any evidence, that this one project is the answer."

Until it's actively in production, you don't owe a film absolute loyalty and focus. You owe yourself multiple projects being developed all the time, so that if any one doesn't go, or falls apart, or otherwise you outgrow it, you can work on others.

Honestly, by the time it fell apart, I was glad it did. I was six years older than when I had written it and had outgrown the script. I was ready to do other projects.

The smart producer or director has many projects on the stove. When in production and post, you should have one main project getting 90% of your attention (100% during shoot days), since that level of focus is required to do work that is any good.

But don't get caught in one-itis while trying to get projects made. Until the universe, the industry, the movie have committed back to you (by getting fully financed and being able to pay you fully to focus on nothing else), you don't owe your movie that singularity of intent.

You have to have a full stable of projects that you are working on at any one time in order to get anything made. Even if it's one script and two treatments a year, that's enough to keep moving forward.

People can help you more if they know what you want.

I deeply believe that when developing your "cashflow" skill you need to market one thing at a time. Your website needs to say "editor" on it if you are planning on making money editing until "directing" pays your bills.

There is an exception to this. You can't write it down anywhere, since "director/editor/2nd AC" will always be a weak marketing slogan, but you can talk about long-term goals, especially when asked.

In a hiring meeting, it's OK to say things like "Oh, but I'd love to direct more" and no one will hold that against you. It might lower your editing rate in the short term, but will help move you towards the directing goal in the long run.

In some ways, it's even helpful. Since one important truth is that people up the ladder are often thinking about other ways to reward people when they have low budget projects coming down the pike and need help. Money is only one of the many methods you can use to incentivize collaborators. For instance, a producer with a production company that has a lot of directing opportunities coming in might well recognize that if they give the occasional directing opportunity to the editor who is eager to direct to "keep them happy," they might be able to pay that editor a little less, since the editor is "also getting to direct," and keep them happy a little longer with that balance.

This happens all the time at smaller production companies who are always trying to find ways to lower costs while doing good work.

Thus, if you are using editing as your cashflow, you can occasionally drop your directing ambitions into conversation, but it's only smart to do it if you like the kind of directing jobs that company is getting. If they are a bland corporate house, maybe keep your directing ambitions to yourself, make as much money editing as possible, and then direct outside.

But if they are a hot young production house making cool commercials and music videos, and it feels organic in the conversation, you can mention longer-term directing ambitions.

Only with the producers, though. Never with the client. Because clients always want to feel like they are in a room with highly trained specialists.

Chapter 2

Finding Your Opportunity

Pain Is the Opportunity

The overall theme of this book is that you need to find a smart cashflow position to pursue while you work towards your long-term goals. To do that, you'll either team up with others to form a "business" or you'll manage your own career as a business. Your hunt for the right "cashflow" position or opportunity is really hunting for a business idea.

All business ideas come from pain.

People will pay a tremendous amount of money to avoid pain. Cars, subways, taxis, people pay for them to avoid the pain of walking to work in the hot sun or the freezing rain. People pay money to solve pain points in their life.

If you are looking for opportunities for your business, the best place to identify new opportunities is to actively look for the most painful part of your personal creative process and find a way to solve that for others. This is such an entrenched part of "business" culture that it is generally part of most business pitch decks: what is the "pain point" and how are you solving it for your customers?

AirBNB solved the pain point of customers wanting more authentic travel experiences but not trusting craigslist to find them. Uber solved the pain point of not being able to hail a cab on your phone. AT&T solved the pain point of walking to talk to people who aren't in the room with you. Identifying your pain point and solving it is a vital step.

Think back to the movies you've already made. If you want to be in film, you've probably already started making small projects. What have been the pain points that most frustrated you?

Within the film industry, Avid solved the pain point of wanting multiple editors to work on the same project at the same time. Production companies solve the pain point for clients of having the skill to produce great video content, and assuming the risk so that the client doesn't have to do so.

Color grading used to be a tremendously painful process simply because it cost so much money, and many color grading companies launched in the 2003–2010 window offering more affordable high quality color grading. Apple released "Color" as part of Final Cut Studio, and that software offered

the ability to color grade for less. Many business people immediately saw the opportunity of providing that service. Almost all of them have a story about the painful color experiences they went through right before starting their own business.

If you are struggling to find your niche in the film industry, as you make projects start paying attention to what parts of your process are the most painful. For instance, managing client notes has traditionally been one of the most painful aspects of the film industry. Frame.io, created by filmmakers, was designed specifically to make the client note experience less painful and more efficient for all involved. Removing that pain is something most creators would happily pay for in a heartbeat.

One of the issues with pain is that we get used to it so quickly. This is one of the reasons why businesses are often started by younger people. If you've been working for 20 years, and color has always been painful, or client notes always a nightmare, you've learned to live with it for 20 years and you often forget that it could be better.

Entrepreneurship requires an ability to stay cranky. To continue to be frustrated by the pain points in a workflow and to dream of systems for improving it. When you are frustrated by something and someone responds "Well that's just the way it is" that sentiment is the enemy of starting and growing a business. "What if this was better?" is the habit of thinking that will lead you to seeing new opportunities. It takes an active effort to keep your brain in that space.

Look around at the painful steps in your workflow and attempt to identify ways to solve them and you'll find business opportunities galore. You'll still need to learn how to actually offer that improvement. Apple took care of that with Apple Color: it was (relatively) easy to learn how to start a color grading business. Building Hive Lighting required acquiring new skillsets and figuring more out on their own. Before you decide what skills you even want to acquire, be on the lookout for pain and how you might solve it.

Bandwidth: Two Things

You need to pick your battles in terms of what areas you dive into for expertise.

Human beings have a limited amount of bandwidth for learning, working, producing, and growing at any given time.

Since in the arts we are usually ambitious, trying to grow, develop new skills, develop as people, it's helpful to limit the scope of how much you are doing at any given time.

Humans seem to have the bandwidth for about two things at a time, your "cashflow" thing and an "ambition" thing. While your ambition thing isn't paying you, you need a cashflow thing. Eventually, your ambition job might start generating revenue, at which point you'll usually pivot to having another ambition.

While you have a day job at a bank, you work on building your video editing business on the side. Once that grows large enough, you quit the bank and editing becomes your cashflow job, which frees up time for your ambition work of directing. Once directing corporate videos starts paying your bills, you might move into an ambition project of real estate investing. The world is full of surprising pivots.

I've had a few friends try to have more than one ambition thing. They tend to progress more slowly, since ambition tasks generally deserve a "deep dive," or "nerding out," in order to gain the knowledge and mastery necessary for you to progress. If you are going to turn your ambition thing into a cashflow thing, you need to get really good at it, understand it, master it. That takes a lot of time.

This will be true once you are doing your "ambition" job full time as well. A "car" commercial director tries to break into food work. A horror director will try comedy. Pivoting is constant.

I deliberately manage my nerding out. If I have a great business idea in an arena where I know nothing, I blog about it and give it away for free. If I don't think an area of the world is one I would enjoy working in, I purposely don't learn anything about it.

When I was in film school, during the second year you had to pick a non-directing specialty to work on as a mid-school project; cinematography, editing, producing, or sound. While it didn't feel momentous at the time, most of the people I knew in school ended up doing what they did on that project for a living. Why? Because when you got out of school, and times got tough and you needed cashflow, you'll use whatever skill you have to earn a living, and that mid-school project was a deep dive into mastering a skill. I deliberately didn't learn sound and avoided offers to work in that area. Because I knew that if I learned it when I needed cash I would go there, and that wasn't a path I wanted to follow. I ran into a friend recently who had done sound for their second-year project and has now spent a decade as a sound mixer, which isn't why he went to grad school.

It hasn't trapped everyone I went to school with, but it did trap many.

Be careful where you nerd out. Look for areas to dive into that lead you where you want to go.

Figure out your cashflow thing and one ambition thing and dive in with everything you've got.

The Perception of Scarcity

One of the things that plagues the film industry in general is a perception of extreme scarcity, which often drives people to behave in bizarre fashions.

Yes, the film business is smaller than many other businesses that feel "larger." The film industry isn't even the largest business in LA (outside the service industry, that's actually aerospace). But there is work to be done,

there are countless hours of content to be created, and there are constant opportunities to be part of that in some way.

However, during periods of "scarcity," people become desperate to find a solution "now" to make sure they survive. One of the biggest things you can do as you set up your plan, either for your official "business" or for the career you'll need to run as a business, is to breathe deeply and calmly assess the situation without the panic that is often created by the artificial feeling of scarcity.

The best way to do this is to make sure you have a cashflow plan set up at every given stage of the plan. This is easiest for cinematographers and editors. "I'll be a second AC while learning to be a good first AC, I'll be an amazing first AC while operating, then I'll operator while occasionally shooting to slowly climb my way to the top." That's a viable plan that has cashflow every step of the way while your goals are pursued. Editing offers similar paths, as does art department.

Because of the nature of directing, the path isn't clear, but that doesn't mean you have to starve for a decade while you get your movie made. Find another path that allows you to eat, and keeps you in the game and meeting people, while pursuing that goal.

Seeing the Field

"How do I know what to do next? My older brother was in visual effects for Hollywood movies, he was making $5k/week in the 90s, but now he can't find any work, it's all going to Canada and Singapore," one of my students asked. He really wanted to know: where were the jobs going to be next? Even in the arts, economic forces like outsourcing, globalization, NAFTA, and more have an impact on what we do.

We know we need to find some way of generating cashflow while we work on our grand ambition projects.

What do we do?

Unfortunately, the best advice in this arena is general, not specific. I can't tell you what to do next, what field is about to be hot. Ignoring the delay creating by publishing this book, even if we were sitting in a coffee shop it's highly unlikely I could spot your opportunity for you.

Markets change. Constantly.

In the 1980s there was no internet. By the 1990s, there was a booming business to be had for freelance web designers, building sites for small businesses, local restaurants, performers, and the like. Money was there. Students in art school were encouraged to study web design. Many financed their independent features by spending days designing incredibly repetitive websites for local businesses.

By 2010 technology changed and pre-built site companies (Squarespace, Wix, etc.) moved in. The "small client" web design market collapsed. There was still design work to be had, but you were competing against the pricing of these venture-funded companies providing great work at insane prices.

You were also competing against designers abroad who could underbid you. My main graphic designer lives in Kiev, the Ukraine. They are great.

A market opened and flourished. Pay was good. People flooded to the market and pay lowered. Technology changed the market, increasing competition and lowering rates more. Many pivoted out of the market.

Wedding photography was another longstanding cashflow job for many photographers. You worked mostly weekends, keeping your weeks free for your creative work. The same gear you bought for weddings would often be used in your personal work. It was usually kind of fun, with a party atmosphere.

Around 2006 it all changed: digital photography came into its own. It exploded, with Digital-SLRs taking over the market. All of a sudden, you were bidding for jobs against the bride's cousin, who had a very nice camera and wanted to break into weddings. All of your arguments that expertise matters, these are memories you want to last a lifetime, go out of the window when your competition is bidding a third of what you bid. And their stills camera shoots video, so they will deliver both. It becomes a very tough racket.

Markets change.

Sometimes, in these changing markets, there are opportunities. A friend had a wedding cinematography company that went hard for film when the digital revolution happened. His sales pitch was "Film is archival, these memories will last a lifetime. Can you even play a VHS tape anymore? Film is romantic, soft and beautiful, like you, like your special day." He did very well with higher end weddings, shooting on 16mm and 35mm. He even expanded into another brand doing Super8mm weddings. He built a business. All because video became a part of the wedding market, a new technology opened up a window for an old technology to flourish.

There is a lot of money to be made ignoring conventional wisdom.

The danger, of course, is that sometimes you are wrong, conventional wisdom is right, and you lose your shirt. Which is why it's important to not only have your theory (people will want weddings on film), but to test it. Set up a website advertising your service, but wait to buy gear and rent it on the first few jobs, until you actually see if clients will hire you.

Unfortunately, this means trusting your instincts and paying attention. By the time word spreads it's often too late.

In 2005, when I was doing my thesis film, a third of my budget was devoted to color grading. It's the retouching of images in motion, like Photoshop but for motion pictures. With a student project, it was possible to get amazing deals on lots of things. Kodak donated film. The camera rental house gave us gear for only the preparation fee. People worked for free. But as hard as I tried I just couldn't get color grading down. There was too much demand, not enough supply, the equipment was too specialized and expensive, and even the price I got was considered a "good deal" by those to whom I talked.

My friend did a feature film the same year, and spent 15% of his budget on color. For a small movie, that was a big chunk of expense. And he wasn't happy with what he got: the vendor treated it like a little favor job and he was rushed through.

There was an opportunity here. I could feel it.

Others could too. I had a friend with a volume film business who asked me to help set up a coloring company, getting some of that specialized equipment on the cheap from a company that was upgrading to the newest stuff. I agreed.

While there, Apple came out with a program called Color. It would allow you to color-grade HD material on your home machine.

The market changed.

I parted ways with the business which was pursuing film (which is still in business and thriving quite well), and decided to go whole hog into color for digital video. I built a business on it. I wasn't the only one in that period to do so. Maybe a dozen companies in LA came in and disrupted the market. One of our interviewees, Michael Cioni, started two of them.

Something that had once regularly cost $1,000–1,500/hr suddenly cost $3–400/hr. If the client didn't even have that, I could be flexible and work around their schedule and budget in ways that were never possible before. Apple Color took what had previously been a "professional" set of tools (with their low volume and high margins), and built a "consumer" tool. Others had done this before; in fact, Color was purchased from another vendor and integrated into the Apple universe. But Color was effectively free (it came bundled with Final Cut Pro, which everyone was paying for anyway), so it grew quickly.

Business grew.

It still exists, that business. Many of the companies started in that moment survived. New software has come into the market to make it even faster, easier, cheaper. Da Vinci Resolve came out quickly and took even further advantage of the consumer model by moving much of the processing to the video card. Video cards are cheap (they are produced in massive volume for video gamers), and by taking advantage of the power of the graphic card business Resolve enabled users to build very powerful machines for not very much money.

So, would I say get into color?

Not right now. The market isn't flooded, per se, but it's close.

Now is the time to get into color if you really really want to be a colorist and nothing else. If color is your undying passion, there are opportunities there to find a career and build a life that you find creatively satisfying.

But as a cashflow job that is designed to help you with your other ambitions? I would say color already had its moment for that. Its great disruption was where there was a lot of opportunity. To survive in the color marketplace right now you need full-on focus, and that only comes if your cashflow job and your ambition job are the same thing. Then you focus on nothing else.

But that doesn't mean cashflow jobs don't exist, I just can't tell you what they are. Only you can see that. I tried, in my first few years of color, to tell all my friends about the opportunity there. The money that was about to be made, what a growth business it was, and how much it was about to explode.

A few of them even tried it, but by the time they did it was too late. I had already been in the thick of it for years, and was well primed to take advantage of it, and I had already been prepared by my experience to build those businesses. They hadn't.

By the time they learned the skills they needed to learn to get into color, the market had moved on.

I can't tell you what precisely your cashflow job is going to be. I can only tell you what mine was.

You can figure out your own. You just have to trust yourself.

Keep up with what's going on in your field. Read blogs devoted to the news of what happens in your industry. And when you have that instinct of "somebody is going to make a lot of money because of that," remember, if you're thinking it, that means that person could be you.

Software Communities

Whether you like it or not, there is a good chance that your cashflow job, and perhaps even your ambition projects, will in some way involve software.

I built a business on a product made by Apple called Color. Color's biggest flaw? Its name wasn't original enough, making it hard to google. This is a bigger problem than it might seem.

With any consumer-software-based business, you can take comfort in the fact that countless others are using the software, and that whatever problems you encounter, they might well have encountered them as well. And, hopefully, fixed them.

If you are using a major editing platform for your post business and have an issue, chances are someone else has had this problem as well. Google it, go on a forum, go to a likeminded Facebook group and there will be answers.

This is one of the pleasures of using consumer-facing tools. Yes, many professionals use Premiere and Final Cut Pro. But since they are also a consumer product, designed to be used by millions of users, there are large communities of users. Around those products, online forums develop. Usually many. Some hosted by the software vendor themselves, some by third parties who recognize the power of a group of dedicated fans discussing the ins and outs of a program.

One of biggest drawbacks of "professional" tools, aside from their high price, is how small the community of people is who use them and how rare it is for that community to congregate to help each other. The tools cost a lot of money, so they call the vendor when problems arise.

This is great if the vendor is open. But sometimes it's 4a.m. in the morning, the vendor's help line isn't returning calls, and you have a bug that is going to

prevent you from delivering the project that is due at 6a.m. West Coast time for the CEO to view it in New York at 9a.m. It's going on a screen in Times Square at 10a.m. and live streaming on MTV and the internet, so it needs to be finished. And no one is picking up the phone.

With a consumer product, chances are somebody has already had your bug. The answer is sitting there on the forum.

Or, even if not, you post your bug or issue or quirk to the forum and others are awake. Someone in Moscow or Helsinki, goofing off in the middle of their work day, sees your post and remembers how they fixed it once. Or, if they don't know the answer, they fiddle around with the software on their machine for a minute and figure it out, since they just woke up and have had their first coffee and are feeling fresh and alive and not in a panic.

Sometimes it's just enough to know that other people are out there who are part of the community.

Tools with a bigger user base also make your skills more transferable from client to client. Professional tools tend to be highly specialized, with smaller market share, requiring you to retrain if you move from a client who uses one tool to a client who uses another.

But a tool with a big enough user base saves you that trouble. If the user base grows powerful enough, your clients will start to adopt the tool naturally, since it makes life more flexible for them as well. Instead of being at the mercy of the small number of freelancers who are proficient in their small market platform, they'll switch over to the tool everyone is using so that they can have the flexibility of hiring anybody proficient in that tool.

It's my secret theory that this is why Final Cut Pro (FCP) took off so widely. I was never an editor in film school, but I remember talking to my editing buddies and they all had FCP on their home machine, regardless of what was on the machines in the lab at school (usually Media Composer). Why? It was really cheap with academic discounts.

The only requirement? It only ran on Apple hardware, so you had to buy a Mac. Apple still got their money.

This created a massive wave of FCP-proficient editors, and when they went out into the world they wanted to work on the platform they knew. They started companies and used FCP, buying multiple full licenses since now they were professionals. Their clients felt the pressure and moved over to FCP as well. Apple built a community, then sold hardware to it to make a living.

Blackmagic is currently doing the same move with Da Vinci Resolve: it is free software that does everything most users need to do with a very affordable paid upgrade. To get video out from your machine to a broadcast monitor, you need Blackmagic hardware. All of my clients are moving to it since the software is functionally free. All the students in school are learning it. It's owning the marketplace right now.

There are a lot of things to be gained from working with tools that have large market adoption. Yes, some of those obscure professional tools have

features you can't get in the consumer software. But are they worth the trade-offs when your business is small and you are your own IT support staff?

Iteration

Basically all creative work is an iterative process.

Building a sustainable business is just as iterative. As many rounds of revisions are required to finish the screenplay or the edit, so you'll need to do even more revisions to your "business plan" (whether it's ever written down or not) to find a way to sustain yourself.

You need to find a way to keep going through it.

Don't get frustrated with the volume of work required. Keep going over it and over it and over it until you like it. Until it's everything it can be. Until it's done.

Sometimes your audience or client will be ready for you to be done when it isn't done yet.

Keep going.

The motorcycle chase wasn't an original part of *Indiana Jones and the Last Crusade*. The studio was ready to release the movie. But Lucas and Spielberg wanted more action in the second half of the second act, so they shot it. They kept going, even after others had approved it, to keep making it better.

Outside approval is nice, but the approval that truly matters is internal. You need to know you made it the best you could possibly make it.

Sometimes that involves a tremendous amount of wasted work. I was sitting with an editor once with a particularly complicated sequence, and I made a suggestion that was the opposite of the way we were going. "Oh, I already tried that," he said, and showed it to me, along with the nine other versions he tried that hadn't quite worked. Hadn't quite sold the moment.

You have to do those nine other versions to know the one you've got is the best.

It would be great if you could magically know how to edit it right when you sit down, but you usually don't, and even if your first pass is the best, you need to do the other options to be sure.

You have to explore it all.

Then you have to pick the best one and move on.

The best give themselves permission to not make a decision until it's the right time to make a decision. Making a decision too early robs you of options. Making a decision too late wastes your resources. There is a decisive moment, and only you know what that is.

But those other nine versions he made aren't wasted work. They are the work.

The early iterations on your business plan, the time period where you see if you can make money in post, make money on set, make enough to survive as a bartender while writing, all of that isn't wasted time. It's testing your theory of how you'll survive while you pursue your ambition.

Advertising

Advertising is a giant hose of money spraying through the center of the economy.

Thus, many filmmakers build their business plans around pursuing advertising clients.

The economy wouldn't function without it. It's not enough to simply make interesting products, you also have to let people know those products exist. So businesses advertise. Sometimes they go too far and attempt to create a demand where there isn't one, making life seem incomplete without the addition of the product they are selling. But, more often than not, they are simply there to remind you that products exist. Everyone needs a bicycle: a bicycle ad is just designed to sway you towards a specific one.

Advertising agencies have the expertise in creating campaigns that fulfill their clients' needs. They manage millions of dollars in a way designed to maximize the return on investment for their clients.

In most areas of business the top priority is to cut costs, to save money, work more efficiently, to mercilessly survive.

Advertising is different. The primary motivation in advertising isn't saving money: it's defending decisions to clients, and they will go for the "best" whenever they can rather than the most cost effective.

This makes advertising a client a lot of people are excited by; designing ads, directing commercials, writing jingles, creating installations and immersive experiences, working with ad agencies can be a great way for a filmmaker to absorb a pile of money that allows for the time to work on their own projects.

The flip side is that agencies have their own clients, the brands that are paying for the work, that the agency has to serve. In order to justify spending the sums of money they do, they always ensure that they can defend their decision-making. This means getting "the best," the person who has "done it before." This makes advertising very, very hard to break into.

If an agency takes a shot on a new director, a new colorist, and the client doesn't like what they get, the client will blame the agency. But if the agency went with a director who had done the work before, delivered hundreds of campaigns, the agency has covered themselves.

At every step of the process, agencies hire those who have already done it. This is the Catch-22 that makes it very hard to break into, and very hard to leave once you are in, since the money is so good.

This is one reason why many in the commercial industry create a large volume of "spec" work to get in, to prove that they have the skills to create precisely the quality work that the client wants.

The difficulty of this scenario is that most advertising work is expensive to produce, and to pay for a spec out of your own pocket can be prohibitively expensive.

There's nothing wrong with pursuing advertising work as a cashflow job, but it takes a tremendous effort to get into, to truly demonstrate to a commercial client that you have the skill that allows them to feel safe in making the decision to go with you.

If you do land commercial clients though, you'll be amazed at how free they are with money. Coming out of independent features, it can be a shock to see money wasted so quickly and almost deliberately. There is almost no incentive at all to save costs.

Interview: Founders of Endcrawl, John "Pliny" Emeric and Alan Grow

Endcrawl makes smooth end titles without judder. Properly formatted, professional-looking, for a flat fee no matter how many revisions. If you've ever worked on end titles for a movie you know that 30 revisions as you catch spelling errors or crew members left out is not uncommon. Endcrawl is one of those tools that is just so useful you almost can't believe it exists. Like the Babblefish in *The Hitchhiker's Guide to the Galaxy*, it solves it's problem so well that you feel like it's a proof of the non-existence of a higher being.

Of course, just being useful doesn't actually make for a successful business, and co-founders John "Pliny" Emeric and Alan Grow faced, and continue to face, a variety of hurdles with a tool that filmmakers desperately need, but only when they are actually finishing a movie.

Charles: Pliny, you were already working in the film industry when you decided to kick off Endcrawl?

Pliny: Correct. It was an example of someone scratching their own itch because I had been trying to do this specific task, end titles, for a long time, doing it the hard way, the manual way. And always wishing there was a tool dedicated to this specific task and eventually Alan and I just decided to build that tool.

My background is both from web and film. I went to film school for a little while. I dropped out, moved to New York and sort of worked in the web 1.0 days as a producer/project manager for web and interactive projects. Then some people I met on a film set, interestingly enough, started a company that they invited me to join. And that turned into an eight-and-a-half-year relationship and I ran post-production there. That was OFFHOLLYWOOD.

Charles: Did you already know post before you dug into post there? Or was it just you saw a need and you're like, oh, we're offering post, someone needs to get good at this, I will be that person?

Pliny: I didn't have years and years of experience in post but it was a time when all these new technologies were happening, and a lot of new tools were becoming available to filmmakers. And we saw that traditional post-production companies were a lot slower to jump on that, 'cause they had established pipeline and established vendors. So we positioned ourselves as the people who understood digital, who understood HD, who understood digital intermediate, and then when

the RED camera came along, through a very fortunate set of circumstances we became the owners of the first two shipping production models of the RED ONE camera. So literally serial number six and seven. And the first five belonged to the owner of the company.

We were able to position ourselves as that and we kinda grew up, I would say, like digital post-production native. So the short answer is no, I didn't have years and years of experience in post when I went in but we just, you know, we just kinda grew up in that era when that was happening.

Alan: Neither did anyone else at that point, you know?

Pliny: Even when DV was a thing, filmmakers would come to us and say, hey, you know, we don't know, what is this HD thing and what is this tape? And how do I get this tape into my editing bay? Like producers just didn't understand. They knew how to budget for a 35 millimeter shoot. They knew how to shoot on short ends or 16 mil, but when it came time to do digital they were just kind of lost.

And so we were like, well, we're gonna learn everything and then we're just gonna make it accessible to those customers and those clients.

Charles: What was it about this particular issue of end titles that made it stand out to you as a business opportunity that goes beyond just us?

Pliny: There were a lot of opportunities I thought about, throughout the years working in post-production, where I said, "god, I wish there was a tool that did x. I wish there was a tool that did y." But I also recognized that there was probably, for most of those things in my mental wishlist, there weren't a lot of good businesses to be built around them.

It was maybe something that would be a good freemium tool, something that would be a cool plug-in, but not something that could really scale. End credits we saw as something interesting to tackle as it needs to be beautiful, it needs to look classic, it needs to look well-designed, but a lot of those don't need to be bespoke. When you need something bespoke then it's an agency model and an agency model is a completely different beast. It's not something that scales; you're always out there like a hunter-gatherer hunting your next meal.

With end credits, we did a lot of analysis of the market, we saw how many films were produced every year, and starting in 2004 when I really entered the post-production business, those numbers spiked dramatically. So now we have probably about 15,000 movies just in the U.S. that are made every year. Feature films.

And so we saw that as a viable business, with many clients that want something somewhat visually similar, and that's why we decided to move on that.

Charles: So there was an actual evaluation process. It wasn't just, "this is an annoying part of my job, I'm gonna fix it." It was "this is an annoying

part of my job, and a little bit of back-of-the-envelope market research tells me there's enough other people that want this fixed. That there's something here."

Pliny: That was our hypothesis. Alan and I knew each other socially so I asked him if we could grab burgers and beer and I ran the idea by him mainly because I had this crazy idea at the time that I could build it all myself. And I was just kinda looking for some advice on how to approach it technologically.

He gave me some really great ideas. And so like six months later he saw me like, "Hey, how's that thing going?" And I was like, "I've gotten nowhere." And we went up to a holiday party, like I think it was at Sound Lounge, and we had a few drinks and we kinda just started sketching stuff on napkins and then talked ourselves into doing it.

Alan: I remember Pliny just sort of bugging me about it. Like he kept bugging me about it and I was kinda like, oh you know, credits. How can that really be, you know, a thing, a useful thing? Is it a problem worth solving? I could tell that it was a big problem for him but, you know, a lot of these hair-on-fire problems don't turn out to be useful to others, they turn out to be very, very personal, you know? And so I wasn't convinced that this was anything more than a, you know, like sort of personal problem that Pliny needed solved.

Basically we had one too many drinks at this party and kinda talked ourselves into it. Then it was like, "Oh yeah, I guess there are a lot of feature films. Oh, yeah, I guess these people are actually paying a lot to designers just to get end credits, and yeah, wow, they really actually, they really hate it."

So, you know, looking at it as an opportunity to build something that people actually wanted. It kind of changed to that point for me and I decided to lend a hand. And then we built this kind of, like, a lean start-up.

Charles: How long was it from there until you had a product that you could show a potentially paying client?

Pliny: I think it was six months, if I remember it correctly. So we threw up a landing page. I was actually on my summer vacation and it was my birthday, I remember this. That we actually launched the landing page I spent all day working on. In 2012. And we put up the landing page. Now when we say a product we had a script on my laptop and a Google doc that we would give to a customer.

We threw up the landing page, said, "Hey, we're here. Who wants it?" And we started getting people; we started getting interest. And so people would sign up for projects, we would give them a Google doc that was formatted in a certain way that we set up, and we said, "Just stay within these bounds, don't color outside the lines.

You know, names go here, roles go here, song titles go here. And then when you want a video output just email us."

And then we would get an email saying, "Hey! We want a new output of our end credits." We would download the .cmv from Google doc, we would plug it into the script, we would get an output. We would take that video, we would manually upload it to Dropbox, manually email people back and say, "Here's the link to your thing."

And it took about 15 minutes, that whole process, if we were on it. And people were used to it taking hours if not, like, a day to get, for that feedback loop. From like emailing a designer saying, "Here are all the changes I want and then let me know when it's done." And so right there customers were already seeing an improvement to their workflow. And they liked the process better so that was really, just like a classic minimum viable product. Was a crappy script on my laptop.

So yeah and I think it was six months from when we decided to do it to when we actually did it. It didn't take six months of writing; it took like a day or two to write the script.

Charles: And was that a skill both of you already had?

Pliny: I already built some websites in the dark days back in '95, '96, I had those skills. And of course Alan's a professional developer.

Charles: Have you ever pursued press and marketing or has it all been word of mouth?

Pliny: Well that's really interesting. So, yeah, we've run a ton of marketing experiments. And when it comes to feature film, most digital ad spends don't really work for that type of customer. We'll interview our customers, we'll do post mortems without customers, just talk to them and, you know, we've heard pretty loud and clear, "I wouldn't pick this type of professional tool based on a Facebook ad."

They're right. You know, once someone said it to me that way I was like, "You know what? That's a fair point." The lion's share of our growth comes from professional referrals and word of mouth. And so our efforts have to be built around how can we accelerate that? How can we incentivize that?

At this stage it's still a lot of stuff that doesn't scale. It's meetings, coffees, it's sitting on panels, it's doing interviews. It's just meeting people where they are. It's hosting events, doing branded education, all kinds of stuff like that. That's where we really reach the people that we want to.

It's tricky since in a feature film, a lot of people working on a feature film it will be their first time, especially if they're serving an indie market. It may not be a second movie that they're involved in and so they won't have previous experience to draw on, this is a

first and maybe only time they'll have to solve this problem so they don't know what they're getting into.

Charles: If you're only doing an indie feature every four years you might even forget how painful it was four years ago.

Pliny: They're coming from the point of view of, "I don't know anything about this process. What's the correct order? How long should it be? What font should I choose? What are the aspect ratios?" They don't know any of this stuff. And so when you present a solution that already sort of gives them a template that answers 90% of those questions, then we're solving, we're getting them over that hump right away. Like, "We've done this 1,000 times. Here you go. You can't go wrong with this. And if you wanna tweak it from the template go nuts."

So the first timers, the value to them might not even be going in, "I'm gonna get the revision 100 times." Right? So we had one first timer who was like, "I'm only gonna make one render please. Can you give me a deal? Give it to me for free?" And then in the end we said no. And he of course made like 180 revisions.

They don't know going in but what they did know is they didn't understand the process and didn't know what they didn't know. And here's someone who's already like laid it all out for you.

So it's a slightly different value prop but still incredibly valuable to them.

Charles: It's scaling up expertise. That's very useful. One of the things Endcrawl provides for you is background knowledge about a subject. You guys know a lot about this and you are able to package that for people.

Alan: Yeah, it's also kind of interesting that we get these adjacent questions about workflow and delivery and stuff. And we just answer them. We're not like, "You know that's off-topic. We only talk about end credits." You know if people ask us questions about like, "Is this the right raster for me?" We'll just answer them.

Pliny: We're a company that started very lean, has sort of been slowly building up automation around it. And also integrates with Google docs for some things. And I've met a number of companies since we started that have the same exact story. In fact I had a call with one yesterday, that started basically as a concierge service, has slowly been building up automation around the most requested features or the most time-intensive activities and integrated with Google docs.

So that's totally a thing. I thought it was just us but no.

Charles: No, it makes sense. So, in terms of, I know you said you kept a mental list when you were at OFFHOLLYWOOD of what, problems, connections, and businesses. How do you guys make the decisions

about where to automate next? Do you have like a formal process of looking at what you're doing most or is it sort of a gut instinct of this is the thing we seem to be doing a lot?

Alan: There's data on it and it's also just painfully obvious, you know? 'Cause it's been, we've had so many films go through the pipeline at this point and it's, you know, kind of the same, I don't know, maybe half-dozen type of questions over and over and over again. So the missing features, what the missing features are, that question has been answered to death for sure.

Charles: So it is only obvious because you are both still so involved.

Alan: And because we have the data, yeah. But both of us, we still do support rotation. Which I think is super important. I mean not just for the sort of negative feedback, you know, "Oh gosh, this isn't working. We need to improve this." But also there's that feeling of like someone comes in, they're stressed, they don't think they're gonna hit their deadline, or they just feel like they don't know what they're doing and then make everything okay. And that good feeling . . . Pliny actually sent out an email yesterday to a bunch of our customers just saying, "Hey, do you know anyone who needs end credits for the Sundance season that's coming up?" Like I'd appreciate a referral.

And it kind of surprised us the response that we got. It surprised me. The outpouring of like how much these people love the service. It's like you kinda forget that you have these customers that are like, "You're my hero. You know? I would get a tattoo of Endcrawl." Like one of our customers told us that once. But you kinda forget about it until you do something like this and then you're like, "Oh, yeah." There's a lot of people out there that we save their bacon and their lives are significantly easier at an already very trying time in their life, you know? When you're trying to finish a film.

Charles: You're not a high touch product but you are a product that people depend on in the most high-pressure period for many people of their life. Delivering your first feature is incredibly stressful for many people.

Alan: Yeah, for sure. It's that endgame stuff. You know yeah, I think it's really difficult for people. You know, and then often people are ramping up for festivals. So you know there's that first premiere of the film and you've got sort of pressure coming in from stuff like that.

It's not just about hey I'm gonna work at home or work at a café or whatever. There are real advantages to having a distributed company. One is that you kinda have to do a lot of things out in the open. Like we encourage the default to open if you're talking about something, talk about it in the Slack. If you're having a private conversation in Slack move it over to a channel so other people can see it, you know?

Instead of having hallway conversations and whispers and things like that, you know, keep things out in the open, keep conversations out in the open, and keep the truth out there.

It also forces you to work on your documentation harder, which, you know, it's a challenge. But a distributed company needs to have a strong written culture. And it also just opens you up to more talent, you know? You don't have to just hire people who are your geographic area. And you don't just have to hire people who do well in a traditional office kind of setting.

You can hire people who would rather just stay at home but are really kick-ass at their jobs. And so I think there are a lot of advantages to distributed work. And the film industry is a little slow to the concept. We're certainly out in front in some areas. Like we've had a very well-developed gig economy for a long time. The gig economy is something everyone's talking about now but the film industry actually knows a lot more about that than a lot of other businesses.

Some big VC recently cited the film industry as having a fairly well-developed gig economy.

Alan: Someone in the tech world did actually point that out. And we were like, "Crap. That's our secret."

Charles: Yeah, so we've all spent the last 20 years preparing for what the next 20 years are gonna look like and it's not as terrifying for us. I mean it's still annoying. So do you guys have like, well first off you're no longer in the same city, right?

Alan: Yeah that's been the case since almost the beginning. Yeah like I feel like maybe the first year that we were operating, like in maybe 2012 did we do some things? I was still back and forth between New York City and Salt Lake City.

For the lifetime of our company Pliny and I have been in different cities. Occasionally we'll be in the same city; he'll come out here for Sundance or I'll be in New York because I used to live there and have things to go back for and stuff.

Around the time when we started Endcrawl was when remote work for me really started to work for me as a programmer. And maybe it was because I'd gotten to that point in my career where I had enough of an established track record that people were like, "Oh, yeah, this guy seems legit. I can see the things that he's built in the past. I'm not worried about him slacking off at home." Or whatever their sort of concern is that kind of prevents people from trying distributed work.

I think a lot of that is like silly, like why even commute? Why even waste that personal time? I think commutes make people more miserable than they even realize. And that's having maybe tested stuff in my own life. I think distributed work is kinda the answer.

You can live and work from an environment that works for you, that you're most productive in. And you don't have to come in and engage in what we like to call 'productivity theater' where you're in an office and you're looking very busy. But it's just about looking busy, it's not about actually delivering value.

Charles: The thing about distributed work is it involves a lot of active management. It involves managers that are actually in touch with what they are hoping the team members will accomplish. And actually following up to see if it's successfully accomplished. I think it's easier to manage teams in person.

Alan: You might be right there. It's a very different management style. Some of the ambiance of an office, where you see the people you work with, you see their face, you see how they're doing, that kind of stuff is actually important. But I think a lot of the things that happen in an office, that people think of as productive or necessary are overrated.

It took me a while to come to that conclusion because I think everyone believes that this is how it's supposed to work. That a manager needs to be really hands-on and nothing else is gonna work. It took me a while to believe that it could work any other way. And I think more broadly, I think it's gonna take a while for the U.S. economy and the global economy to catch on as well. I think it's kinda lagging behind the tech industry.

There's certain things that sort of encourage it. Like Slack, I mean like Pliny was saying, we use the heck out of Slack. Like we have so many Slack channels, most of them don't get posted to in a given day or even a week, you know, 'cause they're just very narrow topics. But we manage everything through Slack. It is almost like you can get the warm fuzzies of human interaction through Slack, like you could just use the giffies and emoji and stuff like that. And then you have kind of a record of the culture that's there that new people can glom on to.

And I think on each other point of being able to source talent globally is also really . . . gives you an advantage as a distributed company.

Alan: We do a lot of in-person meet and greets, and we do Sundance. I'm meeting this guy for the first time, you know. He's got a ton of Endcrawl projects; they're one of our best customers for sure. And he said,

> Oh, you guys are actually kind of unique among our vendors because I have had face-to-face conversations with pretty much every other one but I've never actually met you before. You know it just kinda works, you know, I send you an email and this and that. But like, this is unusual,

. . . is basically what he said.

He wasn't displeased with it; he was very happy with it. But he was just saying, like, "Yeah, this is an unusual relationship that I have as someone in the film industry."

Pliny: Yeah and that kind of surfaced to us how the notion of distributed companies and remote companies is still kind of new to some. So in the gig economy we're probably ahead of the game, ahead of the economy. But in this regard film is behind.

And films for the most part are still locally sourced, handcrafted. You know, they are artisanal things and the idea that you can work with people remotely, that you will never meet, to handle aspects of your film is still kind of alien. And kinda new.

Pliny: And occasionally people coming to Endcrawl will say, "Hey, you know, we have a meeting; we wanna get together on a conference call and we wanna have this long talk," and we kinda, we can't do that, you know? We're not a service agency. And that is an interesting sort of challenge to set those expectations.

'Cause we're not priced as a service agency. Occasionally we get someone who comes along and wants a full, sort of white-glove, high-touch treatment that they would get from a design agency, a title house, or something like that. But they want it for the fast price.

And so, I would say well over 90–95% of people who start using Endcrawl . . . you know, very quickly they get it. They're like, "Oh yeah, I get it. This works. We correspond over email; there are Hub docs, and I can sort of do it all myself. And the support team is there if I get stuck."

But, you know, some people come in and they just wanna hang out. They wanna socialize and wanna have the meetings, and they want all that. And they can get that plenty of places but they don't pay for it.

Charles: But you guys go to Sundance. Presumably you go to Tribeca. You go to these events; you do make yourself publicly available.

You're still entirely bootstrapped. Is the plan for that to continue?

Alan: It's something that you don't wanna completely close the door off to because there are situations when capital at the right time, along with the right sort of strategy would make all the difference. I think kind of where we're at . . . we're kind of under the market size where like traditional venture capital is interested, you know.

They wanna see a unicorn. Probably end credits are not, we're not gonna be the unicorn of end credits or something like that. We're happy with that. You know we're fine with that. But yeah, I guess it's always something we've looked at but just looking back at our trajectory I think I've been very happy that we have bootstrapped. Because we've been able to do things our own way, our

own taste, and honestly growing a company organically and more gradually like we have has built a good company culture and a good reputation and it doesn't sort of get warped from the VC pressures.

Pliny: It's allowed us to sort of decide over time how we wanna do business, how we wanna structure the company, what our values are. And having had the freedom to do so has been, like Alan said, invaluable.

Alan: I highly recommend bootstrapping to anyone else, you know. Just like build an MVP (minimum viable product), find the MVP first, you know, build it, see if there's something there. Bootstrap it, and then if you've got a little traction, then maybe you take investments to take it to the next level if you're going after something really big.

But, you know, yeah it's just like, at least in the tech industry it's like for so long the only way to build a tech company is well you have to take investments and subject yourself to this crazy pressure to grow really suddenly. And I think only in the last few years has that started to change and there are some sort of viable other options.

So yeah I don't know it's just kind of fun to be, to be bootstrapped.

Pliny: Well we, we kinda got lucky. We found validation. We had an initial hypothesis and we found validation pretty quickly and we've been going from there. But we didn't start by spending a year building some product in stealth mode and then launching it with fingers crossed.

We didn't start by taking a bunch of money and then seeing whether the idea was good or not. I built a shitty postscript and then just threw it out there and said, "Who wants this?"

And, you know, in a few months we had done like 20, 30 movies. So there was like, okay, there's something here. Let's keep going.

If we had gotten zero takers then we would have known right there that, you know, our hypothesis was wrong and we would have not wasted our time on an idea that didn't have a viable business behind it.

Chapter 3

Building Your Plan

What is your plan for surviving and thriving in the film industry?

Most people are attracted to working in film for the chance to creatively contribute to a medium they love. Chances are you have had movies and television make some impact in your life, and you want to give back, to participate in creating the next wave of media. This is a noble and legitimate goal.

Unfortunately, the film industry is not a typical "industry" in the way pursuing a career in medicine or the law might work. In many fields there are entry-level jobs, complete with salary and benefits, where if you thrive you could get promoted and move up the ladder. This isn't how film works. Entry-level jobs that pay a real salary and also offer a ladder to the "creative" summit are exceptionally scarce. From pretty much the beginning of your time working in film, you will effectively be running a small business, that of your career as a freelancer. There are exceptions, of course. If you want to be a studio executive you can be an assistant or start in the mail room. But if you want to be a filmmaker, especially a director, there just isn't a traditional path that you can rely on that will come with a steady paycheck.

Let's repeat that so it really sinks in: the film industry requires you to run your career as a business. There are very, very few "salary" jobs where the work of your career can be outsourced. Whether you want to be an editor, a director, a producer, a writer, or just want to do "something in the industry," you'll have to navigate aspects of entrepreneurship whether you want to or not.

It's perfectly OK to learn the bare minimum about business that you need to survive. In your chosen craft, you should dive in and learn every single thing there is to learn. It will never stop, you'll be 20 years into picture editing and all of a sudden have an amazing realization that changes how you think about story. That kind of focus is what will make you amazing at your craft.

You don't have to have that level of focus with business. But you do have to learn the basics so that you can survive and avoid the pitfalls that get new filmmakers in trouble.

This applies to all the crafts, cinematographers, editors, production designers, producers, but it especially applies to directors. It is hard to get to the directing chair, and it's even harder to stay there. It takes an average of a

decade after film school for the small number of students who make feature-length work to get projects produced. Thus you will need to find another way to pay your rent in the meantime, or else give up and leave the industry. I'd rather you figure out a way to keep yourself in it while you work on getting your movie made.

Art Strategy

There is no information in this book on "content" strategy because it doesn't seem to matter.

Students constantly want some advice on the strategy for the art half of their career. Start in commercials? Make documentaries? Do a genre indie? Which genre? I have watched countless friends, coworkers, and collaborators attempt to strategize their movie-making journey. "Start with a comedy or a horror," one producer says at a workshop, so the young filmmaker with no passion for either diligently sets out to create a horror film with no real knowledge or deep love for the genre, and spends years trying to get it financed since it's a "smart place to start."

Meanwhile, the filmmaker who simply loves period family drama writes one and gets it made and gets a career going based purely on passion. Yes, "period drama" is the hardest field to finance, but if that's what you love, it's probably smart to start there.

Artistic currents change too quickly to try and chase them. One summer vampire horror will be hot; try to chase that trend, instead of doing what you personally are really passionate about, and your script will end up part of the avalanche of scripts hitting Hollywood a year later all imitating a number one hit of a year ago. Meanwhile there's a new hit werewolf movie at the box office that moves the trend a different way.

The only guide for the content of your career appears to be passion, intuition, and internal guideposts. That's it.

If you believe in a higher power structuring or ordering this universe, then you should rely on the faith that your higher power will guide your intuition and that you should trust that voice.

If you don't, if you are grounded in concrete science, have faith that your intuition is smarter than your conscious mind. That deep in the recesses of your brain, the same passions and fixations that animate you will connect with others, and still trust your instincts.

That is the sum total of how much this book will deal with "artistic" strategy. For the art part of your career, follow your passions with everything you've got and let the chips fall where they may. Learn every single thing you can about your chosen craft and never stop growing. Trust your gut.

Strategy is for business. Intuition and gut feeling are for art. This book is to help you learn the smart business strategies so you can give yourself the freedom to trust your artistic intuition.

That said, whatever your ambition is, you do want to be managing it like a business to the extent that you can. That means that, the same as in any other business, you're going to need to be worrying about marketing yourself, you're going to have to be trying to keep the short-term bills paid while working on long-term strategy, and you're going to need to be constantly paying attention to your relationships with your collaborators and clients.

The smartest move you can make towards long-term success in your ambition goals is to constantly and neverendingly keep chipping away at them. If you want to either write or direct, you want to be working on a screenplay every single day, no matter what. If you turn out a script a year, when you are in those situations where someone asks you "what are you working on," you'll have an answer and a sample you can send over. If you stay in the industry long enough, by finding a cashflow business that keeps you eating while working on your ambition, you'll have countless opportunities to develop relationships that will help you get those ambition projects made.

They can only help you if you have the self-generated project to get made.

With the exception of producers and cinematographers who move into directing, the vast majority of directing careers are launched from screenplays. The only way to do that is to keep writing, at least one feature script or TV pilot, every single year, no matter what.

If you can, make something every year. A short, a web series, something, anything, to keep yourself going forward, to keep moving towards things. Client work doesn't count here. You have to make your own thing every year to keep honing your craft and keep your momentum going.

You absolutely cannot let the demands of making a living today prevent you from moving towards your goals for tomorrow.

This book isn't arguing that you should create a business instead of pursuing your dreams. It's arguing for creating a business so that you can pursue your dreams.

What Is Business?

In the context of this book, "business" refers to the money-making activities of life.

This is particularly tricky for artists, because most of us would do our art for free. We spend years doing it for free hoping for it to get better and better. We often pay huge sums to go to art schools to spend more years doing what we love. Even once we're making a living in our chosen field, we often still do it for free recreationally in "spec" or "ambition" projects.

At our most basic level, humans seem to have a need for food and shelter, procreation, and recreation. What the caveman did to survive, to eat and stay out of the rain, hunting wild game, storing up food for the winter, building shelter, is what we now call business. Though we've added a layer of abstraction by creating the monetary system, the goal is the same; to create security

for ourselves, to keep a roof over our heads and our bellies full. Recreation is art; it covers almost everything else. All of the stories we tell each other and the pictures we paint for each other to enjoy the non-hunting and romancing part of life, all the games we play, are the art. Humans can't help it; we love to do it.

All aspects of business and the arts are distorted by this drive we have to do it; the fact that art is something most humans desire to do in some way, and many, many artists would and could do for free.

I often hear my filmmaker friends complaining that "nobody ever asks their dentist to work for free, but folks hit me up for free work all the time," and it's good to remember that everybody knows that dentists only spend all day in a stranger's mouth for money; making movies is demonstrably fun. Dentists have an absurdly high suicide rate, to boot. Don't get insulted. You don't have to do it for free if you don't want to, but the truth of the matter is that the arts are a distorted market because it is obviously fun. Movies have it even worse because the film industry has a glamor that makes it seem better than it is. You'll be working with "famous people" and "playing make-believe" so of course you should do it for peanuts, or so goes conventional thinking of many less savvy clients. Even worse is the client who believes that the "exposure" will be worth it.

Experienced clients aren't like this. They know that cinema is magic and they are willing to pay good money for someone who can manifest that magic in the project. High-end filmmakers command astounding fees because of the skills they bring. The studios, in a way, are clients and they pay millions to directors to make movies that they are clearly passionate about making, desperate to make, dying to make. It's the less savvy clients you will have access to as you start your career who have the hardest time paying you, but, if you prove your value to them, they will.

Just because it can be done for fun and for free doesn't mean you have to, and if you learn enough business skills it is possible to make a living doing this fun activity of movie-making. The good clients understand that they will have to pay good money to get really good work, and it's not worth wasting time being annoyed at the bad clients who don't understand paying for what they want.

Sometimes it's just not possible to get paid for doing the thing we're passionate about directly right away. I suspect that even the creator of the cave paintings at Lascaux was expected to spend some of the day hunting or gathering.

It's my belief that, because of hundreds of thousands of years of human history, business activities and survival activities are hardwired into the human psyche, and that it's not possible to become a fully actualized and content human being without engaging with this aspect of ourselves, any more than it's possible for most of us to be happy without getting in touch with our artistic selves.

Business is part of being human.

What does this mean for you?

This means that you don't get to say "I'm an artist, I don't understand how money works, I'll hire a business manager and let them sort it out." Countless

highly successful people in a variety of areas have made that mistake and it's cost them all dearly, being taken advantage of by business managers in whom they place too much trust. American treasure Willie Nelson famously made this mistake himself, in the 1980s, and ended up buried under a massive IRS bill after being taken advantage of by the person he trusted to manage his finances. Leonard Cohen was robbed blind when he went to a Zen retreat and left his business affairs to someone else. They aren't alone.

Managing your business is something you just can't fully outsource, any more than you can get someone else to eat food for you. Only you are going to care enough about your business affairs to make sure they are properly set up. Only you have the power to really enforce the difficult decisions to make it happen. You need to face all of these scenarios head on, directly, to survive.

That's not to say that accountants and business managers don't have a vital place in the world, because they absolutely do. Hiring specialists for specific tasks at which they excel is a tremendous time-saving technique that allows you to focus on your art and craft, and you'll want to hire those specialists as soon as you can afford them.

But you need to understand what they do well enough to be a tough, thorough, and engaged client, and that means avoiding the tendency many artists have to view this whole area of their life as being distasteful, complicated, or "beyond them," which unfortunately leaves them placing too much trust in others, which opens up too high a risk of getting robbed.

I use an accountant, but I make sure that I understand enough of the fundamental principles in play that I have the knowledge to make an informed decision about who to trust with my accounting needs. If you've worked as a filmmaker long enough you have had a "tough" client that understands what you do and demands the best of you, and they generally do get your best work from you. You in turn need to be that tough client to the people you hire for business tasks.

Think about how much you understand about cinematography and editing and how much that knowledge has informed your ability to hire good collaborators on your projects, even if you couldn't do those tasks yourself. The same way you don't need to know enough to be a great DP to hire one, but you need to know enough about their craft to work with them, so the same is true for your accountants and business managers.

Additionally, things are getting tougher for everyone in the film industry as more and more people are getting creative outlets and finding the ability to express themselves. This is flooding the market with content while simultaneously demand is dispersing due to readily available free or inexpensive cinematic experiences. Fewer and fewer fortunes will be made in filmmaking, especially in "narrative features," but more and more people will be able to make a solid living, and when you are making a solid living but not a fortune you can't afford a business manager so you have to do it yourself. You can, and probably should, still use an accountant, however, once you reach the point where their fee is less than 2% or so of your yearly income.

Which doesn't mean you can't survive as a filmmaker, many can and do and it's my belief there are still ways to do something creative for a living and eat, but it increasingly involves a willingness to engage with the function of your finances in a way that many at first find intimidating.

Don't be intimidated. If you have a truly creative mind, you'll quickly find that business has the potential to be just as stimulating as any other creative art.

Business requires just as much creativity as your art, and understanding how it operates can be immensely satisfying.

The Business Model

Your business model is how you plan to make money. This can be formally written out in an elaborate document, or it can just be your internal knowledge of how you plan to keep the lights on.

In film the two most common setups are a services model or a product model. Most filmmakers end up with a services model, getting paid for what you do (I'll direct/produce/edit/shoot/color for you for dollars), but not all. Some end up designing and selling products (such as creating a cool post or production tool that can sell in volume). While a movie is a "product" technically, movies are generally crafted with such care and energy that they are really more like "white glove" service experiences than they are "consumer products." If you run into a filmmaker who is churning out movies like a product (for instance, making six low-budget horror films a year), they are generally not passionate about making each one the perfect gem that most of us got into the industry to create.

When someone says "you don't have a business model," they mean there isn't a way to make money from following your plan. Yes, you might have a plan, but that plan has no money in it, i.e., you haven't fully anticipated how much it's going to cost you, or whether anyone will actually pay for it. Your business model might involve creating commercials for local companies, but if the local companies only want to pay $500 for commercials and you can only find one to do a month, but you need to make at least $2,000/month to pay your rent, you don't have a business model. Or, if your business model is making dating videos for pets, you'll quickly realize that no one on Earth will pay money for that.

Many business models are simple, for instance: "I'll provide editing services for documentaries in exchange for money." That's a common business model for a freelance editor running a sole proprietorship. But even within those simple business models there are often complications. You might not know any documentary filmmakers, so you need to spend money and time getting to know them and getting them to know you and your skills. It's now quite common to create side revenue streams, such as online tutorials, in order to both promote your main business and also provide additional revenue. Creating a business model is thinking seriously about what service you want to provide, and what you want back for it in return.

The next essential element in a business plan is testing and experimentation, which is sometimes called research. You can have infinite ideas about what things might work, but before investing too heavily financially in something it's vital that you test the waters.

One common business model I hear about that I haven't seen regularly succeed is the sound person who wants to do both on-set recording and post-production sound design. "I'll be a one stop shop and provide complete services to the client," they say. The problem with this business model is the difficulty of scheduling. Production and post operate on very different senses of time (production lives in a universe of all-consuming time where 12-hour days and six-day weeks are the norm and day and night don't matter, while post tends to work around a roughly normal Monday–Friday business schedule, with the hours starting and ending a bit later than normal). It's hard to switch back and forth between the two and have them line up successfully. What almost always tends to happen is the sound person drifts towards either on-set recording or post design. The pain in this realization comes if they have heavily invested money into both areas (fancy on-set gear and a fancy post rig) before experimenting enough to see if they can maintain clients in both arenas.

This isn't a universal rule, and there are definitely people who manage to keep a foot in both worlds, but it's less common than one might think and it's certainly not everyone who planned to keep a foot in both. When presented with that plan (which comes up from a student probably twice a year), I always encourage waiting to invest any money in equipment until the theory ("I can be both for clients") is tested. If you need gear to do the test, rent it instead of buying it, until you've proven to yourself that the business model works.

Testing is the key for most business models and, if at all possible, testing before you purchase heavy equipment. Try and see for six months if you can do both on-set recording and post on a variety of jobs before purchasing equipment for either.

Accurately predicting the future is very hard. Every business model has a bit of fantasy built in (MSU, in industry parlance, for "making shit up"), but it's your job to work as hard as possible to eliminate that as early as you can. To develop a plan for making a living that involves creating something of value for someone else.

Unless you have a money tree, if you lose money on every work you create, you aren't going to be able to survive.

Before you launch into any venture, take some time to evaluate it from a business model perspective. I personally like spreadsheets, but I've seen great handwritten business models that spell out how much it costs to make something, or how long you spend on it, and how much you need to get paid to make it worthwhile. If you aren't sure about something, don't be afraid to ask experts or those with more experience in specific areas. A little bit of research can go a long way towards helping you see if your plan is viable or not.

	A	B	C	D
			fx	4
1	INCOME		EXPENSE (daily)	
2	Color Grading, Daily	800	Room Rent	200
3			Labor (me!)	400
4			Hardware	75
5			Software	25
6			Lunch (client services)	43
7			Marketing (website)	4
8				
9				
10	TOTALS	800		747
11				
12				

Figure 3.1 A very rough sample budget.

There are a ton of online "business planning" tools, but most of them don't seem worth the time to learn them. Simply fill out a spreadsheet with your anticipated costs, and anticipated revenue, and see how they line up (Figure 3.1). Don't forget that you have to pay yourself.

Forgotten costs are the biggest killer of business models. You absolutely, positively, must do a budget, and then go over it multiple times to try to identify what you left out. If you plan to be an editor, but forget that you'll need an edit station and a monitor, and snacks, and that the editing system will need software subscriptions and maintenance, and don't figure that into your math, that's the area that will likely bring you down.

Hidden time is the other great murderer of business models. I know many people who have been impressed to discover that their friend is a DP with a $1k/day day-rate but who fail to factor in unpaid prep days (even if the client is willing to pay for prep days, they frequently budget too few and the DP works extra prep days to ensure a good job is done), unpaid color grading sessions, personal gear the DP loans to production because production can't afford it but the DP wants to get the shot, and the years the DP spent developing the skills and relationships to do the job, so it can actually work out to minimum wage or worse.

I'll repeat, the number one forgotten cost I see when reviewing business models in film is the labor time of the partner/principal. Even plans that have every single freelance and vendor hour laid out will often neglect the time of the director and producer who will be required to work on the project to make it succeed. You'll only survive if you account for your own time that you will contribute to these projects.

If you are a heavily software-based start-up (like a post house), there are many apps that can track how much time you spend in various applications (such as Excel or Adobe Premiere), but it gets much harder when it comes to production where you are often out in the field or driving around scouting. You absolutely have to track how many days you spend on a project, even if you are only billing for some of them, to get a real sense of what you are making and what is required of you to make it.

You don't have to break it down to the minute (though that tracking software will be able to tell you to the second how long you spent in Avid and how long you spent on Facebook during your work day). You can work in days, or half days, since that will make it much easier to realistically see what you are spending time on. But you have to track how much work you do on something and account for that in your business plan.

From there, make a spreadsheet with how much you think you can charge for something, and how much it will cost you to deliver it. Think you can charge $800/day for color grading including your set-up? How much, including hardware and software, rental and room, and marketing (spread over all the days you can use it) and most importantly paying yourself a "rate," does it cost to deliver that $800/day?

If it's $400 for yourself and $100 for your hardware payments and rent and $150 for marketing costs to land the job, that's $650.

What's left over is your profit margin.

If you are doing the labor yourself, can you live on the profit and your own "rate"? If you are hoping to supervise others and not do the work yourself, can you live purely on the margin?

I highly recommend tracking these things in software such as Quickbooks, Wave, or another online platform as early as possible. Create invoices for every job, including "free" jobs done to build your reputation, that accurately account for the amount of time you are working on a project. Deliver the invoice with the job, even if it's a free job. Even if you have to "zero out" a line item (changing its value to zero), if you put it in the invoice, it forces you to track it.

All discounts should show up on your invoice as a zeroed-out line item. You want to be able to document the discounts you are giving clients, and you want as much as possible to remind them that they are getting a discount.

Business Plans and Pitch Decks

There is a little bit of confusion that shows up with many of my students between an official business plan and what the tech world calls "the pitch deck." A pitch deck is a formalized series of pitch slides that are designed to help people raise money for companies. A pitch deck is not a business plan. It's a tool for communicating your business plan to others. The business plan itself is simply your plan for making money. It might not ever be written down, and it's constantly being revised as you test and discover what people will in reality pay for.

In the world of tech startups, there is a cult of the pitch deck. They are shared online and picked over endlessly as entrepreneurs try to identify what helped some raise money, while others faltered.

Pitch decks serve a much different world in the film industry. In truth, venture capital is seldom interested in your production company or post house. Venture capital wants to finance businesses that can scale, that have the potential for huge returns, and while a production company has the possibility to make a tidy profit and provide a good life for those involved, it's a rare production company that sells out or reaches an IPO that venture funders are looking for. There are companies in the film space that venture capital is interested in so you might need to worry about this if you build that type of business, but if your desire is to build a production company or something else that supports your directing or creative career it's very unlikely you'll need to do a deck for an investor.

So why do a pitch deck?

While many think about the "pitch deck" as being a relatively late part of a business plan (you plan first, then pitch to investors/outside vendors), I personally do a pitch deck as early as possible in the process of developing a business idea since a pitch deck has tremendous value in evaluating an idea and forcing you to think through certain aspects of the idea. Imagining the process of pitching an idea to another person and anticipating their questions is a helpful exercise in forcing you to reckon with your business plan. A pitch deck and a budget, done together, can help you evaluate an idea and decide whether or not to pursue it quite quickly. Pitching it to a friend and answering their questions, which will generally be surprising as outside perspectives come into your idea, can be incredibly helpful in refining an idea.

Pitch decks are a great format for helping founders evaluate precisely what the opportunity is that they see and why it is an opportunity. It's a thought exercise that can save you a tremendous amount of time wasted in pursuing an idea you don't believe is possible, or that might not have any potential revenue in it.

It is also possible that you could discover there is a real, actionable, investable idea in your business. There are many projects in the film industry that have received outside funding (we interview three, including Frame.io, KitSplit, and Hive, later in the book). While film is a small, specialized niche market, we are also a market where people do spend actual real money, so it's possible that you might have an idea on your hands you could get financing for.

Outside financing will mean giving up a stake in your company, but some ideas need financing to happen, and a pitch deck is a great place to start getting a handle on precisely what your model is for building a business that could develop that investment.

Let's take a look together at a sample pitch deck that was done by a student in my class, Lina Gasperaviciute, way back in 2012 before KitSplit even launched, but that we would call today "KitSplit for Props." It was called TurboProp. I have lightly revised the pitch deck to make it more applicable to teaching the concepts involved.

Pain Point

- Finding a key prop can take countless prop shop visits since web inventory is poor.
- If you have your own props, there is no good platform for sharing them with the film community.

Many decks start with the pain point. Your pain point is generally the problem in the industry that your business will solve. Clearly identifying this is tremendously helpful as you refine your plan.

If you aren't saving anyone any pain, you might not have a business. Pain is the great driver of business. In this specific case, the person creating the plan was an art director, and thus could speak clearly to the pain that existed in her workflow and how she planned to solve it.

Solution

> # Our Solution in Detail
>
> Our website allows individuals to post their goods to be seen by prop masters. As we grow, we will actively recruit existing prop houses to use our system to advertise and manage their inventory, saving prop masters time.

How do you plan on solving that pain for users? Is color grading the pain point you want to address? How are you going to do it differently to make clients attracted to you for making their lives easier? In this specific pitch deck, the plan was to offer an online sharing platform for props to open up the reserves of personally owned props available for production use. Some discussion of how the solution would make money (charging a percentage of each rental, for instance) could go here.

User/Customer Acquisition

> # How We Get Users
>
> • Direct recruitment of crowdsourced inventory through social and craigslist.
>
> • Active direct recruitment of propmasters through founders network: directly managing their first touch. Considering incentives.
>
> • Direct recruitment of prophouses by offering free photography/inventory services.

How in the world will you find your users or clients? Do you already know half of the film industry? Have you been doing this for someone else for a decade and have clients that will come with you? Do you have a huge marketing advantage? Where will your users or clients come from?

You might be wrong, you might discover clients come from somewhere wildly surprising, but it's good to think about as many ideas here as possible.

Competitive Landscape

Competitive Landscape

If you are looking for a sword, you have to know what prop house has the sword you are looking for. No web images, no real-time inventory, you drive around the valley looking at all the different swords for a $50 rental.

Prop houses are dis-incentivized to innovate because the current system rewards them for deep relationships with prop masters. They are afraid an open system will lower prices.

How are people doing this now? Specifically, who are doing the exact same thing, but that you can do better or for a better cost? Or, if you are truly on the cutting edge, out ahead of the pack, who is doing something similar that you can innovate past?

Founders/Team Biographies

Who are you? How did you have the special knowledge to see this opportunity? Why are you best qualified to pursue it? And, especially, who might you need to round out your team?

For this specific project, a developer to build the platform is needed. Maybe you are creating a production company and you are a great producer/director; finding a great executive producer (EP) who has relationships with clients will be a key feature you need to consider.

Founders/Team Biographies

CEO/Founder Tony the Tiger

Two years of constant work as a freelance prop master, prop builder, and interfacing with the prop rental system. Has run her own parade float construction business.

Superfun Lion Co-founder, Operations
Art department and props for three years, other stuff.

Dev Co-founder
TBA

Market Data

Market Data

How many prop masters are there?

How many do you think you can get on your site and why?

How much budget do they monthly manage?

How much of that can you bite? 2.5%? 10%?

Then you can start to actually predict revenue.

Do some research on your market. How much are people currently spending renting props? Want to be a post house? How much can you charge? How much is everyone else charging? Ask questions of those you already know who are working in this area to find out what real rates look like.

Expansion

Expansion

If you are successful in dominating the small
market you want, where do you go?
- Expansion into other motion picture markets, NY,
 NO, international
- Wardrobe and other departments
- Expand beyond film to the short-term rental of any
 object anyone owns of short-term rental value:
 complicated power tools

Let's say you pull this off, everything goes swimmingly, and you are in business. It does happen. Where do you go from there? What is your next move after that? To where could you expand?

These elements are all designed to help you sell your business to someone else, but putting them out on paper (or in a slide deck) will help you articulate to yourself if there is a sustainable business in your plan. Forcing yourself to say "Here is what we want to do, here is how it will make money" is a huge exercise as you plan out your next steps.

Professional vs Consumer Businesses

One of the biggest dangers for the filmmaker in business is confusing the distinction between a consumer business and a professional business. With a very small number of exceptions, if you are in the arts you are in some way in the professional business realm, but unfortunately most of the famous businesses and business stories that circulate in the world are consumer businesses.

A consumer business is built on volume; selling thousands or millions of an object in order to make money. Margins are low, but the company is able to survive or thrive due to making that small margin consistently over a vast volume of sales. Consumer margins sometimes creep down below 5%, but if you are selling millions of units you can build a business on that.

Professional business volume is much, much lower (sometimes in the 100s of items, sometimes making only a single item), but workmanship is generally higher and you have to have a correspondingly higher profit margin or else you

will go out of business. With that higher profit margin comes correspondingly larger expectations of service, support, and client interaction.

A good example of the difference between consumer and professional markets is in the tool aisle of the hardware store; there are a range of drills around $20, and then another pile of drills for $250 or so. The $20 drill is for consumers, people who won't use a drill very often and are thoroughly unlikely to wear it out, but, if they do, they aren't going to be particularly frustrated by it. They will throw it away and buy a new one; their expectation isn't tremendously high.

The $250 drills are for professionals, who make their living with the drill, day in and day out. Because they use that drill as a tool for generating more income, they can justify paying more for it (and probably write it off their taxes). If the drill craps out on them, they might lose a day of work, which will cost them the price of the drill or more, and they are likely to go about replacing that drill immediately. The loss of the tool loses them money, so they are more careful in the choice of drill.

They spend time with other professionals, and one of the things professionals talk about with each other is their tools, which leads to word of mouth spreading more quickly, and with more weight.

If something minor goes wrong with it, they are more likely to want to figure out how to fix it, to call the company for input. The company needs to keep support staff available. Replacement parts need to be manufactured, as well as accessories that accommodate using the tool in a variety of ways.

In my world, there is a hard drive manufacturer that makes drives that are about 20% more expensive than the competition, but I request that my clients buy them anyway. Why? Because about 30% of normal hard drives give you some sort of problem if you are using them intensely out in the field; with this brand, I've only ever had problems on one occasion, after dozens of drives. When I had that problem, I called their tech support number and someone answered the phone; no menu, no receptionist, the tech person just answered. That's a professional vendor, and that reliability and support is worth the 20% upcharge.

As a filmmaker, you are more than likely providing a "professional" product. Your client will have needs and expectations of it, there are levels of craftsmanship and durability required, unless specifically designed as a feature of your art is that it degrades. Even the platforms we interview, Frame.io and KitSplit, offer a higher level of customer service, and faster response times, than would be normal from a purely consumer-facing tool.

Pricing Professionally

If you are creating a professional product, you need to price it professionally, which means a full understanding of what you are creating and how much it will cost, and a margin on top of that which takes into account all of the time you will actually put into its creation.

It's hard to do and no one does it consistently for every job, but try on your next job to take into account all the time you spend on it. The Saturday hike you spend thinking about it. The shower you spend mentally working out its problems. The idea you wake up with at 3a.m. and write down before going back to bed. The countless emails with clients before the job even starts. The phone calls with clients a year after delivery answering their questions about new ways the job needs to be formatted for newly arrived media.

This is all the great unaccounted-for time that goes into film projects, and it's why they cost what they do. Nobody successfully tracks them for every gig. Few track them accurately for any gig. But if you are going to price your work in a way that allows you to survive, you need to at least understand in rough terms what is going to go into the project.

And, most importantly, that what you are selling usually doesn't scale. A computer maker is always hoping to move more volume, but there is a physical limit on the hours in the day you can spend creating your work, so, if you are going to survive, you need to be paid enough in those hours to not starve. Once you've reached your volume limit, your prices have to reflect that effort.

A company can only grow as big as the capability of its managers to manage it. A consumer business can scale to the bandwidth of the factory to make widgets, but until we figure out how to clone people, your business will scale up only to your ability to supervise the work and put your personal touch on it. There is a finite number of hours in the day, and you need to be paid properly enough to eat with the hours you have to offer.

One easier method is to assign a line item to each job you budget for "company overhead," and estimate it based on the number of days you think it will require your attention. For instance, let's say you are bidding on a $50,000 project, and have done an "internal budget" for yourself where you can do it for $35,000 in hard costs, meaning the crew you need to pay, the gear you need to rent, etc. If you estimate it will take up to two weeks of your life to do this job properly, look at your monthly overhead costs (either for you as an individual, or for your company), divide it in half (we call a work month four weeks, and it's going to take up two weeks of your job), and put that in your budget. If your company burn is $6,250/month, you need to add that $3,175 to the budget. It decreases your "profit margin," of course, but it more accurately reflects the costs that are going into creating that job.

As you evaluate what jobs to take, you need to be doing so as a professional, not as a consumer, business.

What you are selling is you.

If you are going to pursue a life in the film industry, what you have on offer will be work that is solely, personally, and completely yours and could not be created by somebody else. Yes, even work-for-hire client work.

Which doesn't mean selling out. You can have a wonderful career and not work with clients whose ethics bother you. I have passed on jobs with

companies that engage in work I don't approve of, or whose business practices I found unprofessional, and I encourage you to do the same; there are many, many clients in the world, and if you don't want to make work for an oil company or an arms manufacturer, or someone who takes too long to pay you and doesn't respond to your emails, you don't have to.

What it means is that it's your obligation to fully bring yourself to the job. Your taste, your opinions, your skills are what are being offered.

There is an instinct, especially as the checks get larger, to try and do what the client wants. You've heard "the client is king," after all.

Never forget that if the client could create work on their own, they would. They are hiring you for your expertise.

Sometimes, maybe even often, you are going to have to find ways to disagree with the client and win, when you know that what you are proposing is better than what they are asking for. When their note is ludicrous and will create a terrible result. When they want to cast their significant other in the lead part.

If you are going to survive and thrive doing this work, you have to do work that you believe is good, you have to listen to your inner guiding voice, you have to keep pushing every step of the way to make the work as good as you could possibly make it.

What they are paying for is you, your taste, your thoughts. You aren't just a robot hand holding a camera executing a client's vision. You are an artist.

Then, once you've fought as hard as you can, sometimes the client still insists on their terrible note. And you do it. This is a service industry.

And, every once in a while, they are right. Smile politely and let them know how great that note was.

Other times, they are wrong. Smile politely and take your name off the work.

But never forget, it's your job to have an opinion. You wouldn't be an artist if you didn't. You don't have to hide it.

Some are afraid that if they give all their "tricks" away to their assistants they'll eventually lose jobs to them. That they need to keep their process a secret to ensure clients keep coming back.

Do you want to be hired for your tricks?

Or do you want to be hired because you do good work that nobody else could do?

I had a client I was afraid of losing. They were my "major client." I was the producer on all their jobs, and I directed a few. They really loved one of the jobs directed by someone else that I produced. It was their favorite. When the time came for another big job with them, I took the directing reins again. They loved that last trailer and wanted something like that again. I was determined to make them love what I did as much as they loved the other spot. I showed the whole crew that spot and said "we're going to do this, but better." I set that spot as a target.

At the end of the gig, the client didn't like the new spot. "It feels just like the old spot rehashed."

I had failed to deliver what they really wanted, something new and surprising, that only I could have delivered, and no one else.

Of course, they asked for that spot rehashed. But that didn't make them happy. It's amazing how often people getting what they think they want doesn't make them happy.

Learn from my mistake.

Giving people what they think they want, what they ask for, almost never works.

You have to give them what they really want.

You need to get to know yourself. You need to figure out who "you" are. This isn't an easy process for anyone. Many people start the process of figuring out who "they" are by imitating others. Many musicians talk about their first album really being an imitation of another album they loved.

But that can't last. Imitating someone else is a part of learning and growing when we are young. But we can't do our best work until we find our own voice. We figure out who we are.

Then we find ways to give that sense of ourselves to our art. Whether for a client or not.

Competition

Fundamentally, what you are putting on offer is yourself.

So, there is no real competition. If someone else gets the gig, it's because someone else is a better fit. And you can't change who you are.

Work as hard as you can to be who you are, to find your voice, and let it go when you don't land the job. You can't land them all.

This is incredibly difficult for those of us who do creative work for a living because we invest so much of who we are in what we do. So "not booking" a job feels like a rejection, not just of our work but of who we are as people.

It's difficult, but try to re-frame it as that you aren't the right fit for that particular job.

Think about all the miscast parts you've ever seen, good actors in a role that just doesn't fit them, and realize that this is the scenario you are in. Losing a bid doesn't mean you are bad. It simply means you don't fit that particular project.

Why bother trash-talking other artists to try and get a job? If they want to go with someone else then let them, they want what the other artist can bring to the table and you wouldn't be able to satisfy the client anyway. It's nearly impossible to do good work by throwing others under a bus.

MVP

You will frequently hear the term "MVP," or "minimum viable product," used by entrepreneurs. This term is used to get people building and testing the smallest version of their product or business without worrying about every

single feature and every single tool. Without this focus on MVP, many people would spend months or years building their perfect website without showing it to anyone, only to discover no one is interested in using it.

This particular problem is a huge issue in the film industry since we are all used to working for months or years on movie projects without showing it to anyone, then magically hoping that it connects with audiences. From a business standpoint, it's a crazy way to work, but somehow good movies keep getting made.

The argument for an MVP is that you want to create the simplest, easiest, cheapest version of your product as quickly as you can so you can test if people actually want it. This means, if you are thinking of creating a post house, what's the simplest thing you could do? Find a nice space, use your home computer, rent a client monitor on days clients come in, and put up a website. With that, you have a relatively low outlay to see if you can start landing clients based on the quality of your work.

Some filmmakers feel the pressure to put together the most high-end facility from the start. Take out a loan, buy a massive system with the latest and greatest of everything. Unfortunately, if you haven't proven to yourself that you can find and maintain clients, that financial investment is risky.

The concept of the MVP is an important one to remember no matter what phase of your career you are in. Thinking about investing in some major hardware to upgrade part of your business? Is there a way to rent it to test first if you can land clients with it? Is there a way to keep it lean and explore before committing major time and resources?

By focusing on an MVP you save yourself both wasting a lot of effort on something with no potential market or audience, and also potentially wasting large capital investments in services or tools you can't make work.

Bootstrapping

"Bootstrapping" is business slang for starting your company without outside investment. Building a tool, putting together a production company, or launching a business without taking on a massive outside investor to get the project going.

Bootstrapping is useful in some arenas since it allows you to avoid taking on an investor. Investors, while wonderful, will pressure you to make money sooner, and might not always understand your business niche and what you offer.

On the flip side, investors' capital is sometimes necessary to build and market the tool at all.

Fear

Everyone talks themselves out of good ideas. Fear is a tricky part of launching your business. It is natural to feel nervous as you pursue building a business.

It is somewhat terrifying, since it often comes with less safety and security than a traditional job.

But in the film industry you have no choice. You have to dive in and do it.

As my colleague Sarah Cawley likes to say, "work conquers fear." Every time you get nervous, dig in and start chewing on another task required to get your business going.

First to Market

There is a common perception among those who haven't done a lot of work in business that the only way to succeed is to be the first to market. I've been in a lot of discussions where someone brings up a great idea, and someone else says "oh, but there's already someone doing that," as if it completely kills the idea. They bring up the website of the "person already doing that" on their phone, and that is the end of discussion, regardless of whether the existing competitor is actually good or not.

This same perception seems to filter especially hard through my friends in film, since you by necessity want your spots, videos, and movies to be innovative; you don't want to make work that is derivative, you want to be original.

However, the truth of business is that it isn't necessary to be the absolute first to market in order to be a success; it takes a combination of innovation and excellence in order to succeed.

Facebook wasn't the first social network. Dropbox wasn't the first cloud storage app; that idea had been kicking around since the late 1990s at least (I know because the first business plan I ever wrote was in 1997 for a cloud storage system we were going to call X-drive). BMW and Audi weren't the first car companies in Germany, and Chevrolet and Dodge weren't the first car companies in the US. Being first is great, but it's more useful to be the best, or at least really, really good.

If you see an opportunity, don't let the fact that there are others in the space prevent you from going after it. There is generally room for multiple competitors in a given field. In fact, the presence of competition is often a good sign; it usually means that the opportunity you see is a good one, one that is worth pursuing, and it's your job not just to see the opportunity but to deliver on it, better than those who see the same opportunity as you.

The inverse is also often true; if you find yourself seeing an amazing opportunity that no one else is seeing, it's useful to ask yourself why. It's possible that you are in a privileged position to see information no one else can see, and that might lead to great insight. It's also very possible there isn't the opportunity there you think there is.

This is the perfect time to write up a business plan, to see if there might be a real opportunity there. Most business ideas are a result of special knowledge. You happen to be working in a computer company in the 1980s, realize that digital animation is about to be a thing, so you know before anyone else that

it's time to start a VFX house. Specialized knowledge. But if you look around and see that you are really first, and no one else has jumped in yet, be sure to do your research to see if there are actually clients ready to buy and that the scale works out. As David Bowie famously said, "the first one to the bleeding edge gets cut." Starting too early can sometimes mean you run out of money before the market is ready for you.

I know many filmmakers who have set out to build a web series, YouTube channel, or branded content company but haven't done the research into how much money can actually be made by those ideas. YouTube ad rates are low: the reason most "YouTubers" are video blogs and prank shows with little editing and no sets is because that's what the ad revenue will support. Among the first things you should do when you have the idea is research the competition and be excited if the competition exists since that means that there could, potentially, be a living in it. Then research how those companies are making money and what their actual revenue is. Launching a YouTube channel without understanding what the revenue actually looks like on YouTube is a fool's errand. Looking at YouTube revenues, then working back from there to see what kind of content you could create at those revenue rates, puts you in a better position to thrive in that environment.

As technology continues to evolve there will be opportunities for artists to build artistically based businesses that grow out of that technology. When Apple released Color in 2007 I realized that the world of post production was going to undergo a massive transition away from "big iron" and dedicated hardware towards a world where major films and campaigns were being finished with consumer hardware, but I wasn't the only person to undergo that realization, and a plethora of post houses were born on the back of that transition. I helped start not just one but three of them, two of which are still growing strong.

The failure was ColorCorrection.com.

Don't let the existence of competition scare you. Let it embolden you. Competition forces us to become the best we can be. It can also be a comfort to realize someone else is in the space, sees the same opportunity, and is somehow making money from it, making a living from it, able to thrive.

ColorCorrection.com

On paper, ColorCorrection.com made a tremendous amount of sense.

Color grading had gone through a massive technical revolution in the years between 2005 and 2010. After two decades where the price of entry to color grade was in the hundreds of thousands of dollars, computer development had reached a point where images could be graded on home machines and a $10,000 investment would put together a fantastic color suite.

At the same time, clients had pivoted towards remote supervision of work. As clients went from managing a single project at a time to instead managing multiple campaigns or features at once, they frequently wanted to

plant themselves in their own office and be sent links to review rather than going out to supervise work directly.

Many colorists were anecdotally reporting that more and more of their own work was remote even with clients they had met in person. After a few in-person sessions, the work was increasingly handled via email and Vimeo links. It wasn't the smoothest process, but it worked. A whole other business, frame. io, interviewed later in the book, would successfully launch to make the process smoother for all aspects of post. Working with partners I was part of founding a business dedicated just to building a front end for finding new color clients through the internet.

ColorCorrection.com was born. If the work was moving to remote services, why shouldn't there be a web-first color grading platform to help new clients discover the color grading process and get affordable, professional work.

Like many web businesses, it started with the idea that the smartest move is to build a good website to attract clients, but, rather than building tools to automate labor, to manually do the labor until the product is demonstrated and it makes sense to build tools. Many, many web businesses fail by investing a large amount of money into building a tool before they have proven that there is a desperate need for that tool. While C3 wanted to eventually have tools for initial look build-ing conversations and final client review to make the experiences more seamless, all of that initial work was entirely handled by hand, emailing back and forth with clients and presenting multiple looks to hone in on the clients' goals for the project.

In every way, C3 looked like a smart business decision created through the partnership of a team that had experience creating successful businesses in the past. There was a sophisticated focus on SEO, the best possible domain name, and an active push to find and build an audience.

Fewer than five clients came through the portal. Perhaps two converted to paying customers, if that.

Why didn't ColorCorrection.com succeed?

Lack of customer research.

Yes, there are customers who google "color correction," and ColorCorrection. com would come up and they would visit the page (the site got plenty of hits) and learn about the color grading process. However, typically those projects could not afford even the exceptionally reasonable rates, far lower than a typi-cal post house, that were advertised. The type of client who knows so little about colorists that they were googling it were the same clients who didn't have a real budget to spend on a project.

Clients who actually had budgets, even the low budgets C3 were offering, weren't randomly searching blindly on the internet for color grading services. They were asking the director they had hired, the editor they had worked with, or other contacts in the industry for recommendations. Color correction was at the time, and remains, a word-of-mouth personal recommendation business. In fact, it being a "web service" was a turn off, more than a bonus, to clients looking for color services since it felt "commoditized," and color should feel "custom."

If we had done more client research perhaps we would have built a LinkedIn-style site where you could see your social overlap with potential clients (so you could ask for recommendations). Or some other set of tools that would build on how clients actually find you.

There are plenty of businesses where clients are found on Google. Hiring a handyman, or a cleaning service, or a plumber, many, many people simply google "plumber zip code" and find plumbers who service their area.

But the truth is that searches for "color correction" are usually made by people in a period of their career where they aren't quite ready to pay money for the service.

The key takeaways from this experience are for you to think long and hard about where to find clients and to discuss it in detail with your friends and the clients you actually book about where they found you. Search engine optimization is a huge deal for certain businesses, but doesn't matter at all for others. There is no "one size fits all."

As the industry keeps growing, and more and more work is created, there might be a window of time where there is room for an online color grading business, but this will likely need to be integrated with a machine learning system and a plugin for an NLE so that it serves as a remote grading supervision for a local project, and it will likely need to charge a very low amount. Online businesses are often a race to commodity pricing.

Well-paying color grading jobs remain the product of word-of-mouth relationships and traditional networking.

Interview: Founders of KitSplit, Lisbeth Kaufman and Kristina Budelis

"It's like Uber for . . ." or "Airbnb for . . ." is such a cliché of pitching that you almost aren't allowed to do it, but, if you aren't familiar with KitSplit, one way to think about it is "Airbnb for Gear." You can rent cameras, lights, lenses, and more there, and you can offer up your own gear for rent.

However, unlike Airbnb, KitSplit goes further in terms of building professional and social connections between its users. With popular meetups and educational events, and frequent collaboration arising from rental introductions, KitSplit, along with their major friendly rival ShareGrid, proves that competition can be good in a marketplace. In fact, traditional rental houses have embraced the new rental platforms as another avenue for connecting with customers.

All because one of the founders didn't want to take the train into Manhattan to rent gear.

Charles Haine:	What were you guys doing before KitSplit?
Lisbeth Kaufman:	My story goes back to probably the day I was born. I was lucky enough to be born in to a crazy family of filmmakers, so my dad

is an independent filmmaker, his name's Lloyd Kaufman, he runs Troma Entertainment and he is the creator of *The Toxic Avenger* as well as dozens of other films, and they have a library of like 800, 900 films. He's been doing it for 50 years. My mom was the New York State Film Commissioner. She did that for 20 years and built the tax credit program that exists in New York today.

She built that tax credit program, it's financed billions of dollars' worth of films and made thousands and thousands of jobs here. My sisters are filmmakers, my aunt and uncle are set designers and set decorators. My uncle's a filmmaker, whole film family. So I grew up in that environment, on set, very inspired by my dad and my mom and also their entrepreneurial spirit.

I have been inspired by film but have worked on the business side. I went to Yale undergrad, came out of Yale and worked in consulting in Washington D.C., and while in D.C. I got pulled into the policy world.

I worked at a think tank, the Center for American Progress, I ended up in the Senate, advising Al Franken on policy. So I learned a lot there about business, about PR, about working in an inefficient system. And I had enough of that system, so I went on to business school, I got my MBA at NYU Stern, where I met Kristina.

Over the years of working in consulting and policy, I would dabble with my dad on projects with him. So when I was in business school, I produced a film with him in Cannes, at the Cannes Film Festival, that was originally called *Occupy Cannes!*.

Then in business school I worked on a bunch of startups and focused on film and focused on the entertainment industry specifically on the distribution and tech side of things. And then I met Kristina, and she had the idea for KitSplit. So we started working on that while I was in business school and Kristina was in grad school. And then we've been doing that since.

Kristina Budelis: I have a background in video journalism. I fell in love with journalism and storytelling in high school and continued working on it in college. I also got into video and film while I was in college and ended up interning at *The New Yorker* magazine in their video department when it was just getting started. And then, while I was still in college, they hired me as a full-time video producer at *The New Yorker* magazine.

So I had a very hectic semester, juggling classes and full-time work there. But it was a really incredible first job and opportunity. And part of it, a big part of it, was making videos, and all of the creative parts of that. We were a small team, there were just two of us who were focused on video, so the two of us really

did everything from A to Z, from pitching, producing, shooting, editing, as a team.

But because we were a new department at an old magazine, I found that part of the role was also very entrepreneurial, which I hadn't really expected but found that I really enjoyed. So, it was this brand new department, and a lot of people at the magazine and outside of the magazine didn't know that we did video, and didn't necessarily care at that time.

A lot of the role became figuring out what does it mean to do video at a magazine? And at *The New Yorker* specifically, what should that look like? And also, how do we get people inside the organization and outside the organization to care and become more invested and become more active in helping us make these things and also in watching them.

I found that I really liked and was good at the entrepreneurial parts of it, as well as the more specific creative parts of it that I had originally, that had originally drawn me to the role. So I was there for a few years, made a lot of really awesome projects, got to collaborate with really amazing writers and artists while I was there. We shot a lot of awesome people from Woody Allen to Greta Gerwig, to Tavi Gevinson to Gay Telese, and had a lot of creative freedom in our projects, did also some multimedia projects collaborating with writers and photographers and technologists. And a few of those were nominated for Webbies, which was really exciting.

At some point, I had never actually studied film at all, I was self-taught, and I felt like there were some gaps in my knowledge and that I would really enjoy and benefit from taking some courses. I also really enjoyed working on those multimedia projects with a cross-functional team. But I felt like I had so much to learn in terms of what was possible for those and how they could work. So I started looking for graduate programs where I could take some film classes but also learn a little more about coding and design and multimedia storytelling.

So I landed at Tisch ITP, which is a really awesome interdisciplinary program in New York. And while I was there, I was doing a ton of freelancing, mostly video and multimedia projects. And it was really a wide range of projects, from making a video for *Vogue*, to making videos for startups like Maker Bot, to consulting with larger companies like JP Morgan on video and multimedia content marketing. And so it was this crazy mishmash of projects, but I found that something that united almost all of them was my frustration around the gear rental process.

During this period when I was in grad school, I was really kind of hustling and super busy all the time, juggling all these things, and so,

I would have days where I was like, I had a long day at school and then I had a freelance thing at night. And I was living in Brooklyn and working in Brooklyn, and a lot of my gigs were in Brooklyn. But sometimes I would have to go all the way in to Manhattan to pick up gear to rent. And come back, do my shoot and then go all the way back to Manhattan to drop it off and come back home.

So I had a few days in a small period of time where I literally spent more time picking up and dropping off gear than on a shoot. So I just felt like that was really frustrating and silly. And meanwhile I started occasionally renting to and from friends, which is pretty common in the industry. But I always felt a little worried about doing that without a contract or insurance, because my camera is the most expensive thing that I own.

Basically through these personal frustrations, I came up with the idea of KitSplit. Essentially to solve my own problem. And I think specifically I was using Airbnb and loving that and I was like, why isn't there an Airbnb for cameras? And when I first thought of the idea, initially I didn't intend on building it, I was just like, this would be awesome, why doesn't this exist?

I mentioned it to a few friends and colleagues, and I got such a strong response off all these people who were like, that's an amazing idea, I would love to use something like that. And after a few of those conversations, I was like you know what, this is a great idea, and it's not out there, and I really want to make it happen.

Around that time, I was looking for co-founders, and I told Lisbeth about the idea. We met in a fellowship for grad students interested in entrepreneurship, and we expressed interest in and were put on a project that was film related. So, I mentioned the idea of KitSplit to Lisbeth and she was super excited about it, and obviously there were a lot of synergies between our backgrounds, so we started working on it together.

Charles: Do you know how many other people in that fellowship started businesses?

Lisbeth: There's a few. It's now a nationwide fellowship. It's called InSITE Fellows, and it's for graduate students across the U.S. interested in entrepreneurship, and they basically set up consulting practices where the grad students go consult for startups.

Kristina: The two of us were consulting for a film-related startup. We were working on KitSplit for a few months in grad school and then realized we needed a technical co-founder, and I had met Ken in ITP and we had sort of bonded over our shared film background. So we brought him in, I think we started working together in spring of 2014 and brought him in spring of 2015.

Charles: You managed to get a year without a technical co-founder. Then you were like, this is crazy and we've gone far enough.

Lisbeth: We managed to get pretty far without incorporating, without having a developer, just through basically the idea and an MVP (minimum viable product) of it.

Which was like almost us spending a year researching and learning, like what are the needs of the industry, and who are we serving, and will people use this, and the resounding answer was yes. We got this very basic website up and running, and then sent it out to people we knew, and then word started spreading, and then it ended up getting picked up in *Forbes* and *Fast Company* even before we had become a corporation.

The word started spreading and we were in business school, but I was spending most of my time working on KitSplit, and vetting people and answering questions and helping them get their rentals. Because it was just kind of taking off before our eyes.

Kristina: We would both be in our classes, and it was invite only so we had to accept everyone. So I remember just being in class constantly just secretly doing that.

Charles: Were you able to use this as class projects in any of your classes?

Lisbeth: I used it, I mean in business school you can focus on entrepreneurship, so yes, I used it in every class project. And I got my teammates, my class, whatever, classmates, to do work on KitSplit. Everything was, okay, how can we use this for KitSplit? And we brought in professors and got advice from them.

Kristina: Yeah. For ITP it was harder because I had a lot of really specific projects that I couldn't quite get KitSplit to fit in to. But I used a lot of what I was learning in school to make the first version of the website.

We used, a lot of it was this prebuilt platform called Sharetribe. But, there were a couple of sites that we've made from scratch, that I made from scratch, and so I had taken a design class and a coding class that were just introductory, but it was like just enough knowledge to put to use right away and make this splash page for the site.

I also remember asking a lot of my friends who were better at coding. I would work on the site at school and get help from my friends at school who were better at coding and design and had done more of that. So it was a really supportive community in which to make this.

Some of our first rentals were from ITP students and Tisch film students. I remember doing rentals of my gear to other people in the building really early on which was awesome.

Charles: So like, this is one of those examples where a graduate program was actually really beneficial. Because you had a thing that was born of it, because you met each other there. You were able to use the resources it offered because you had the thing you wanted to do.

Kristina: Completely. And it's also helped us meet each other and helped us meet Ken, and I think directly and indirectly it was really supportive in other ways. And actually, NYU has since come on as an investor, which is awesome.

Charles: How long did you survive in total bootstrap with no outside money?

Lisbeth: So the first year, I mean, we didn't incorporate the company until 2015, but we were spending for like a year of time, like researching and setting things up and figuring it out. So that whole time was like, totally no money.

Kristina: There was no money.

Lisbeth: It was just our efforts. And then once we graduated school, we had this really great press, things were taking off. And at that point we applied for and were accepted to an awesome accelerator in the city. So that was our first check, and we got funding from a fund called Dorm Room fund. So those were kind of our first two checks. And then from there we were able to really build the business and raise more money.

Kristina: And that also enabled us to be able to work on it full time and be able to pay ourselves a little bit, so that we could work on it full time.

Charles: So eventually you stopped doing the thing where you were in class and doing freelance work, and trying to build a company at once? You were like, I'm just going to work on building a company.

Kristina: Exactly.

Charles: Do you wish you'd learned even more about coding earlier? Or are you comfortable with the extent to which you had a handle on it?

Kristina: I think that it was a great MVP actually. It's funny, I was just talking to some friends who are starting a company yesterday. I feel like even if you had the knowledge, which I didn't, to build that whole platform from scratch, it's often not the best approach to begin with. I think that for us, by using a prebuilt platform, we were able to get it up and running. And you can set up, the company we used was called Sharetribe, but it's basically like Squarespace for marketplaces, and you can set something like that up in a day.

Even if you're an amazing coder, to make an equivalent product would take you months. And so it was really valuable to be able to get it up quickly and start learning from the process. So I would recommend to founders, whether or not you know how to code, try to find a quick and easy and affordable way to get an MVP out there, whether it's a Google doc or Squarespace or something like Sharetribe.

Charles: A way to use prebuilt tools so you can see if the idea is actually interesting to people.

Kristina: Exactly, before spending all the time building something. It was helpful to know a little bit of coding, we made a couple of custom pages to supplement this prebuilt tool.

Lisbeth: We kind of knew we had to transition away from prebuilt tools because we needed to build a platform that was specific to our community, the entertainment content creators. There are so many things that are unique about the entertainment industry, and this world of people who you're researching, who are the entrepreneurs of the content creation world. So, we knew that we would need to transition off of this prebuilt thing, and we would need a CTO regardless. So, yeah, so we've been very lucky to have Ken and we have an amazing team of developers and designers, who are, many of them are filmmakers themselves. I mean most of our team have experience in content creation, so truly understand the people that we're building for, and are super passionate about enabling content creators.

Charles: It might not have happened yet, but has there been a point in the company where you've been like, oh, we're going to be okay?

Lisbeth: I mean, I kind of think really early on when we got our MVP up and running and we had no money and we had hundreds of people signing up and then we got press and got thousands of people signing up, I feel like that was maybe the light bulb moment of, this is a real business and there's a huge need for this out there.

You're researching the entertainment industry, and all of these people who are not going through the elite Hollywood system of agents and gatekeepers, and we were interested in that as well. From a business perspective, there's a huge opportunity out there of independent content creators who have a passion and a vision and are pulling super scrappy, pulling together their resources to get their projects done, and so that was kind of the moment where we were like, there's a lot of these people out there and they need help.

The system today, the Hollywood studio system, is not built to help them, it's not built to enable awesome content creation on a small scale, and a big, wide diverse scale, and that is a big gap in the industry and we need to fill that gap.

Yeah, and I don't even know if we've talked about our ultimate vision for KitSplit. When we first met, Kristina had this idea about gear and like an Airbnb for cameras, and that's what we're building today, and that's what we've got up and running. But as we've been researching this challenge and what the community needs, what all of these content creators in video, film, TV, photography need, there's a huge gap in the industry, and there's huge inefficiencies.

So we're building a system to provide all of the resources that content creators need, from gear, studios, content creators, all of that, to kind of rethink the studio system and enable, put the power and the resources in to the hands of the broader world of content creators. To enable them to tell their story.

Charles: So how much direct outreach have you done to traditional rental houses? Are there traditional rental houses who are on your platform?

Kristina: There are dozens of traditional rental houses on our platform, and we really see them as partners. And actually the first rental houses to join approached us. Because when we first started, it was with more of a peer-to-peer focus and that was who the very first users were, individuals, but really quickly some rental houses got wind of what we were doing and were like, hey, this is really cool, we love what you're doing, seems like very forward thinking and a way for us to potentially get more visibility.

We've had a lot of rental houses join and now we see that as really part of our value proposition. That on the renters' side you can see all the options in one place, including individuals as well as rental houses.

Lisbeth: We have a head of business development who comes from the rental industry. So he started Audorama Rentals here in New York, and he also ran rentals at Abelcine. So we hired him in part to help us work with rental houses.

Charles: What's the longest you've gone without a day off?

Lisbeth: Oh good question.

Kristina: That is a good question.

Lisbeth: I feel like early on, we were like just

Kristina: Yeah, like the first year.

Lisbeth: Yeah.

Kristina: We probably didn't take a vacation.

Lisbeth: Yeah, or weekends. We were like, insane.

Charles: Are you at two-day weekends now?

Kristina: Often. Not always. But yeah, I think, you know we've been working on it for four years now which is crazy, and I think definitely early on there's this sense of you need to spend all the time on it to just stay remotely afloat. And we still have that to some extent, but I think we've also realized, it's a marathon not a sprint. And it helps to take weekends and take vacations and recharge.

Lisbeth: We've hired an amazing team of really capable people. So early on when it was the three of us or four people, that's a very different scenario from now, we have 15 people who work on KitSplit broadly and who are amazing and brilliant.

Ken, the CTO, then enters.

Charles:	So you were in film before joining KitSplit?
Ken:	Yeah, absolutely, so my background is originally in film and in television. So I studied film in college.

Then I moved out here to New York after graduating about more than ten years ago now. So I moved here, started working, kind of doing what I could at the time, PA'ing here and there, I eventually started working in post production and that kind of was a longer gig for a while. I worked in reality for some things, a TV show called *Say Yes to the Dress* for a few years. I started as a post PA and then by the time I left I was a post supervisor. I kind of was running a few different shows, helping the post process along, doing color, all this stuff. So I did that for a few years and at the same time, kind of along the way, I was making websites for people. So I was making websites for friends, local businesses.

I learned that just kind of growing up and it was just an interest of mine. I was always into coding and that side of technology, so just messing around, kind of taught myself when I was a kid. My dad was an engineer so that helped a little bit, he bought us a computer so that we could teach ourselves.

I did that, I continued to make websites for people even when I was working full time in post, and after a few years I was itching to do something new. I wasn't sure what. And out of the blue, a friend of a friend reached out to me. He was starting a company in San Francisco, or had started a company and was looking for a developer. I was in New York at the time but we met for drinks and I was convinced basically to leave and move to San Francisco and try it out.

So I left my job, moved out west and joined this startup. And in retrospect, it wasn't the best run startup, but I learned a ton along the way. I learned the culture of Silicon Valley, the startup world in general. And then most importantly I had a couple of great engineering mentors who really taught me the ropes on working in a development environment that's for a company, not just little toys that I was building on my own, or like simple websites for people.

I did that for a year, the company folded and I moved back to New York. I started, at that time I wasn't sure what I was going to do but I was really starting to get interested in making video games, and not just video games but like interactive media in general. Interactive toys, things like that. So just anything that was kind of creative and artistic and yeah, kind of playing with what you could do. And I did that, so I focused, made some games, made a game, while I was freelancing and doing contracting work, building apps for people.

I released a game back in 2012. It did okay but it's kind of not enough to survive on. So, it was a great experience, I'm still embedded in the games community here in New York because of it and still do a lot of things with them, with people. And after a couple of years I decided I wanted to learn more. So I was interested in going to ITP. I was drawn to it because it was just like-minded people and I had met some alum who just spoke highly of it, I did a Hackathon leading up to my decision to go, and half the people there were ITP alumni who were just like super interesting and seemed to know a lot more than I did. So I decided to go, and that's where I met Kristina.

Kristina: We met the first day of classes and we actually got drinks after our first graduate class ever. Me, Ken, and one other woman. So we were basically each other's first grad school friends. And I remember at that drink, the three of us had all worked in film in some capacity and it's kind of how we bonded. Talking about film stuff. And the other woman actually invested in KitSplit. So the three of us all ended up working together.

Ken: Which was great, my first "meeting new people at grad school" happened to be you. So KitSplit happened, I think, you started it about a year later probably ish, after the start of the program. We did the grad school thing, pulled in a thousand directions trying everything, but as we were starting to graduate, I was looking for work, so kind of at the end of the third semester, sort of the fourth semester before graduating, just kind of actively reaching out to everyone, every opportunity, I was just open to anything.

I knew that Kris had started this and was working with Lisbeth, and we happened to be in a class at the time, and we were working on just some random project, we were meeting for that. But she was super stressed about something, which turned out, she was stressed about trying to find a co-technical person to join the team. And I was just kind of kvetching about horrible interview experiences at these larger tech companies, and Kristina immediately said, you should think about KitSplit.

Within five minutes she was like, I'm supposed to meet with Lisbeth, I canceled to have this meeting, but maybe we should still meet. So she called Lisbeth, Lisbeth was like three blocks away, we just ended up meeting and it just went from there. I kind of almost said yes immediately, I just kind of knew that it was the most interesting opportunity and something that I personally care about and just have experience with. Even though it had been a few years since I'd worked directly in film or TV in any capacity at all.

Charles: But how much does your work in film or TV influence your work as a developer?

Ken: On the day-to-day stuff, not too much, but in terms of a lot of higher-level decision-making, like higher-level strategic choices and decisions we make around the product and around what to emphasize, what to de-emphasize, specifically with KitSplit, it's just, just because I know gear, it just helps so much. I can just know that something, just intuitively that it will or won't be something that our users would like.

Then when I meet people it's just an entry point to conversation, I get what they're doing. So in that way, in terms of meeting customers and talking to them it's great as well just because I can hear what you're saying and understand exactly what you're saying and what you're going through because I've been there and that really helps inform our decision-making.

So directly in terms of writing code, not so much, but those code decisions are all dictated from these higher-level decisions that are based on our knowledge of the industry in general.

Debt and Investment

Debt

"If this were 2006, I would cut you guys a $100k line of credit in the room, but after the bust, there's nothing I can do," he said with a regretful smile. My partner and I were sitting in the lobby of the bank we had used for three years, and that I personally had used for a decade. We were in a cash crisis, billing well but waiting forever for clients to pay, and there was nothing he could do to help us through that to our next stage of growth.

Business credit and personal credit are fundamentally different animals.

Personal credit is an issue for another book, but I will say that, in many cases, it's possible to live entirely without it if you are careful with your money, except for secured loans like mortgages, which are tied to physical property.

Business credit is almost impossible for a business to survive without. From the smallest companies to the largest multinationals, credit in some form or another is used to help smooth out the inconsistencies of cashflow. This is because your costs are often regular and unceasing (payroll twice a month, rent and utilities once a month) while your income is irregular and delayed. This is particularly hard on production companies since production work is so irregular. You might have three videos one month, then no videos for three months. This is why so many production companies pursue TV work (steady, regular income over time), and why so many have multiple revenue streams, such as post production or effects, which can smooth out income irregularities.

Thus, business credit is often used to cover current expenses when you have known future income to cover them; you pay the interest on the credit for the service of being able to cover your costs today. Even large multinationals occasionally use credit for this purpose; it's called short-term paper.

You are going to find this credit almost impossible to get. After the financial crash of 2008, small business credit has all but disappeared. You have to have been successful in a profitable business for several years for this credit to open up to you, and you need a business model that reflects a high likelihood of future growth. Few production companies have this, so you can almost never get this type of credit early on.

One avenue you can pursue is what is called factoring invoices. Once you have invoiced the client, and they commit to pay, you can then sell that invoice off to a third party who will pay you immediately in exchange for a percentage of the invoice, which is based on the creditworthiness of the person or institution who owes you the money.

Factoring works in certain arenas, but in general the percentage it eats is high enough that it won't be worth it; with many of your smaller clients, it won't even be an option.

Some businesses use a business credit card to help with cashflow; while most payroll companies won't let you charge the payroll payment to a card, by putting items on the card (expenses related to a project, for instance, like rentals of equipment) that you would otherwise pay for in cash you can free up cash to cover other expenses.

Unfortunately, credit card interest rates are designed to maintain debt, not to be used as an effective business tool. If at all possible, avoid doing this, it's practically a guarantee of bigger problems.

The other common form of business credit is secured credit for specific equipment purchases, generally in some form of a lease agreement.

Since the lease is secured by physical property, this is relatively easy for even younger companies to get, and it can be a very saavy move for the expansion of your business to lease equipment instead of purchasing it, since it frees up cash that might otherwise have gone to equipment purchases to be used for other tasks.

Since a business generally uses equipment it purchases (such as computers, phones, etc.) for 2–3 years, it makes sense to pay for them over the course of that 2–3 years, rather than sink a massive cash investment into the equipment all at once.

A business lease can either be market value or $1 buyout; a $1 buyout lease allows you to buy the gear at the end of the lease for $1, but it will cost you more in monthly payments for the duration of the loan. Market value leases require you to buy the gear for market value at the end of the lease, or it's returned to the leasing company. If you think you'll continue to be able to bill with the gear after the lease ends, $1 buyout makes sense, since, once the lease is paid off, the gear can continue to be yours and can be used for billing into the future.

Since the IRS requires that you write off equipment over the period of time that it is useful to you (this is called depreciation) if you buy it outright, leasing equipment allows you to write off that equipment over a similar time period that you are paying for it and leads to tax savings.

For most small production companies, leasing is the best way to ensure they are keeping as much cash in the bank, on hand, as possible at any given time. That, combined with closely watching your margins, is the best way to build up a cash reserve that allows you to effectively smooth out the pain of waiting for clients that take forever to pay. Using credit practically guarantees you'll never be able to build a cash reserve, since the interest on the credit will eat up

your profit margin. On every job be relentless in managing your costs and you can build up a real cash reserve.

Non-Bank Debt

In addition to banks, there are other areas where small business artists can look for capital: family, crowdfunding, and investors.

Venture capital investors (VC) are primarily a long shot, since most film businesses aren't the sort of scalable, highly profitable enterprises that are attractive to VC. Of the companies we interview here, only two, coincidentally the two that have the most power to scale digitally, worked with VC while a third brought on a more traditional investor. More creatively focused artistic businesses can usually only grow to the size that the artistic output of a small core of artists can generate, which doesn't make for a massive investment opportunity. There are exceptions, such as the fashion world where investing in an individual designer early in their career can be highly lucrative, but even in those situations it is exceptionally hard to find investors willing to take a chance on a startup fashion brand with an unknown designer.

The exceptions are individual projects that are sometimes attractive to investors, such as specific films where there is the potential of a large financial return. However, the investor usually invests in the specific project, not the company, and those funds are spent on the project. This absolutely exists in the film world, but the "independent film" market right now is just not a thriving marketplace for making a regular living.

You can, and absolutely should, pursue investors for your dream passion film project with all the vigor and energy you can muster. However, this won't get a lot of attention here for the unfortunate reality that it just usually doesn't help you pay the rent. Financing an independent feature can take years, and often leaves many even established producers in dire financial straits as they wait for financing to come together for a project.

We are focused in this book on building steady regular lives that allow you to have the freedom to stay in the game and work on getting those independent projects made. It's close to impossible to finance indie movies, but it's easier if you are able to eat while you work on it.

By far the most common form of small business finance in almost all areas of the world is family. Cezanne had his father the banker, Van Gogh his brother the art dealer, and countless others have accepted family support in some way, shape, or form in order to make a career in the arts sustainable. Many also don't, of course, and it's not always necessary, but it is common.

The biggest issue is that money changes relationships. Accepting an investment from your successful aunt who is a dentist might feel like the only way for your business to survive, but be prepared for it to change the dynamic of your relationship not only with that individual but also others in the family. The best way to manage the situation is to be as clear as possible what the

terms of the arrangement are. Is this cash a gift? Or an investment? If it's an investment, what share of the enterprise are they getting in return? If it's a loan, what are the repayment terms? What's the interest and what are the penalties for late payment? For some reason many take family capital without being clear about what the terms are, and both sides will make assumptions that lead to future tension if it's not all properly discussed and papered.

For all loans above a certain dollar value, the IRS will impugn interest, meaning that whether you formally agree to interest or not, the person making the loan will be expected to pay taxes as if they are earning interest income. Talk to your tax expert about this, but it is best if you assign an interest rate, even a minimal one, to loans, even from family members.

Even with all this clarity, the family dynamic will often change, and people who put money into projects often expect that that gives them a corresponding amount of input and control of what is done with that money. Tread carefully.

Crowdfunding is an increasingly popular option for getting film projects going, wherein your prospective consumers of the project (the fans) pay ahead of time, using a variety of popular websites, in order to get the project off the ground.

If you have a project that is easily shared, talked about, and passed around, crowdfunding can be a great way to finance a project, but it's important to realize that many projects and businesses that are perfectly viable don't necessarily fit the crowdfunding model, and a failed crowdfunding campaign doesn't necessarily mean you should not continue.

Crowdfunding is also not a zero sum game. Many artists are frustrated when "rich" people, successful musicians, actors, directors, or artists, turn to crowdfunding in order to fund their projects, when they could "easily fund them themselves." Crowdfunding is selling tickets ahead of time to your dedicated fans, and often those celebrities are bringing new people into the crowdfunding world that didn't previously know it existed. There is actually a relatively small pool of dedicated crowdfunders out there looking for things to invest in: for the most part, it's a tool for activating your specific audience. Use it as such.

Turning a crowdfunded product into an ongoing business can be particularly complicated, and it's not uncommon to see those product-focused businesses go under quickly. In the camera world a major lens manufacturer in the "crowdfunding" space that had raised money for many interesting lens designs recently went under because they failed to adequately plan for their necessary production costs. As always, unanticipated costs are the major killer of business.

Bootstrapping

Bootstrapping is the process of building a business without taking in any investment whatsoever.

The key with bootstrapping isn't just avoiding having outside investors to "fend off" who might want to interfere with your business. The key with

bootstrapping is that, by taking in no outside money and having to grow the business with income from clients, you have an incredibly fast response curve in terms of finding out what is working and what isn't. It forces mental clarity.

If you aren't able to quickly provide a service or product that clients want, you will know, almost immediately, and your company will go under. If you have something people want, and you are bootstrapping, you will find a way to either charge enough to be profitable or lower costs enough to be profitable. You figure it out because you have no choice.

Many, many businesses take investment wisely, but the danger in investment is that it can often distort decision-making in terms of what is achievable and what isn't. It's hard to tell what people will pay for something if the goal is "we'll give it away for free for a while, then we'll charge," which is often the pricing plan of many investment-run businesses.

Both the businesses we interview in this book that took investment capital were also charging for their service from the start, so they had proof, to themselves as much as to everyone else, that their business model worked, people would pay for it, and they could provide the services adequately at the rate people would pay. Venture capital wasn't needed to prove the business, it was used to help the business grow.

Investing in Gear

Many filmmakers want to own a camera. Fancy cameras have been so hard to have access to for so long that it remains one of the first things people want to acquire when they start acquiring gear. The idea, apparently, is that just by having a camera around you'll be able to make more things, more of the time, with less planning and coordination. In reality, putting together a production involves writing, organizing, paying and feeding a crew, securing locations, and a dozen other things that take effort, time, and money. Owning your own camera doesn't magically make the rest of it fall into place. However, it's a natural urge to own your own means of production, and one to consider as you start the process of launching your career.

Buying a camera isn't a bad idea, necessarily, but it's one that many younger filmmakers don't run the numbers on thoroughly enough in order to make the decision with the best information possible. For instance, many filmmakers decide to buy a camera and then rent it out in order to pay it off. If you run the numbers, this can in fact be a smart decision that leaves you with free access to the camera whenever it is not in use.

However, you have to go beyond simply looking on rental company websites, such as KitSplit and Sharegrid, to see what the advertised price is on a camera. To the extent that you can, you need to reach out and talk to people who currently own those cameras about how often they are actually renting, and what sort of packages (accessories, lenses, etc.) are going out together to create that revenue stream.

For smaller cameras, you have about 18 months after purchase to pay the gear off. This means that if a camera is announced in October to ship in January, and you get your order in to be among the first to get it in January, you'll have 18 months to pay it off after that. What about those who buy it in June? Well, likely by that point the market is starting to fill up, driving down rental rates and rental frequency, so honestly by that point you will often have only 12 months left of rentals providing enough income to justify the expense before the price drops to the point where it's not worth the effort.

There are absolutely camera platforms that have "longer legs," and continue generating rentals into the 2–3-year window; the best example of this is the Alexa Mini which is still very dominant years after its release. However, for more affordable cameras, you have a much shorter window of time where you should be focusing on getting your initial investment paid off. Of course, that doesn't mean you shouldn't keep the camera and continue to use it after that first window: if you like the images it creates you should be able to get many years out of a well-built camera. But the hot period for rentals is when a camera is new, and that requires a willingness to dive into the market when it first gets released.

This math changes a bit for other gear that has less of a turnover than cameras. Purchasing lights, monitors, sound boards, and more can have longer useable legs than cameras since there is less innovation in that marketplace. Rental rates won't be as high to start, but won't drop as dramatically.

One factor many forget when doing their math on a camera is maintenance and expendables. If you are using a camera, and especially if you are renting it out, it will need regular visits to a repair facility to stay in tip-top shape. While it might be tempting to hear about a new camera package and bid out a package that would run you $2,500/month to lease and think to yourself "If I rent it out two weekends a month it'll pay for itself!" you absolutely need to pencil in some rough sense of how much it will cost to maintain the camera properly. Getting estimates for regular maintenance can be tough, but a phone call for a bid on a camera overhaul from your local repair facility is a good place to start. Additionally, plan on replacing cables regularly and factor in the price of viewfinder, battery, and other cables, all of which are much more expensive than anyone wants them to be.

The other forgotten item in this conversation is time. Renting out a piece of equipment is not "free money." You need to prepare the package for rental (going over everything to ensure it is all there, ready to go, still works, batteries are charged, etc.), you need to do a checkout with the renter, going over every item and ensuring it's all in good working order and they know how to use it, you need to check all the gear back in when it's done, checking that it all works and wasn't damaged, and then you need to store it somewhere. On top of that, you need to manage all the emails/texts of setting up a rental, coordinating the constantly changing schedule of when pickup and drop-off will occur, when to take the package in for repairs, and navigating any field issues that come up that might require phone calls at all hours to walk people through these issues.

On top of that, you need to arrange for a backup system to be available if yours goes down. This is all time, and you absolutely need to factor that in the math of whether or not owning gear is right for the current stage in your career.

This is the reason many owners work with rental houses to handle their gear. By partnering with a rental house, you get a dedicated repair and rental team, a scheduling department, somewhere to store your gear, someone to answer the phone at 2a.m. on Saturday when something goes wrong, and a full inventory of accessories to support your package. In exchange you give up a percentage of your income to the rental house. There are many rental houses who do this, from the small shop around the corner to the biggest shop in your market, and with some of the major houses you'll find that a large percentage of their inventory are entirely sub-rentals. Developing a good rental house relationship will also benefit you on your own productions, since, when you are taking out your own gear for a shoot, you'll have the whole array of their support equipment you can rent from them (and try to talk them into a discount on), which you can pick up at the same time you are picking up your equipment.

Do not underestimate the wonder of just having your gear stored somewhere safe, where it is tracked properly and there is a prep floor for pick-ups and drop-offs. While many owner/operators keep their gear in self-storage lockers, and that can be great for lighting or other less technical or expensive gear, nobody wants to do a full camera check out in the parking lot of a self-storage facility.

The "should I buy a camera" conversation gets even trickier if you are working as, or want to become, a director of photography. As a cinematographer, the key thing to accept is that if you own your own camera it has two major drawbacks which, while not deal breakers, can be annoying. First, clients will rarely pay what it's actually worth to rent it, if you are also the DP on the job. Say your day rate is $1,000/day and your camera usually goes out for $750/day; clients will constantly try to get you to just "bring it out" since you own it, as "it'll just sit there if you don't bring it along," or ask you to give them a "combo" discount, say, $1,250/day for both you and the camera. Since your time is worth something, and the gear is worth something, this is very annoying, but will happen constantly nonetheless.

One strategy for dealing with this is to go in with a few friends on the camera package, which is one of the few areas where a "collective" model seems to work. You buy the camera as a group (lowering the investment cost), and you have the excuse as you negotiate rates that it's not just your camera, you own it with a group, and the group has agreed to a certain minimum. While this isn't really any different from you having a price you set yourself, in practice it seems to work better when negotiating with a client who wants a deal for everything.

The other thing that will happen is all of your jobs will land on that camera body, even jobs that should have gone to another platform. Let's say you are a huge Arri Alexa fan, but you can only afford to purchase a RED, with the thinking being "My small jobs will use my RED, but the big jobs will still rent

an Alexa." Unfortunately, once you are a RED owner/operator, your clients will start to think of you in association with your RED package. You will find Alexa jobs few and far between since you've acquired RED gear.

The best strategy for dealing with that is to only buy the camera you are legitimately excited about working with most of the time. This can potentially mean taking out a lease on a more expensive piece of gear, but one you want to use, as opposed to purchasing a piece of kit you are less excited about just because it is what you can afford.

Always remember that as a cinematographer you want to be hired for your ability to craft the perfect image to tell a story, to collaborate well with the director and production designer, and your ability to manage a happy, creative, engaged crew. There are many cinematographers who own nothing, who rent the right tool for every job, and show up with little more than their own personal light meter when arriving to set. That is a perfectly valid career path. Owning a camera can potentially open up some avenues to you along the way, but it is by no means a requirement.

Many cinematographers, instead of investing in cameras, invest in other equipment that gives them the ability to do the work they want to do and might not be something the production is willing to rent. Many cinematographers will invest in highly color accurate monitors such as the Flanders DM-250 or the Leader LV5333, since those are items productions might not be as willing to rent but they give the cinematographer access to more accurate information for making on-set decisions.

Margins and Cashflow

Margins

If you get hired to make a video for $10,000, and manage to make that video for only $7,500, you make $2,500. That's your margin. Most small businesses operate with margins of 5–15%, where "margin" is the profit left over after all of the expenses of the job are paid. Movies are no different, but there is a trap that many fall into that makes it seem like it's different.

Everyone dreams of a business where it's possible to get your profits up above 15%, but it's very, very difficult since, once you do so, competition arrives in force to undercut you. Once you've achieved some level of fame or reputation that clients are willing to pay you for prestige purposes you can sometimes get your margin up above that amount since your fame can protect you, but, while you are climbing, that's about the sustainable upper limit. Those elements that allow you to get your profit margins up above 15% are what Warren Buffet talks about when he says he likes businesses that have a "moat" protecting them. That moat is what lets you charge more. In film, fame, reputation, long customer experience, and truly exceptional work can let you get your margin up above 15%, at least for a while.

A margin of below 5% and you run out of cash and go out of business. Even a 4% margin is just too small, as it leaves you with absolutely no room to cover unexpected expenses. Your PA crashes the grip truck into a parked Volvo? There goes your 4%, just on the insurance deductible alone. Lose a sub-tenant in your office, have to pay finance charges because a client is late to pay, need to offer your freelancers a bonus to really deliver the job right? All of those eat up 5% in the blink of an eye.

Hence 5–15% is the most common range, with the real goal being 10–15%. That's a small difference. Looking at our mythical $10,000 video job, that's only a $1,000 difference between "minimum" profit and "maximum" profit, and it requires all of your skill, cunning, and planning to save that extra $1,000 on the job.

The trap that most filmmakers fall into is confusing the margins on individual jobs with the margins of the overall business. Most film jobs are based on the individual gig. You book a commercial, a series of social videos, a web series, a single music video. Each of these will have their own individual

margins, but they are all part of the cashflow of your overall business, which also has expenses. You might book a commercial every three months, for instance, but your rent is still due every month.

These margins on individual small jobs are usually higher than 15%, giving you the delusion that you have found a business in which a wellspring of cash is available. It is often possible to get a client to pay $10,000 for a job you can do for $6,000, giving you a $4,000 leftover and giving you the delusion that you are making 40% profits. However, the big mistake that most make is to fail to include some sort of fee in their internal personal accounting of the job to cover their monthly operating costs; the rent, internet, and other supplies that keep the business alive. In addition, the creatives frequently forget to pay themselves anything at all. That $6,000 "budget" will frequently just be hard costs, with no fees at all for the director or producer, despite both of those individuals working hundreds of hours on the project.

One of the most important things you can do as an artist in business is to have a firm understanding of exactly what your monthly burn rate is: as the saying goes, "clarity leads to abundance." How much does your business spend each month on supplies, rent, internet, everything you need to do your work. Knowing your monthly burn is the first step towards accumulating a cash reserve. If I am asked to talk to someone about their business, either in an informal consulting capacity, or at a meet up, or just by a friend who is struggling, the speed with which they can answer the question "what's your monthly burn?" tells me a lot about how healthy their business is. It's not important what the number is (you want it to be as low as possible, of course, but there are hard costs to life you can't avoid). It's important how quickly they can answer it, and how clearly. Someone who says "you know, it varies, but I think maybe like $8–10k/month" is way less likely to be in touch with their business than someone who says "Our hard burn is $6,450 every two weeks." You need to know precisely what that burn is. If you do a weekly money meeting (and you should), burn rate is on the list.

You need to assign a portion of those intermittent gigs to cover that monthly burn. This is especially hard since you need to account for how much of your time the job will take, so that you can apply the right amount of your burn to the job.

If you book a job that is going to occupy half of your time for three months, you need to factor in 1.5 months of burn into the budget of the job.

Chances are, this will bring your margin down to the familiar 5–15% range, if you are lucky. If you aren't, you'll discover that you might actually lose money on the job. When working with younger filmmakers, this is often shocking, since many young filmmakers have real trouble accurately valuing their own labor. The job is just too much fun, and they've wanted to do it for so long, that the idea that they also need to make sure they are paid to do it seems ridiculous. It's not. Start with your local minimum wage, and ensure that you are making the bare minimum when you work on these projects.

You have to do this accounting to make good decisions about which jobs to take and which to pass on, because as an artist you have a fiery passion to

do your work. And in your eagerness to do your work it's very possible to find yourself taking jobs you want to do that actually cost you money, and you end up effectively paying the client to do the job. Sometimes, this is an alright decision to make (rarely, but if you feel like you can legitimately improve your reel and expand your client base it might be worth it), but you need to know that that is the decision you are making, and you need to be making it consciously.

Another error many filmmakers make is putting the entire profit into "new equipment" that they hope will be used on future projects so they won't be taxed on the profit. While that is tempting, it is often better to wait to buy new gear until you are truly too busy for a rental to make sense. If you are using that camera every month, or twice a month, it can be worth buying, but if you are only using it every 2–3 months, renting makes more sense since it lets you keep more of your hard-earned cash in your account.

Actively tracking your actual profit is a habit you need to get into even while your overheads are low. If you have a day job, and are working from your living room on weekends, still try and factor some payment for the use of that living and for your own personal time into the budget of jobs, so you can start to make decisions for which gigs to take in a realistic way. Even though it's not going to drastically affect your side-hustle business if you don't, the earlier you get in the habit of properly accounting for the time and resources you give to jobs, the easier it's going to be as you start making more money and when you have more to keep track of.

It'll also, not coincidentally, help when it comes time to do your taxes.

Cashflow Is King

Net90: if you don't know what that term means now, you are likely to learn it, and eventually to curse it.

Businesses take forever to pay each other. The larger the business, the slower they are to pay.

My production company nearly went out of business in its first year of operations after one of the biggest financial firms in the world took seven months to pay us. Probably the biggest financial firm on earth. They had the money. Seven months.

I say that not with anger, because the little guy can't be mad. We can't waste time on it. I say it just to take me back to the moment of being flabbergasted that they would take so long to pay. I mean, they had the money.

Business used to operate on Net30; once you invoiced the client, they had 30 business days to be sure you got paid. That is still frequently the law in many areas, but it's a hard law to enforce and often the sums involved are just small enough not to be worth suing over.

Somewhere during the financial collapse of 2008, Net90 became the norm; business just started taking longer to pay. Net90 now often feels more like a guideline than a rule.

The simple reason for this is that big companies are doing a lot of different things with their money. If they have enough cash, they are investing it in a variety of ways that generates more cash. Even if they just put it in a savings account, they are earning interest on it, but they have better tools than savings accounts to earn from with the cash they have on hand.

Large businesses also have layers of bureaucracy and approvals for any payment they make, which slows the process down.

An additional reason is that many small and even medium-sized businesses don't have a lot of cash on hand themselves, since their clients are also businesses. Thus, they are waiting on payment themselves from their clients, which is often slow to come. One of the production companies I freelance for had to wait a year for a payment from a national retailer of more than a million dollars. That production company usually takes 6–8 months to pay me even small payments, which isn't a surprise considering how long they themselves wait to get paid.

The darkest reason, which I have always suspected and once got confirmed from an accounts payable person after they left their large firm, is that the big guys deliberately pay the little guys the most slowly. Because they are not likely to work with us regularly; because we aren't traveling in the same circles they are, and we aren't a major item on their "accounts payable" list so we can't make a lot of noise; because the sums they owe us are too small to sue over while the sums they owe other large companies are massive and thus litigable. And, because there is a good chance we'll be going out of business, because most small businesses fail, and if they pay us a month before we go out of business, they'll feel like they wasted that money.

So they sort their "accounts payable" by amount, and pay the biggest accounts first. They pay each other huge sums quickly, while the smaller sums often sit.

Of course, the irony is that most small businesses go under because their clients took so long to pay.

Is that true of every large business? No. Some (a very small number) pay quickly. Most pay slowly surely out of paperwork and approval slowdowns. Some pay the biggest accounts first because those accounts can make a bigger fuss.

In every business you are eventually going to be in the middle of this cash crunch, waiting on clients to pay while you struggle to keep your vendors (suppliers, freelancers, space, etc.) paid. This is hardest when you are just starting out; your current clients aren't going to be paying for a while, but you didn't have clients six months ago, so you aren't getting checks from back then either.

The initial instinct is to bill your way out of the trap; go out and hustle, and sell, and book more jobs, and more jobs, and bigger jobs, and get more money coming in the door.

It's a great instinct, to hustle, but it can also be a trap, since as the jobs get larger, your expenses also go up (those supplies, freelancers, bigger space, etc.), and the clients tend to get bigger. And slower to pay.

The way out of this trap is to build a cash reserve, 90 days' worth of your regular expenses, in cash in your account, so that as clients are slow to pay you can still pay your bills.

This will be one of the hardest things you ever do. Because it involves the discipline of knowing where all your money is going, and only spending it on things that are absolutely vital.

It also involves doing something many artists are loath to do, which is pay taxes. Since, to keep that money in your account as cash, you'll have to pay tax on it. Many small business owners, hearing the terrible advice "everything is a write-off", will constantly invest in new gear. In December, they'll buy new printers, new cameras, new everything since "If they don't, it'll just go to the tax man." But it leaves them vulnerable, since that decreases the cash they have in the bank, and when cashflow gets tight you can't pay your gaffer with a printer.

So it's worth keeping cash on hand and paying taxes on it. Without it you can't survive for very long. Without it you choke.

My favorite book on accounting (see recommended reading) calls this the desert, and in the desert you starve. You've got work coming in, you owe people money, but your clients aren't paying you. You've got to get yourself out of it, which takes time and patience. And, often, outside revenue sources in order to keep cash flowing while waiting on clients to pay. This is why you see so many production companies with multiple revenue streams, doing big commercials that take forever to pay and balancing it out with smaller but fast-paying gear rental, post services, or production services jobs.

Because money is constantly flowing out of a business, to your vendors, your employees, and your overhead, and they all expect to be paid whether you are getting paid by your client or not. It's part of your commitment as a business that you will pay them for the work or service provided. Leaving you in the middle of a stressful situation.

One vital trick is keeping regular overhead as low as physically possible. This is why many businesses don't hire employees, they hire freelancers. Freelancers can come and go as work is needed, there is no need to keep them busy and keep billing to pay their salary. Flexible space, where unused space can be sub-rented out to others when it's not needed, also helps. Rental platforms like KitSplit and Sharegrid, where you can keep your gear working every day even if you don't have work for it, help as well.

Because nothing chips away at your cash reserves like the regular hit of rent and payroll.

The cash that flows through your business is like a river, and the instinct is to grow the river as large as possible. But if you aren't diverting any of that river to irrigate your fields, if you aren't saving any of that money, a larger river just becomes a force of destruction.

Partner Payroll

It's common when the company starts to treat the partners as freelancers, who "eat what they kill." Three editors get together and decide to start a post house, and the least busy editor makes the least since they are booking the fewest jobs.

This can be a long-term sustainable method for growing a business, but it often fails to account for what actually happens in a company. If that third editor is doing the book keeping, helping the other two editors land jobs, maintaining the website, and in general keeping the ship afloat, that will often slow down their "billing" but should still be rewarded.

Moving the partners to "payroll" is a discussion that should be considered, but comes with a long conversation about precisely who is expected to do what and why.

If you are a sole proprietor, it can still be useful to put yourself "on payroll," with client checks going into your business account, then a regular draw going from your business account to your personal account.

Discount for Prompt Payment

Many small businesses offer a discount of, say, 1–3%, for payment within seven days of invoice.

Yes, 3% can be a huge discount on certain jobs, but it is something that some accounts payable will notice and take advantage of. I would estimate in all my years of including a 2% discount for payment within seven days the discount has been taken advantage of once. But I appreciated it.

I leave it in there, in the notes field by default in my invoicing software, just in case.

Credit Card Fees

Credit card fees for small business are annoying high. When your margin is in the 5–10% range on a job, it can be very frustrating to give up anything for a payment processor, especially when there are alternatives like checks that cost you nothing.

However, many clients prefer credit cards even for large financial figures, and arranging for some method of processing credit cards will occasionally allow for speedier payment from clients. Since when you get the money matters so much in allowing you to pay your sub-contractors, you will eventually want to set up some method of processing credit cards.

Weekly Money Meeting

You need to do a weekly money meeting with all partners. If this is just you, and you have no partners, you need to find someone else in your life (a parent

you trust, a significant other, even a friend and you agree to do it with them in return) to talk about money with weekly to check your assumptions and relieve the stress of carrying it all in your head.

This is not the same as the "Monday morning meeting" (MMM) that practically every small business has where they talk about the upcoming week. That MMM is where you plan your goals for the week, who will be doing what, if you have a space what will be in each room, which freelancers will be hired, etc. That MMM is almost always a full team meeting which everyone working that week should attend so that everyone has a handle on the goals for the week and how their part fits in: who they will receive assets from, who they will hand over to, what the deadlines are.

The Monday meeting should also usually end with an email to outside free-lancers and work-from-home team members with an update for them on their responsibilities that week. Even if you aren't expecting anything from them for a few weeks, staying on track is a good thing.

The money meeting is another meeting. Typically Thursdays or Fridays, the money meeting looks at a few essential elements and makes sure every single "partner" knows the health of the business. Once you grow large enough, you can have a team member generate a money report to go over, but while the business is small you can just pull up your accounting software (QuickBooks, Wave) and take a look, and open up the actual bank software to check balances and review transactions. Even once you get large enough to be looking at a report, still occasionally check directly in the accounts to be sure that report is accurate.

1. Cash On Hand

What is in your bank account? You should be checking this every day, and doing some form of accounting daily, but it's often something only some part-ners do, and getting all partners together to go over the accounting as a group is an immensely valuable exercise that cannot be overestimated. Know precisely how much cash you have on hand. Go over recent charges on the account together to be sure all know what they are.

This is vital as you grow since every partner needs to have a real understanding of precisely where the money being spent is being spent. If the Ukrainian VFX company to which you outsource roto has raised their rates, all partners need to know this so they can hunt for competition. Everyone needs to watch the money.

Also, and this is depressing but true, fraud is still a thing. Credit card skim-ming happens. Checking all recent transactions can also catch fraudulent activ-ity more quickly.

2. Money Coming In

Otherwise known as accounts receivable, this is the people who owe you money. Because of the way businesses pay each other, this is something you will con-stantly struggle with. Know precisely who owes you money, and divide and

rotate through pestering them to pay you. There is a light and polite business professional way to be a nuisance and get paid promptly, and it should never be up to one partner to do that.

3. Money Going Out

This is money that will be leaving the account soon. If you cut checks every Friday, these are the checks you are cutting, which of course need to be within the amount of cash you have in the bank.

The Burn

The burn rate is part of your money going out. As a filmmaker, most of your "money going out" will be to other filmmakers, to the editor, to a colorist, to a propmaster, and maybe you needed a cool logo made for a commercial, so to the graphic designer as well. Those irregular expenses aren't part of the burn, and can often be assigned against a specific budget for a specific job. Then there are the regular expenses, rent, utilities, payroll, etc., that need to be paid every single week or month: the burn.

The burn deserves special mention because it is so often completely neglected. You absolutely, positively need to know your burn on a regular basis, and you need to actively state what it is in your weekly meeting.

Burn creep is one of the things that take a company down. You decide to give someone a raise. You splurge on the faster internet so you can "deliver" to your clients faster. You kick out a sub-tenant in order to take over their space. Each individual decision feels small, but if you are watching your monthly burn, all of those costs creep up together quite quickly. You need to know your burn precisely and then you can notice if it slips up. If you know your monthly non-payroll burn is precisely $3,254, and it goes up because your internet provider raised their rates to $3,294, and you are paying attention, you'll notice.

Every single element of the burn needs to be fought against with everything you have in your power. Call every utility vendor and ask for a better rate. Speed test your internet to see if it really does offer benefits. Evaluate raises carefully: they are useful, but be 100% sure you can afford them before you give them. Bonuses are easier to plan for and easier to afford since they don't affect your burn, and you don't need to pay them every single month to survive.

Know your burn. If you don't know your burn, you won't properly account for it, and you'll eventually not have enough to cover it. And then you'll be out of the game.

Interview: Frame.io founder Emery Wells

Frame.io is currently working very hard to be the standard "work in progress" review tool for anyone trying to get a team to agree on a final version of a video, still image, or, soon, written material.

Founder Emery Wells is a big believer that Frame.io is able to be as good as it is because he himself had a deep knowledge of the specific need. Having worked in video and post production, and having navigated the pain of client review, he could speak clearly to precisely what needed to be built to fix the problems inherent in the process. Working closely with his technical co-founder, and keeping the engineering in Manhattan, Frame.io is able to rapidly grow its toolset in ways that closely integrate customer needs.

Charles Haine:	So what were you doing before this came to you?
Emery Wells:	I owned a post-production company, so I'd been doing post production for about 20 years. I started when I was 18, so that was 2000.

I never had infrastructure when I started out. My first post-production workstation was some kind of relatively crappy Dell that I bought for $1,000, and it was FireWire 400 and just capturing digital video over FireWire 400 was actually not even particularly reliable. It was with like Premiere 5, so that was about the era that I started.

I had just graduated high school and did some stuff in classes that exposed me to making video. I was like, "Oh, this is really fun," and I wanted to keep doing it.

I've spent, whatever, close to 20 years in post production, not quite, but doing everything there is to do. I've been a video editor. I've done motion graphics, visual effects, visual effects supervision, pipeline engineering, color grading, finishing, dailies, all that stuff, produced original content for network television, and then started my own post-production company that I wound up running for seven years until I started Frame.io.

Frame.io started as an internal tool at my post-production company. So actively doing the work every day, that facility primarily did dailies, color grading, and finishing. Not so much editorial. That was Katabatic Digital here in New York. We were well known for doing all the SNL digital shorts. I color-graded all those for three and a half, maybe almost four seasons. But mostly it was broadcast advertising work, agency work here in New York City.

I was the sole owner, so it was a boutique agency. And at its height, I had a few full-time employees, and then we would have permalancers or freelancers that were in there. So on a daily basis, it would probably be like seven or eight of us in the office more or less. So boutique. I was responsible for everything business-related.

Charles:	You had the creative skills and you simultaneously had to land SNL as a client?
Emery:	Yeah. It was a pretty standard I think kind of boutique owner/operator model, where I had people that were helping me with

stuff, but I was both the lead creative and lead business, which I wouldn't recommend. As a matter of fact, I think a lot of people typically do have a partner that's like a business partner, and I never had that, and it leads to some awkwardness with trying to have this creative relationship that's like, well you don't want to be the guy that is trying to be creative with clients and then also hounding them when they're not paying you. And, obviously, I had a producer who did that, but he was my junior.

Charles: You also don't want to be in a situation where you're pitching bigger and bigger ideas and then also being the one to tell them how much it costs. In a dream scenario, it's a creative conversation, and then someone else is like, "That's $70,000."

Emery: Yes. But I mean, I did it all. The people that I employed were really just supportive. They weren't really leading much, and that allowed it to be very financially lucrative because I'm owner/operator. I kind of brought the clients in. I did the work. I'd hire freelancers for different things. Mostly the work I did was color grading. That was the actual kind of hands on, ass-in-the-seat, hands-on-the-keyboard work was color grading.

I had a pretty early Assimilate SCRATCH system. They were the first system that could play back R3D footage in real time. They did a partnership with Boxx, between the hardware–software combo, they were able to get R3D footage to play back in real time. That was before the RED ROCKET. You could have 4k R3D footage that would play back in 1080 in real time. So I bought it then.

I was working at various networks. I worked at Viacom. I worked in Nickelodeon and just kind of contracting around doing various things, motion graphics, editorial, kind of typical bounce around, do what needs to be done. I was kind of a jack-of-all-trades.

Then I had one of the very first RED cameras. So that was a real catalyst to starting my post-production company and being in a position where clients were coming to me. I didn't really have to look for clients because I had this camera that everybody wanted to shoot with and use.

Charles: So this was like '07?

Emery: Yeah. Yes. Timeline-wise. I had camera number 40. Serial number 40.

There were four cameras that were shipped to New York City in the first batch, and I had one of them. So there were four cameras in New York City for about 12 months, only four cameras in New York City for about 12 months, and I had one of them.

Emery: I was able to get camera number 40 because Mark (Pederson, from OFFHOLLYWOOD) was in super early because Mark was bffs with Ted Schilowitz when Ted went over to start RED with Jim (Jannard, founder of RED Digital Cinema). And so he was involved

in all these early conversations, so I'd overhear him on the phone talking to them, and I mean, I don't know if he was supposed to be talking at that time or not, but he'd always share, "Oh man. They're doing this stuff. It's crazy. Blah, blah, blah." And so I kind of had the inside track of what they were doing.

And I was also familiar with and friendly with Ted and a little bit with Graeme Natress, and so when Ted and Graeme joined and my inside sort of knowledge from Mark, I was kind of all in the RED camp from the beginning, and so at that first NAB where they offered the reservations, I wound up getting serial number 40. Probably would've got like number 10. I had a breakfast meeting that morning and I got there like an hour later than I wanted to.

But anyway, it was still in the first batch of shipments. And so having that camera, then all these big people were contacting me wanting to rent it, wanting to shoot with it. And so I was renting it out. Started making money renting the camera out. I lived in Bushwick on a sixth-floor walkup at the time. I was so broke back then.

I borrowed the money to pay for the camera. I was lugging like four or five cases of camera equipment up and down the stairs of this sixth-floor walkup and going out to show the camera to these various DPs and directors and producers that wanted to see it because I had one and it was this magical thing, like, "Oh man. Can we test with it? Can we shoot with it?" People were apprehensive to actually rent it out and shoot with it on a real job in the very beginning, but everybody wanted to see it. And so I was lugging it to different camera rental facilities and to different places.

Then I eventually started renting it out. And naturally being one of the only people in the world that had one, I could play around with it all day and I figured it all out and started just being there on set with it as a DIT.

The next pain point was, "What do I do with the footage? I don't know how to deal with this footage." And so I started offering dailies services to transcode dailies overnight. None of the facilities, none of the existing facilities, at least in New York City, nobody wanted to touch the footage from whoever it was, Technicolor, Company 3.

Charles: Company 3 required you to transcode it to DPX.

Emery: I built a huge business transcoding Company 3's RED stuff. Yeah. So they came to me for a long time to do that.

So I started transcoding overnight. I would be on set all day as a DIT and then literally overnight, I would go back home and I would set up all the files and transcode. And this was RedAlert for transcoding, the early versions of RedCine weren't out yet. It

was all in RedAlert the early transcoding. And that's how I sort of started building this business. The dailies turned into kind of more dailies and more dailies, and I wind up getting enough of that work where I didn't have to go out on set as much anymore. I didn't really particularly like being on set.

And then the dailies turned into people coming to me for the online conform prep. The Company 3's, they just would not accept R3D files. So they would come back and I would take their R3D files and do like a pre-conform. I would conform it, and render out with handles to DPX. And then slowly it was just like, "Hey" The client that was coming to me to do the conform, I was like, "You don't have to do this extra step. Why don't you just come over here. I'll color grade it for you." And started doing that.

And that's how the color grading started. And prior to doing that I actually had never done color grading and dailies. Prior to that, my background was primarily in visual effects. I was doing compositing. So that's how it just kind of naturally expanded from I was like the RED guy in New York City and doing the RED-specific work, but eventually I started getting just more the color grading jobs, and, eventually, people started coming to me with stuff that wasn't shot in RED, and that grew into more of a full-service post-production company with the three primary services: dailies, color grading, and finishing.

Charles: And Katabatic had the data calculator app, right?

Emery: So that was my first foray into software development. My co-founder here at Frame.io was an employee of mine at my post-production company. I hired him to do pipeline engineering and various kind of assistant tasks to do dailies and conforms.

I hired him right out of college. It was his first job. And he did this interesting program up at RIT called motion picture science, which was the School of Animation and the School of Engineering combined together to create engineers for the motion picture industry. So it was a little bit of coding exposure, but it was a lot of color science, color theory, image processing, stuff like that with some exposure to coding.

And then when he joined, that's who I worked with to build KataData. That was both of our first app. I designed it. He built it. First, we just had so much fun building the app. I had two dreams in life. One was to be a filmmaker, one was to make software. And being able to make an iPhone app was such an exciting thing. I was like, "Oh my god. We can do this. This is exciting. Let's do it. Let's figure it out."

So we did it, and it was a great app. People loved it. It was five stars on the app store. We sold it for five bucks. We made like

$50,000 off of it. Not a huge amount of money, but people were paying for it. It's a niche little app. We weren't expecting to sell millions of copies, but it was pretty widely considered the best data rate calculator on the market.

After that, we were like, "Okay. We can build stuff. What do we build next?" And we started thinking about all kinds of stuff. Some stuff that was related to post-production in filmmaking. Stuff that wasn't related to post-production in filmmaking. Starting building like a location-based photo sharing app. And then we're like, "Eh, you know what? That's like a lottery. You're either Instagram or you're nothing." We could spend all this time and energy trying to build this location-based photo sharing app, and maybe we would be billionaires or nothing. There's no in-between.

So we thought, "Let's not do that." So we decided to start building what became Frame.io, which was, "All right, we're using some tools that are kind of in this space. We have all these challenges with sharing files and getting feedback and all of that." I was familiar with Wiredrive, and we were using this other service called INTERDUBS, which is kind of like the poor man's version of Wiredrive. Both of which, despite the nice people behind those companies, I think are terrible products. And they were kind of expensive.

At that time, Wiredrive was really just a glorified FTP, and it just didn't feel right. I'm like, "I don't want to pay 300 bucks a month for that. It doesn't feel worth it."

I think at the time it was like you got like half a gig of space or something like that or even less, and it was just like that seems absurd. And they would charge you astronomical amounts for additional storage.

So we decided to start building something that we thought would be better than those, the solutions that existed, and that was how Frame.io was born. But I think any project that kind of starts as like an internal thing, I mean, we had a business that was functioning and making money. And my co-founder, who was employed as an assistant basically at that company was still doing post-production-related tasks, and it was kind of a side gig. For both of us, it was like our little side hustle. We worked on it during business hours.

As a boutique post-production company, there's times where you just have absolutely nothing to do. You don't have clients. There's a whole week, no clients. So we would just work on KataData all week, then after that we'd work on Frame.io.

Over time as we started building more, it started to kind of pick up more momentum and eventually we realized, "Hey. There's a big opportunity here, and if we want this to be something real, then

we got to put our full focus and effort into it, and that means I have to shut down my post-production company."

There's no way I could've done both. I didn't build it to be anything without me. I was the brand of the company. I did the color grading work. It just was never built to exist without me, so I shut it down. And it was still totally making tons of money. I mean, I built a great lifestyle business for myself. I was making a million bucks a year and kind of living the good life honestly. I'd been doing post production long enough where there weren't any real challenges. I had figured it all out. High-end workflows were pretty simple and easy at that point. And I decided it was time to let it go. We incorporated the business in 2014, and then I think we did our prelaunch some time in 2015. Something like that. Yeah.

Charles: And what was the gap between closing the last business and starting this one?

Emery: It was less clear. I didn't have the heart to really just hard shut it down and just say . . . put up on the website, "Sorry. We're closed." Basically, my tasks for Frame.io started increasing and increasing and increasing, and I was continuing to take jobs for Katabatic as long as I could, but then it was like I'm either going to get this Frame.io thing done or take this job. And I would tell old clients that I was booked because I kind of kept my options open as long as I possibly could. So I just kept saying, "I'm booked. I'm booked. I'm booked. I'm booked."

I had some colleagues that I would try to bring in or I would try to pawn off some work to some colleagues and take a cut, and I tried doing that. It was just too hard. I was stuck in the middle. I was still spending cycles communicating. Eventually, the longer I just told people I was booked, they just stopped. They just kind of trickled off over a period of months. The spigot sort of slowly turned off.

At that point, I was already pretty deep into Frame.io. So I kept the spigot open basically until Frame.io officially launched publicly in the market. There was still a little bit of my old client activity going on. And then when we launched publicly in the market, we were only launched for three months before we raised our Seed round of capital. We got a $2 million Seed round from Excel. So by then, it was just 100%, 150% on Frame.io.

What Frame.io solves, the work-in-progress review and sort of all the hassle and pain of that was always terrible. It was significantly worse back when we started working on it because when you're sending stuff for review, the services that existed back then, they didn't transcode the media that you uploaded. You would have to upload something in a hundred different formats. They're like "I need a high-res MP4, and I need flash."

I'd say realistically on any given job, there might be maybe like five to seven different upload requests. We were doing advertising, so if you were doing a 30-second and a 60-second spot. You have the 60, but then you have the 30 and the 15, and then you have maybe a different end card and a title.

So you wind up uploading like 70 assets. I mean, the way that it multiplied because you'd think, "Oh, I'm doing a 60-second spot." But the sort of versions and permutations and the different types of file formats that they needed, some with black in the front, some with not black in the front. All that stupid stuff.

There would be that one oddball format that you couldn't make on your Mac, and you had to figure out how to do it. The whole thing was just terrible. But it would really quickly escalate to being a lot of different formats that you had to upload.

And then when you go through kind of iterations or changes, I'd be there with clients, and we'd go through that whole process of creating that stuff, and then they're like, "Oh, we've got to change this one thing." You change that one thing, and then you've got to go through that whole iteration of uploading that stuff again.

It was all terrible. And then prior to that, it was DVDs and it was even worse. So it was always problematic. I mean, the entire time I'd been doing this work, it was always part of the process that kind of sucked.

Charles: But it was always painful and you had just gotten used to the pain, and it wasn't until you were sitting around with your co-founder, and you were like, "What are we going to solve next? We solved data rate calculation. We solved the question of how big a hard drive do I buy," which is a pain point. And then you started looking around at what are the other things that we could do?

Emery: I mean the data rate calculator, that was more of a fun side project. Sure, it's an issue. You have to know. But you can do the calculation and kind of look it up. This was a substantially larger problem. In the beginning, I think we thought this was still going to be a relatively niche product. Because you think of like a Wiredrive, relatively niche, right? But as we continued working on it, you spend more and more cycles thinking about it and you realize that anybody that makes video has these challenges. My little world was broadcast advertising. That happened to be Wiredrive's little world, which is why I was familiar with them. That was kind of the world they were successful in. But people are making video for a thousand different purposes and reasons.

And it doesn't matter what type of video you're creating, you actually have a pretty core set of collaboration challenges that are exactly the same. So whether you're doing broadcast advertising or feature

films or web video or wedding videos, or you're making video to teach a subject. If you're trying to teach cooking, and you make videos to teach cooking online, whatever you're doing, everyone goes through the process of needing to share files that they are working with, let somebody watch those files, and then probably communicate about them. I mean, some very kind of fundamental thing.

So we realized the market's pretty huge, and it's only getting bigger with the kind of proliferation of video online and the number of people that are creating video that weren't creating video five, seven, ten years ago. A lot of our clients, a lot of our customers, a lot of the new media companies and traditional media companies, they all have these huge video departments that they never had before. Companies that were traditionally just doing written media are of course now doing video.

So a lot of explosive growth and we realized a big opportunity. Shutting down my company that was earning a million dollars a year that was very profitable, that sounds pretty ballsy, which it was, but we had some signals that Frame.io was going to reach some baseline level of success. So before we launched, we had a prelaunch where we had a splash page. It was just like, "Hey. Here's what Frame.io is." And we got 15,000 people to sign up for that, and then we were on the front page of Hacker News. And being on the front page of Hacker News got us exposed to investors, other entrepreneurs, and so I got, shortly after being on the front page of Hacker News, I got an email from the CEO of a now publicly-traded company. Said, "Hey, I'm the CEO of X company. What you're doing looks really cool. Do you want to chat?" And that led to getting a $10 million acquisition offer prior to launching at all. We had not launched anything. It was just me and my co-founder. Just us. That was through a series of meetings and things like that.

So that gave us a lot of validation that, "All right, we can make something here." And then we also had a lot of interest from investors as well. So one of the first investors that reached out to me was from Andreessen Horowitz. My very first pitch ever for Frame. io was at Andreessen Horowitz to Steven Sinofsky, who was the former president of Windows at Microsoft. So we were dealing with some big time people. Andreessen and other really big investors and then this big public company that wanted to acquire us. Actually three now public companies . . . they weren't all public at the time, three now public companies actually made us acquisition offers, but one was particularly large.

So we're like, "All right. Let's do this. Let's make this happen." So I shut down the post company, focused on it full time, launched the product, raised our Seed round of capital, and then continued to

just kind of just see phenomenal growth, and we can get into sort of the rocket ship of growth that's happened since we launched Frame.io three years ago.

The other thing that I realized is that I would say I'm a post-production expert. I feel confident that I have an expert level of knowledge. I was a good colorist. I wasn't a great colorist. I was good. I did the work for broadcast, but I knew people that were better. And I don't feel like, when I look back at the work I did at my post-production company, I don't know that I was super well-suited for the job I was doing. I think I'm significantly better suited to build Frame.io than I was to build that post-production company. There are artists that are better.

So like most post-production companies, if you look at the average post-production company or, say, the average job out there, your average broadcast job, really anybody could do it, right? The bread-and-butter work out there, I would say that almost any professional can do. And then there's the stuff that's truly exceptionally artistic, and there's only a handful of people that actually really are the good ones, and the rest are just doing an adequate job.

You have to know your stuff. You have to be professional. You have to have some base level artistic capability. And I think I was in that category. I knew my shit. I worked hard. I never said no. Delivered on time. I would say I did some stuff that I thought was artistically pretty good, but I'm significantly better suited to do what I'm doing now.

Charles: Well, and it's great you had the right thing to prep you to do this to see the opportunity. This is an opportunity you only see when you've been living with the pain of having a post company, and then you see this opportunity. Which you then built on pretty quickly.

Emery: We were doing $30,000 in monthly recurring revenue in the first 90 days of launch, and that's what really led to raising the Seed round of capital.

We didn't offer any free choice. A lot of people launch, and it's just like all free and then they figure out plans later. We launched with paid plans from day one and got that early traction.

We tried to raise capital prior to launching, and we had all this interest, all these top-tier investors, they were all like, "Wow. Amazing product." Because the product was built. We could show it to them. "Wow. Amazing product. One of the most impressive products we've seen. Great demo. Great pitch. All of that. But come back to us when you can show that people will actually give you money."

And so that's what we had to do. And we showed them that people were willing to give us money, and then we were able to raise our Seed round.

We've now done three rounds. We've done a Seed, a Series A, and a Series B, so we've raised $32 million across three rounds.

Three years ago, it was starting from zero, just me and my co-founder, and now we have over half a million users. The company has grown from me and my co-founder now to 70 people.

Most of the 70 are here in the Manhattan office, and then we have like five that are distributed in other parts of the country or world. We have one person in Prague, one person in Ireland, a few people in LA, a few people in San Francisco. Engineering's all here. I work incredibly closely with the engineering team. I don't know that we ever even considered not working in the same building. We tried one remote engineer, and it didn't work out.

But we work closely with them. I think to build the type of product that we're building, you need that. You need to be here and part of one team and working together on the same mission and having all of that just shared knowledge that happens just all the time from proximity and side conversations and all of that.

There are very few examples of successful companies that use the model of an entrepreneur that had an idea and then outsourced somebody to build some prototype or version of it that was ultimately successful.

It's kind of like saying, "I have this great idea. I'm going to build a car company." But then try to go find someone that can build cars. You're like, "Wait a minute," but what you're saying is . . . you are saying that you are going to build a car. The reason for being is to build cars, not to say that you have an idea to build a car company and then hire somebody else to build cars. So if you want to be a technology company, you have to be the technology company. Your founding team should be responsible for building the thing that you're going to be putting out onto the market.

I think there's two important reasons for that. One is that the process of starting anything is so iterative, you're going to run out of money before you get something right. You can't pay somebody enough to iterate like you need to, so you have to be able to be scrappy. I mean, it depends on your situation and your founding story. Most people are starting something, and they have to do it on the side or leave their job or whatever.

And if you have to pay every single time you need to make a change, and I've seen this happen, I've had friends that hire a development company to do something, and literally every single time they want to think about the smallest change, it's dollars out the door. Versus me and my co-founder, we sit next to each other all day and just change it every day, 24/7, working on it, hustling, making it better, fixing it, changing it. Non-stop. No extra money involved.

And then the other reason that doesn't work is because you cannot pay somebody to care. You just cannot pay someone else to have passion. You can, but it takes an extraordinary amount of money. You can't pay someone a normal amount of money to care. You have to pay someone such an enormous amount of money that it's like, "Holy shit. I'm not going to let this slip by me. This is something that is going to change my life, so I'm going to hustle as hard as I can." But usually, you don't have that kind of money when you're doing this. So that's why I think your founding team has to be responsible for building the thing.

Charles: So your co-founder, technical CTO, knows some code. Have you ended up having to learn any code?

Emery: I've dabbled, but I wouldn't call myself an engineer. I was responsible for designing the product. I designed the first version of the product. I led the whole product vision. I did everything else that is not the code.

It was interesting because we would meet people, and different people, when we would tell them about what we were doing and what each of us was responsible for, and some people would think I'm worthless, and some people would think John's worthless. Depending on if we were meeting other engineers, they're like, "What does Emery do?" And they wouldn't understand. Or if we met kind of more entrepreneurial or business-focused people or whatever, they would think like, "Well, you don't need to give John any equity. What does he do?" Which is crazy, because I would respond, "He builds it." So it was interesting. I mean, it was absolutely a partnership. We would not be here if it weren't for our partnership.

Charles: Are you guys thinking you might eventually IPO?

Emery: Potentially. We're focused on trying to build a great big business, and I think there will be a lot of opportunities for success along the way, one of which may be an IPO. We never set out specifically with the goal of being acquired or having an IPO. I think our focus is on building a great product and a great business, and we'll assess kind of opportunities as they come our way.

Right now we're certainly going to be doing a lot more around supporting the whole ecosystem of creative assets that you have to work with during video creation.

Chapter 7

Taxes, Insurance, Lawyers, and Retirement

Deal Memos

A deal memo is an informal contract. For jobs under a certain budget, it doesn't make sense to pay for a contract through a lawyer, especially if it's with a regular client, so most do informal deal memos instead. This works for jobs that are a tenth of what you make in a year or less.

Deal memos tend to be written in a faux-legal language, mostly for clarity's sake and to avoid confusion: being forced to spell out things like "the client shall receive X in exchange for Y" gets everyone onto the same page about what the expectations are on the job. "Legalese," as the language of lawyers and contracts is called, is really about creating as much clarity as possible.

Important things to spell out in a deal memo:

- Payment. How much you are getting for the job, and how it is coming. Are you getting 70 up front and 30 on delivery? If so, spell that out. The going standard is 50 up front (though some markets are "zero deposit," meaning no money up front and the production company fronts the entire cost), but 70% up front is something you can ask for, and some clients will give, and that makes life much easier as a production company.
- What delivery means. Since generally at least part of the funds are paid on delivery, what constitutes delivery? A five-minute edit? A five-minute edit and one 30-second cut of the commercial? It's rare, but I have seen clients delay approving a delivery in order to avoid payment, then go on to use the work in another format while they still haven't paid. These items usually get called your "deliverables," and you want to have a clear list of what your deliverables are. Do you need to deliver a version with URL and without? You want to know that up front.
- Credits. Are you getting a "film by" credit? Directed by? Edited by? How is it going to go, will it be at the end or the tail, or is your name spelled or do you use a nickname?
- Will you deliver without final payment? Many artists do, but some are COD (cash on delivery), meaning if the client wants the goods, I have to have received my final payment.

- How much input will the client get? Do they get to see the work in various stages along the way and give feedback? If so, how often?
- How that feedback should go. A trickle of notes from eight different people that conflict with each other is a nightmare. I spell out "a single group of notes showing consensus from the client within 48 hours of the review being sent in for comments." This gives clear boundaries and keeps the project moving; I've had jobs stall because it took one of the eight people at the client two months to give notes. Give a time window, and make it clear that they need to get to consensus on their own. If two of the clients disagree with each other, you don't want to be in the middle of that fight. You'll end up being the bad guy for not being able to achieve the impossible task of making work that two people who disagree both like. If there is disagreement within the ranks of the client, you need to make sure they focus on figuring it out themselves.

There are times, of course, where the client only thinks they disagree; one person wants it "faster" and the other wants it "slower," but what they really mean is the music is too slow and the edit pace is too fast, and you can make changes that will address it. If you can, getting on a phone call or in-person meeting and asking a lot of questions will help unpack this conflict.

The deal memo process forces both sides to get very clear about what is being agreed upon; once you've done that, print it out, sign it, get the deposit, and start work.

It says in my deal memo that I don't start any work without the deposit.

Unfortunately, I often do. Most clients are big companies that take a minute to get rolling, and I love what I do, so I start scouting locations, and talking to crew, before the deposit comes.

I strongly recommend against this. But you probably aren't going to listen to me. This is one of those places where movie-making being fun really distorts things.

What I absolutely refuse to do before receiving the deposit is spending hard cash money or officially booking crew. I will soft hold people, but, without the deposit, putting people on firm hold, meaning they pass on other job offers, is unprofessional. A soft hold says "Hey, if you get a firm hold, let me know, but keep it penciled in," and that's OK when you are feeling strong on the job and the deposit hasn't come. Until the cash hits the bank account though, a firm hold can cost your crew other work. While waiting on the deposit, early prep work is the only thing you should be doing, if anything.

For certain small jobs, an emailed deal memo can work: you write up the terms of the job in an email and end with "response to this email with a 'yes' will constitute a deal memo between us for the start of work," then they respond "yes" and away you go. I'd say this works for jobs that are one hundreth of what you make in a year or less.

For jobs up to about one tenth of your yearly billings, a deal memo signed and emailed back and forth will do fine.

Anything more than one tenth of your year, then you should involve your lawyer: the money it costs will be more than balanced out by the money you save if something goes sour. Because the bigger the budget, the bigger the risk.

A sample deal memo from a small production job might look something like this:

> This is to serve as a deal memo between Filmmaker LLC and Client Corporation for the creation of five 10-second social media videos for the platform of Instagram.

1 Client agrees to pay $4,000 for the campaign, with a 75% deposit due before start work, and 25% due on final delivery.
2 Client gets no less than three days of full-time in-person editorial if they like.
3 Client gets up to four rounds of post-production revisions handled via a platform such as Frame.io or similar. Client has 48 hours to turn around unified notes after receiving notification of edit available.
4 Creative pitch for this project is attached and considered approved.
5 Final deliver will be in the format of 2160×2160 H.264 videos.
6 Filmmaker LLC will store all original media for up to six months for revisions, though revisions will be subject to a separate negotiation/contract.
7 For versions including credits, Filmmaker LLC will get a logo card and crew from Filmmaker LLC will be listed individually.

A simple deal memo of this type would work with a regular client. Laying out terms and, most importantly, expectations. A $40,000 job would have enough room in the budget, and enough risk, to make involving a lawyer worth it, but, for a $4,000 job, a deal memo should suffice.

If you have a bad feeling about the client, and are afraid they are going to disappear and not pay you, it's better, for a job so small, to pass on it than to try and involve lawyers. Lawyers will cost you more than you would have made on the job.

Deal memos only work with clients with whom you have some small measure of trust.

The exception to this is situations with residuals and liability. For instance, when working on a book, even if the advance is very low, you should use a lawyer with domain area expertise.

Insurance

If you have an office, or arrange for a shoot, and someone gets injured in that space or at that event, you are potentially liable.

You need to have insurance. Talk to a few different brokers and find out what coverage is required of you; most states have legal requirements.

The world is actually a very safe place. This is largely due to how predictable most people's lives are, sitting in offices working on computers all day. Driving the same routes over and over. The routine creates a sensation of safety.

Movies are demonstrably less safe. Movies aren't predictable. Sure, you drive all the time, but all of a sudden you are driving to a place you've never been before, at 4a.m. in the morning, looking for a location. There's more travel to other time zones. You end up in a crane rigging lights, or carrying heavy loads up the side of a hill, or in a helicopter. Non-professional drivers drive large trucks and cargo vans beyond their abilities.

This creates a greater likelihood for accidents.

It's not that people in movies are reckless: habit and routine create safety, and our movie world is almost purposely about breaking out of habit and routine. You need to be extra careful doing this kind of work. There is just more danger in film from lack of routine.

You need to worry about ventilation in your studio so you and your crew don't get hospitalized by inhaling paint fumes from the set or toxic fog from a video shoot.

This is all just part of the process of making movies for a living.

When you start buying equipment, you need to insure it against theft or damage. If you don't, one major theft could put you out of business.

Even if no one breaks in, sometimes your freelancers steal from you. Sad but true. They know how to use the tools, and decide that it should be theirs instead of yours, that "you can afford to replace it" and they can't. It sucks.

Cover yourself.

Partnership

"If partnership was a good idea god would have had a partner."

My mechanic, Janusz, is a font of wisdom. In addition to keeping my various rear-wheel-drive vehicles going for a great series of years now, he is also a source of wisdom about topics ranging from relationships, education, the dangers of creeping socialism, and business.

His little shop is a sole proprietorship; he owns it entirely himself. It's his. His wife has a small business, and it's hers. It makes for a healthy marriage he says.

Partnership isn't always a bad idea; it wouldn't be a legally acceptable business model if it was. But it is a business arrangement fraught with pitfalls, many of which are of particular danger to the artist who "doesn't really have a head for business," and most of which are easy to avoid if you know about them.

There are two keys to any good partnership:

1 A real shared vision for what the enterprise is all about and where it wants to go.
2 Complementary skillsets that balance for each other, and real clarity about those skills and the responsibility that comes with them.

The first of these is easier to sort out, but only slightly. This is why almost all businesses have a mission statement at one point, to guide those involved

in what they are doing and to provide a benchmark against which to measure success. If your goal is to "produce avant garde cinema that pushes people's buttons," you have a criterion to help you decide if you want to take the job doing a sizzle reel for an arms contractor's corporate retreat (probably not, but, who knows, maybe you need the money).

This is basically a prerequisite to starting a business with partners, and it's very common; it's in the mythology of business, in fact, the two folks having a conversation late at night, one looks at the other and says "We should do X!" and they write it down on the diner napkin. The business and the mission born at the same time.

Where this gets tricky is that businesses change; IBM started out building punch card machines. Currently they don't even have a hardware business and are entirely a consulting company helping governments and large businesses implement technology more effectively. Its vision for itself changed. This is a hard process for any company to go through, but the most successful pull it off.

Your partnership will likely be put under strain by miscommunications about the vision or the way that vision has to change. One partner will get really excited about doing the corporate video gigs while another wants to hang on to the original avant garde goal. It's a natural part of life. It's called a pivot. Businesses do it constantly, but it's very rare that all the original partners stay in sync while it happens.

The other key, which is less often discussed, is more likely to cause partnership problems: having actual complementary skillsets and real clarity about what they are.

In that same production company, if both partners are directors, they are going to be competing with each other for jobs, while simultaneously neither is going to be happy staying in the office running the books. If both partners have the same basic skillset, eventually one or both partners will think "Why am I splitting the profits with the other gal when I can do everything they can do? I should just keep it all to myself!"

And they should.

True partnership in business grows from having real knowledge of your own strengths and, more importantly, what the skillsets are that you don't possess, and finding complementary teammates who have those skills that are essential enough to be worth sharing your profits with. True partnerships go further together than they ever could alone, because they balance each other out.

But to form a real partnership you need to be able to honestly assess yourself, what your strengths are and what your weaknesses are, and then partner with someone who balances you.

The most obvious pairing is a numbers person and a creative person, but that's just one of the many ways people balance each other out. Another common one is the long-term strategic planner and the day-to-day tactician; it's rare you'll find someone great at both, and by pairing those two skills together you can build a business that both operates efficiently and keeps moving forward.

Whatever the pairing, it's important you know why you are engaging in a partnership, what you are getting out of it, and, vitally, you have to communicate what you actually expect the other partner or partners to contribute. If possible, in writing.

I've heard the line "Well, we're good partners because . . ." from countless friends and associates forming partnerships. The explanation that follows is only convincing a small portion of the time. It's usually self-justification for starting a business with your friend. Do the serious work of figuring out if there are real complementary skills there. And, most importantly, that both people see them.

Dissolution of a partnership can be costly in time and money, and the number one thing that pulls partnerships apart is differing expectations for what everyone is supposed to do. "I thought you were supposed to be doing that" is a very common phrase when problems arise if you haven't clearly delineated who is doing what. And the real danger with a partnership is when false assumptions are made about roles and responsibilities.

I like to call these "invisible contracts." One partner has in their mind "alright, I'm going to do the grunt work of doing all the assistant editing jobs myself to save us money, and in exchange the other partner will set up all the utilities." But if it's never spoken aloud, and the other person doesn't set up those utilities, it's a recipe for disaster.

When you form the business, write up job descriptions for all the partners; have everybody joining together in writing their own description and the descriptions they expect from all the other partners. Have a meeting and go over these together, and make sure you walk out of that meeting with finalized job descriptions for what everyone will be doing, that covers the vital areas of doing the work, marketing, sales, accounting, management, and recruiting. Have everybody sign their job descriptions.

Yes, the jobs in a startup are constantly changing and evolving as the company grows. But you want to know who is responsible for what, not just assume. Assumptions will lead to resentments, and that will tear the company apart.

Very few partnerships last forever. This isn't a marriage, this is business. You might partner up with someone to move you along to the next level, then, when the time comes, you go your separate ways.

Most partnerships fall apart not due to failure but due to success. Artists are used to suffering; it's part of the job. I've seen business partnerships that last through years of financial pain, sleepless nights at the office, broken relationships, only to fall apart when money or awards start to flow. Artists can stick out the suffering, but when profits come and you have to split them with someone else you really start to question what you are getting out of the arrangement.

The two main reasons people want to team up is to share the risk and to acquire expertise. Eventually you might have acquired all of each other's expertise, and you might not want to share risk anymore, since sharing the risk also means sharing the reward.

Do You Need a Partner?

The most important question to ask yourself is: "why do I feel the need for a partner?" Many want partners but don't need them: be sure it's actually a partnership that benefits you.

Most people seek partners because they are afraid to do the project alone. But remember, you won't be doing the project alone: you'll have vendors and clients and your audience. You'll have a team that you are working with. But they won't be equal partners, there will be a structure.

Ask yourself why a partner is the right choice for this business.

Is it really and truly to balance for deficiencies in your knowledge or skills?

Knowledge and skills can be gained. And tasks can be outsourced. Not good with the numbers? There are bookkeeping outfits for that. Not good with the sales? Get a sales rep.

There are wonderful, functional partnerships in business, but you need to go in with a clear understanding of what it is you are looking for in a partner.

Personal vs Business

"If you don't think marriage is business get a divorce," he said over tea, "and if you don't think business is personal, sell a company. It's all the same." I was selling my first company, and I had sought the advice of my friend Paul, who had gone through both business and romantic divorce.

This is an unfortunately true fact about human beings. When we marry, finances come into it. And when we start or run a company, feelings will inevitably get involved.

However, it is our job to attempt to remove the emotional sting from business transactions.

This is really hard for filmmakers. We are, as a group, prone to be very sensitive. It makes us good at what we do, it makes us notice things, it helps us create and improve. But it also means that it's easier for us to get those same feelings hurt.

Business isn't about those feelings. "I feel" generally has no place in a business context: business is about "I think."

Hence the common phrase "this isn't personal, it's just business."

Which means,

> I have to make the best decision possible for my own future and for the future of my employees and firm, and while I realize and accept that that might make your life more difficult or hurt your feelings, it's not intended to and you shouldn't take it as a reflection on you as a person, it's just the best option on the table for taking care of myself and my team.

This is very, very hard to do. This isn't hard in spite of ourselves, it's hard because of who we are and the things we do.

Dividing Up Ownership

If you are going to do a partnership, you will need to decide at some point how to divide up ownership of the business. There are two times when it's hard to divide up ownership: before you've made any money, and after you've made money.

If it's before you've made money, it all feels very abstract. Sure, it could be equal shares to all, that seems "fair," but what if someone had the idea and financed the startup funds, is that worth something to the ownership split? What about who does the sales? Who does the work? It all feels very abstract since you don't know who will actually do what; it's all guesswork at this point.

Of course, the other time it's hard to split up ownership is after money starts being made. It's a truth of human life that we tend to overestimate our own contribution and underestimate that of others. If we get in the office at noon and stay until midnight, but the other partners leave at 6p.m., we tend to focus on those last 6 hours we were there all alone, forgetting that the other partners were in 7a.m.–12. We weren't there, so it's hard to really value it, but we were there all alone from 6–12 so it seems vital.

Determining "who" booked a job is also very, very hard in movies. Let's say partner A meets someone at a party, finds out they are in a band, and introduces them to partner B who directs music videos. Partner B pitches them an idea, partner C does a budget and schedule and talks to management and locks the deal. Partner A, B, and C could all argue it's their "client" in a way.

There is no magic rule for how to divide up ownership. But there are some questions you can ask yourself when you are figuring it out. I was guided in this process by a wonderful blogger named James Altucher (https://jamesaltucher.com/blog/the-ultimate-cheat-sheet-to-starting-and-running-your-own-business); I wish I had found him sooner, he could have saved me tremendous headaches.

1 Who is putting up the money? There is always money. There's a term, "sweat equity," which refers to putting work into earning a share of the company; this is different. Who is risking their cold hard cash on the venture? Because filmmakers will always work for free, and odds are that the person putting up the cash is also going to be doing a ton of unpaid work too.
2 Who is managing the company?
3 Who is doing the grunt work of producing the product/art?
4 Who is bringing in revenue, recruiting clients, having the contacts, etc.
5 Who had the idea? This matters. Not as much as many think it matters, but it does matter, at least a little.

Once you know those five things, Altucher suggests you can roughly divide it up in shares to those areas. If, as time goes on, it turns out you were wrong (Tina was supposed to bring in the revenue, but man Linda is killing it at sales),

you can re-apportion that section of ownership, but if Tina put up the original money, that doesn't get touched until more money comes in.

If two people go into business, the common first instinct is to just split it up 50/50. This is fine if all of the above areas are indeed equal. If they aren't, eventually there will be resentment. Usually from the partner who put in all the money, or the partner who feels they are bringing in all the revenue, but the ownership doesn't reflect that.

One thing to be conscious of is that it's important to remember these are broad strokes. Generally keeping the split relatively rough (70/30 or 60/40) is much easier than trying to perfectly account for every single sale that comes in the door and who it belongs to. That kind of accounting generally requires more work than filmmakers have time to track.

Taxes

I am not a certified tax professional and I highly recommend that you consult with a tax professional who understands the specific needs of the industry you are in. However, there are a few things everyone should understand about how taxes work if you are going to work in the film industry.

W-2 vs 1099

These are IRS terms describing how you are being paid by your client: W-2 is the system that most of you and everyone with a normal job is familiar with; you receive a pay check on a regular schedule that already has income tax, payroll taxes, and social security taken out. It's very convenient for the employee.

There are many rules in this arena that define when this is required, but a good rule of thumb we use in film is employers are required to pay via W-2 in all situations where they are dictating an employee's schedule: if you are required to show up at a set location at 8:30a.m. every day, or even for one day, and work for a number of hours set by the employer, you have to be paid W-2.

Many employers like to avoid W-2 and pay their employees via 1099, which is how freelancers are often paid, since it saves them on payroll taxes. A 1099 employee is one where they can make their own schedule, for instance a plumber who tells you when they will appear at your workplace, or a work-from-home editor who does the work whenever they feel like it, often from wherever they like, and delivers it to you. This is a vast oversimplification of somewhat complicated IRS rules, but it is the rough math most in the film industry use.

With 1099, none of your taxes are taken out for you, but you are still responsible for them, and it is often required that you pay your income tax quarterly instead of waiting until the end of the year. The IRS encourages freelancers to pay a quarterly estimated tax. This means every three months paying an estimate based on how much you made the year before. There is a small penalty for not doing this, so some freelancers prefer to save this money instead in an

interest-earning account, since it is "their money," and the penalty for not pre-paying is small and generally offset by the ability to have your money on hand if you need it or earning interest if you don't.

It's one of the biggest mistakes I see young artists make, not properly saving a portion of their 1099 income in order to cover their tax bill at the end of the year. If you don't think you can properly save it, I would recommend pre-paying the IRS 30% of your 1099 income as it comes in, regardless of what your quarterly estimated tax is, since your quarterly tax estimate is based on your last year's income, and if you are having a good year that will leave you under-prepared for taxes. While many think that this is a waste, effectively loaning the government money without collecting interest on it, it can be a very effective way of ensuring you are prepared for your tax bill when it comes. Yes, the IRS doesn't pay interest to you on that money you "pre-pay," but, on the flip side, it's better than having to scramble or borrow your IRS payment when it's finally due the following April and paying interest if it is late.

If you truly don't save, you can work out payment terms with the IRS. Traditionally they appear to be more generous if you are up front with them; the more contact you initiate the better. Waiting on them to pester you doesn't seem to work. But avoid that by simply saving and planning for taxes through the year.

Having 1099 income has that annoyance of requiring planning, but it does come with some benefits. One of the perks of a life in the arts is that many items that are not normally a write-off for others can be written off as business expenses for us, provided you are incorporated. If you are an actor, for instance, haircuts and other appearance costs can be written off against your income from acting (but not your income from SAT tutoring). Filmmakers can write off movie tickets and their cable bill. This is an area where an accountant versed in your particular field will be priceless, especially as tax laws do change.

This is why it's incredibly helpful to have a separate business entity and a separate business bank account, since while individuals are taxed on income, businesses are taxed on profits. If you have very low profits in your business, because each job costs you a lot to do, your business tax bill will be low.

One area you need to watch out for is equipment depreciation: while you can write off equipment you purchase for work purposes (cameras, computers, monitors, etc.), you are often given the option to spread that write off over the time in which you will use the equipment. If you purchase a large computer workstation which you might use for 2–3 years, it generally makes sense to depreciate the cost of the workstation over the lifespan of its use, spreading out the write off over several years' taxes.

For the most part, your parents weren't paid 1099, but most of us go to our parents first for financial advice. If your parents weren't freelancers, you definitely need a good accountant or a good book on taxes to guide you along the way.

Don't forget; even if you pay someone "1099," you are still required to send them a form at the start of the year informing them of the total you paid them. If you want to write off your payment to someone on your taxes, you have to send out those notifications by the end of January. There are many services online, and your accountant or bookkeeper can also assist in sending out the proper forms in time.

For every single person you pay, you need to collect a W-9 form from them with their tax ID or social security number so you can process them as a business expense. You also need an invoice of everything you pay them, which will function as a receipt. This habit will become second nature to you with time, but when first starting out it takes a while to get used to. Don't be that person running around in January trying to find out where to send out tax forms. Collect this information as you hire freelancers and send out your forms the first business day in January, and your freelancers will appreciate you for it.

As a freelancer, get in the habit of sending along a W-9 form the first time you invoice a client.

Business Entities

LLC, S-Corp, C-Corp

When it is time to incorporate your business, you'll choose between LLC, S-Corp, and C-Corp.

How do you know it's time to incorporate? Generally the answer is "as soon as possible." Even if you are a "sole proprietor," which many freelancers are, there can be benefits to incorporating. Your personal accountant will have the final answer, but when you start to have significant freelance 1099 income, you should make yourself a business officially.

If you are ever going to seek investors, trade in public markets, be a multi-billion-dollar company, go for a C-Corp in Delaware. Work this out with your lawyer.

Most of the time, if you are just starting a small film business, you should go LLC, and only pivot to S-Corp once your billings are high enough to justify the increased fees. That's usually around $600k–$1million a year, depending on your state, unless indicated otherwise by your accountant.

An S-Corp comes with increased requirements for paperwork, regular meeting minutes, etc. This won't be worth the hassle when you are small. Some individual accountants prefer S-Corp since it allows you to pay less into social security. I have worked with accountants that kept a business LLC that billed $650,000 one year, and I have worked with an accountant that took me personally S-Corp in a year where I billed less than a quarter of that. Your accountant will have their process, but the important thing is to get started on incorporating early.

Most states also require at least one person to be on payroll for S-Corp status. Since as either a LLC or a S-Corp will be paying money to the owner/partner of the business (you), this isn't a deal breaker, but can lead to slightly more paperwork.

The purpose of these business entities is to make bookkeeping easier by keeping your business and personal accounts separate, and to provide you with some measure of protection. Bookkeeping gets easier since the company can get a bank account, and the "business's" finances don't get co-mingled with your own. It's easier to have clarity about whether or not the business is actually making money, especially if you have other sources of income (a day job, for instance, or multiple companies) that pay into your personal account. You need to be able to evaluate the business's health independently, and that requires separate books and banking.

The protection is provided in that the business can enter into contracts with clients and vendors and take out loans. When the business is small, you'll be expected to sign the loans personally, so there isn't much protection. But as the business grows and develops its own creditworthiness, your personal guarantee won't be required, and the risk will be assumed by the company.

This protection is somewhat limited (hence, "limited liability corporation"). It limits your liability, but it doesn't eliminate it. If your company fails to pay an employee, and the company goes out of business, as an owner of the company you are potentially personally liable for the debt of the company and some creditors might go after you personally.

The upside is that you make money if the company makes money. The downside is you are potentially liable for debts and risks that the company takes on.

Lawyers

For some reason filmmakers at the start of their career seem to want to avoid lawyers at all costs. I fell into the trap myself.

Primarily, I thought it would be much too expensive to work with a lawyer, that they wouldn't necessarily take me and my movie business seriously, and that, well, it was for "real" business.

I am not sure what I thought real business was (perhaps something evil, like turning baby seal oil into bombs), but production companies and post houses definitely count, and it's ended up costing me more money than it saved to have avoided lawyers as long as I did.

The first thing to understand is that different lawyers have different specialties, and getting your cousin who is a specialist in maritime law to give you free advice on your entertainment questions is like asking your cousin, the high school sports videographer, to shoot your upcoming food commercial. There will be some general shared knowledge, and you might be lucky enough to find someone who knows what you need, but you really want to find a specialist in the specific area you are dealing with, because they will have practical experience in this area of the world that will help you avoid costly and complicated mistakes.

Most of what we are doing has been done before, in some way, shape, or form, and lawyers dig deep into their area of expertise in order to have a mastery of the transactions that have come before and how others dealt with the situation. It is a wildly useful set of knowledge, which is why they can bill so highly for it.

There are a few ways lawyers can be billed; some work on a percentage basis, while many are paid hourly. The percentage basis would be for a lawyer you would retain for all of your dealings and they would take a cut; this is very common in entertainment, where an entertainment lawyer would take 5% of all your deals in exchange for handling your contracts.

The percentage deal works out all around for a regularly working entertainment professional; the lawyer is incentivized to get you the best deal possible (they make more as a percentage of your fee), while also maintaining your relationships with your clients (so that you can book repeat work and they can keep getting their fee), and you don't necessarily need to worry about precisely how many hours they spend on a deal, since you aren't being billed hourly. You can pester them with questions and calls without worry, and if things go well a relationship that can last years and that is beneficial to all can develop.

Hourly lawyers are more often contracted for specific deals. When I sold a stake in a company, I've retained hourly lawyers, since it's not like I'm selling multiple companies a year; it's more likely a one-off transaction where it makes more sense to pay by the hour. My personal estimate is that I will end up spending 5–10% of the deal on legal fees, since the larger the deal, the more protracted the negotiation and due diligence tends to be, but, even with that estimate in mind, you'll still end up paying hourly.

Don't be afraid to shop around when getting a lawyer. When in need of good representation, ask everyone you know for their recommendations, and try and set up a call with all of them; most lawyers will take the time to at least do a call with potential clients, where you can talk about your upcoming needs and feel out if this person would be a good fit.

Do they listen well? Do they seem to understand the situation you are in and are able to offer insight into it? Do you feel comfortable talking to them?

This is a person who you will potentially be paying thousands or tens of thousands of dollars to over the course of your career; if you are successful enough, maybe even hundreds of thousands. But sure they are someone you feel like you can trust to look out for your best interest in exchange for that fee.

Retirement

Most artists work pretty much until they die.

However, oftentimes your earning potential slacks off as you reach the end; in these scenarios, it's helpful to have retirement income.

If you are paid 1099, it is likely that social security is not being paid into. Thus it's up to you to provide some sort of retirement savings for yourself.

Since you likely work freelance, an employer retirement plan is not available. However, you can still set up any of the variety of retirement plans that are designed for freelancers. While your country might have different options, in the US this would include something like an IRA, or a SEP, two retirement options that are popular with freelance and contract employees. I can't advise you on which one to choose, but I can say that you need to set one up.

You should do this right away.

Seriously.

It's incredibly tempting to think "oh, I'm going to be earning so much more later in my career, I'll worry about retirement then." And, for some of you, that is indeed the case; you will have meteoric rises to success and make so much money you'll pay someone else to deal with it.

However, for most of us in movies, that just isn't the case.

The income comes and goes.

Save something for retirement right now.

The stories of filmmakers, wildly successful in their 30s, or 40s, or even 50s, who lose it all and end up penniless in their old age, are legion.

A SEP is a 401k-style device that is used for the self-employed to save for retirement. Like a 401k (and for non-profit business the 403b), it depends on the performance of the market. As the stock market has done well over the last 50 years, it is a reasonably good place to save for retirement. However, you are still at the mercy of the performance of the market to provide for your retirement.

There is one option that is the gold standard for filmmakers that you should attempt to join if you are ever offered it, and that is the "defined benefit pension." These are rare and getting more rare by the day, but they do still exist in several of the filmmaking unions and you should be aware of them, especially since they are often not heavily pushed by providers.

A defined benefit pension pays you a certain percentage of your salary in retirement. Markets go up, markets go down, it doesn't matter, you still get your pension. They generally require a certain number of years to "vest," but, once you've vested, you get the pension. The more years you put in, the higher the percentage of your salary. With some pensions you could potentially make 100% of your salary in retirement, which is often when people choose to finally retire. Some even include healthcare in retirement as a supplement to Medicare.

Defined benefit pensions are very expensive to maintain and something unions have to fight hard for, but they are the best way to ensure you continue to live through retirement if you never "struck it rich" but simply lived a good solid life. If there is the potential of one, it is well worth pursuing it.

Chapter 8

Bandwidth and Hiring

Hiring

You will end up hiring people. Maybe freelancers. Maybe vendors. Maybe full-time employees.

Who you hire for these positions will end up dictating a tremendous amount of the quality of the work you are able to deliver.

As important as your vision for your business is, even more important is the team you build to execute that vision. In film, with the wide variety of projects, you'll end up hiring both "regular" or "fulltime" support, and also a new crew of freelancers for individual projects.

Hiring is a tricky business.

Even before you are ready to hire full-time help, you are going to be hiring freelancers for specific projects.

You will also be hiring specialists to help you with various aspects of the business – lawyers, accountants, perhaps a graphic designer for your logo.

As you grow, you will eventually end up hiring full-time help. Maybe you don't own your own business, but you are the lead editor on a project and are hiring the assistants. We all end up hiring.

Hiring your friends is tricky, since it makes it awkward to fire them. Even if it's for a freelance gig only lasting a few days or weeks, the feedback loop where you direct them towards what you need is often distorted by friendship.

Find good people, train them, and share everything you've learned with them. Help them grow and improve.

There is not a finite amount of knowledge in the world. You don't need to hoard it.

Every business can only grow as large as the ability of its leadership to manage it. The better your employees are trained, the less management they need, and the more work you can do.

Somebody asked Fellini, "why don't you start a film school in Italy to train the next generation of filmmakers?" To which he responded "Are you kidding, we should be stabbing them in our cradles, they are going to take all of our jobs!"

This attitude comes from a closed-system world, an attitude of scarcity, where there is a limited resource to be coveted. Fellini lived through World War II and survived as a street cartoonist, so it makes sense that he feels an intense sense of limited resources. Luckily the same doesn't apply to us now. Fellini's life experience, where he lived through World War II and the Depression and had to struggle to survive, drove his worldview of limitation and intense competition. But it's not the only attitude we can take.

I knew a director of photography who was constantly giving all his "tricks" away. The special way he would tweak a light, the homemade rigs he used to create certain looks, he was always showing his assistants, or making online tutorials, showing it off. He didn't want to be hired because of his "tricks." He wanted to be hired because of his work, his talent, his skills; those immaterial things you can't give away.

A lot of people hoard all their tricks out of fear that they wouldn't work at all without them. You can tell this, sometimes, when you ask a professional how they did a certain thing and they get clammy or nebulous about the answer, and they dance around the issue. They are afraid if they share that information that you'll steal their jobs.

Take the other path. Have an attitude of abundance, and help your employees and collaborators grow as much as you can.

You want to hire "the best," of course, but "the best person at this job of all time" might not be "the best person for this job right now."

Be wary of people with incredibly strong credentials (senior artists) willing to work for way beneath the going rate. Sometimes you are lucky enough to find someone who really resonates with your vision and wants to help. More often you find yourself working with a professional who somehow burned enough of their high-level connections that they are now working beneath their normal pay rate reluctantly. This generally leads to a difficult working relationship; they are accustomed to a pay scale and set of corporate perks (overtime, coffee, etc.) that you are probably not able to offer in the beginning, and their expectations not getting met leads to a grumpy employee and bad work.

If they've burned their previous connections and can't get work there, you want to find out why before bringing them on.

This is especially important in film since the world has changed so dramatically over the last 30 years. I know a VFX artist who went straight from high school into work in the early 1990s and was making $2k/day in VFX before he turned 18. It's not impossible to find that kind of money today, but it is getting harder and harder to find, and many younger, scrappier companies prefer to pay more in the $500/day range. When he goes to work for smaller companies, there is often a heavy negotiation period to find a way to make sure that he gets paid something he feels comfortable with and they get the benefits of his 20 years of work experience. It doesn't always go smoothly.

On the other end of the spectrum are the young and hungry junior artists; the arts are always full of ambitious young people, often still under their parents'

financial support, willing to work for cheap or for free just to break into the world they desperately want to be a part of. They feed into the notorious, and evil, "20/20/20" philosophy of "find 20 year olds, work them 20 hours a day, and pay them $20K a year."

First off, know that in America free work is illegal. Internships are only allowed as part of specifically designated school programs that provide direct training to the intern beyond their making copies and getting coffee. Volunteer work is only allowed for non-profit organizations. If you allow someone to work for you on a profit-making venture (whatever you are doing that isn't specifically under the umbrella of a non-profit 501c3) without paying at least minimum wage, you are breaking the law.

In addition, if you are considering being an intern for someone else, know that the value decreases over time. Generally a month or two is enough to prove yourself invaluable. If they are able to make a place for you, they should be able to do that within a few months, no more than six ideally but generally within three. If they want to keep extending your internship but can't find you income, they are taking advantage of you.

Your goal with any internship is to make yourself so useful that they can't help but want to hire you. This is tricky since at the start they might not give you much to do, and, when they do start to give you tasks, you need to constantly focus on under-promising and over-delivering.

The low wage employee also requires more training in addition to more feedback and management. They might have done some amazing work in school, but have never worked under a real professional deadline before. The ability to create amazing work when the only demand is their own vision often leads to creating work that is tailored to their own skills. When you hire them to execute on your, or your client's, vision you might quickly discover that they aren't as flexible as you need them to be. Be prepared to spend more of your time than you hoped showing them how to do what you need done.

The senior artist will be full of experience, but also opinions and habits from how it was done before, at other facilities, on other projects. The junior artist comes without that skill base, but also without those prejudices.

If you find a great junior artist and train them well, be prepared for them to be poached by larger companies who can pay better and provide more stability.

Take this as the compliment that it is, both to their talents and your skills in recruiting and training them.

Senior artists can be great collaborators that help you grow and end up teaching you techniques and styles that you wouldn't have explored otherwise, provided you have the self-confidence to collaborate with partners who might have more experience than you do.

Junior artists can be great executors of your vision but seldom help you expand and grow your skill set.

There is no hard and fast rule: a good mix of seniors and juniors can build a great team.

As your budgets go up, your collaborators' rates should go up as well. This will allow you to hire senior talent at their standard rate and to work with people who will genuinely challenge you to grow.

Never forget that when you take a client assignment you are agreeing to deliver a certain product, and the team you build needs to be capable of that delivery.

Eventually, you will have to fire someone. Do it face to face, and allow time for there to be a conversation. If they ask why, it's generally best to answer honestly. You aren't doing them a service to sugarcoat the truth of why they aren't working out anymore, unless you honestly think they are unstable enough to not handle the truth.

Loren Michaels of *Saturday Night Live* fame has a 4a.m. hiring rule. "Never hire anyone you wouldn't want to see at the office at 4 in the morning." It's not the goal that you are working crazy late nights all the time, but it will happen from time to time that the hours will get long, the deadlines will get stressful. Try to hire people that you wouldn't mind spending ten minutes talking to at 4 in the morning while waiting on files to render or a light to get moved.

Film sets are full of crazy people. But there is crazy-exciting and crazy-uncomfortable. Avoid crazy-uncomfortable.

Human beings value things based on what they pay for them. Whenever I do free work, I get treated terribly by the client. It becomes impossible to enforce deadlines or structure since they didn't pay anything so there is never a fear of getting charged an "overage." Try not to do the same if you can avoid it. If you are in a situation where you are asking someone to work for less than they normally might, still treat them exactly as you would on a full paying job. And avoid working for less than what you need in all but the rarest of circumstances.

Leveling Up

We are all trying to get somewhere with our work. A bigger audience. A bigger client. A larger budget, better actors, a bigger theater. Ambition burns inside us.

But, as we discussed in the cashflow chapter, margins in the content creation business tend to hover in the 5–15% range; there are exceptions, of course, but that's where a lot of us seem to operate.

Of course, most film and video projects leave many decisions that affect the budget up to the artist. What quality materials to use, how much to pay freelancers, what props to rent, countless decisions are made by the creative team that ultimately need to fit within the budget.

If you have a $100k budget from your client, the difference between 5% and 15% is $10k; that's a massive chunk of change that can dramatically affect the quality of your outcome, its effect on its audience and thus the happiness of your client.

First off, it's your responsibility to spend as little as possible while still delivering the quality of project you agreed to take on, and that you can feel proud about and share with the world. If you aren't going to be able to create work you can be proud of, pass on the job; if we were in it for the money we'd all be lawyers for the oil industry. We're not just in it for the money, we want to do great things, and if you don't believe you can do something good for the budget available, let it go.

But once that's been decided on, a helpful model that many people use is to divide jobs up into "reaping" jobs (or "payday" or "cashflow" jobs) and "sowing" or "ambition" jobs. You'll always want to do a good mix of both. My goal is something like 80/20.

Fundamentally your work is your greatest marketing tool. The primary thing that will get you hired over and over again will be delivering interesting, ambitious, well-crafted work for your clients; they'll tell others about it, strangers will see it and seek you out, word will spread. Mostly, it's "ambition" jobs that lead to this kind of word of mouth, where you sow the seeds that go on to lead to better work coming back around to you.

On those ambition jobs, it's OK to let the margin creep down to less than 5%. I've gone out of pocket on ambition jobs, putting my own money in, because I wanted to make them better than the budget would allow. From a business perspective, if you have the money, it's alright to do this on occasion; it's a marketing expense.

But it creates a dangerous precedent with your client. Their expectations for the next job will be set by the last job. If you have a $10k job and deliver a $20k product because you pull favors and put in your own money, then on the next job with that same client they are going to expect $20k's worth of value for their $10k spend.

It's very difficult to turn an ambition client into a payday client. You almost always lose them because they get used to getting more than they can afford.

The most sustainable model I've seen is to treat certain clients as permanently ambition clients, where you always over-deliver, always make no money, always knock it out of the park, and use the work you do with them to develop payday clients where you make a larger margin and are able to keep your bills paid. These clients usually don't know how little your ambition client is spending to get their amazing work, and are happy with getting good work for good pay.

Never fall into the trap of thinking "I'll do nothing but ambition work now, and later it'll pay off and I'll do nothing but payday work." This is a trap that captures many filmmakers, but it's not sustainable. At every stage in your career you need to be making enough money to pay your bills or you won't be able to survive; you'll go under, burn yourself out, burn out the support of your networks, and many people leave the film industry for this reason.

Equally dangerous is the idea that at some future point it will become all payday work. Then you stop growing, stop expanding, stop staying current.

If you pass on all the jobs that don't have quite enough money, your work starts to get stale and stagnant. Soon, your portfolio is out of date, and you stop being able to book payday jobs. You're finished.

Up and down the commercial industry, directors continue to do "specs" every year, even directors at the top of the field. Why? Because the commercials that actually get made by the major brands normally have less interesting creative. If your reel is made up entirely of "real" spots, it's going to be impressive, but flat. If you want to do the really interesting work, you need to keep developing relationships at agencies, finding out the spots they almost shot then the brand killed at the last minute, and self-financing those to keep your work current.

A good breakdown is 80/20, to remind ourselves that we have to keep going, keep stretching, at all times: 80% well-paying jobs, 20% ambition jobs.

One of the biggest mistakes people make is falling into an "all ambition" period. This is what film school is for, but you can't survive by doing that in reality. If you have five projects, none of which are paying you any money now or soon, you need to rebalance, cut down on your ambition projects and pick up something for cashflow.

The same that applies to clients also applies to your collaborators. It's OK to sometimes ask your collaborators to cut their rates, come out for favors, to stretch. I've called freelancers with "this is an ambition job for me, can you come in a little less?" But the flipside of that is that on the payday jobs, you should bring those same crew out and give them their payday too. Because most of the time that favor job that helps you book more work isn't helping them book bigger jobs, it's only helping you. A DP can level up on an ambition job, it can generate amazing things for their reel, but it seldom does much for the gaffer.

Always negotiate before the work is performed. If you bring a freelancer out without negotiating first, the assumption is that they will be paid their full rate.

CEOs

At the start of your small business, everyone does everything. People manage, people do sales, people create content, people meet together to go over the books, things are small and exciting and the future is bright. As the company grows and becomes more real, eventually you need to start hiring more traditional people to staff it to keep things going. One temptation many filmmakers fall into is to bring in someone to "run the operations while I get to focus on the creative." Often, a CEO.

Never, ever hire a CEO unless you are being forced into it by a major financing round that in and of itself is going to make you incredibly wealthy, to the point where you could leave the company forever and not look back.

The dream for filmmakers who want to hire a CEO after they get their company going is that the CEO will manage all the pesky business stuff and keep the company thriving while the filmmaker gets to direct full time. That's often

the point of the business – to generate steady cashflow passively for them so that they can direct back to back.

Specialization is a fine instinct, and if you are indeed a creative person you will want to spend most of your time on that creative work and leave certain tasks to those better qualified. No one gets to be creative full time without worrying some about the business, but you can and should outsource much of the management when you can.

Hire a business manager. They are affordable, can manage the operations for you, and someday maybe will get a "chief operating officer" title if they want a c-level credential on their resume. Many business managers manage a few companies and won't even cost you a full-time salary.

This is the right power relationship; you founded the company, had the vision and the passion and the connections, and got it here. You want a business manager who works for you, delivers on your needs, and supports your vision.

If you hire a CEO, they are going to want to put their stamp on the company. Most of the time this means getting rid of some or most of the founders. Situations where the founders survive are the exception, not the rule.

If you do hire a CEO, give them skin in the game and an ownership stake to incentivise their work, but be sure it's structured so that they earn it over time.

Make sure that skin in the game doesn't affect the structure of the company such that you can't fire them if you need to.

Be sure there are clearly delineated targets and expectations for what they deliver.

Hiring a CEO doesn't let you stop worrying about business. Nobody gets to stop worrying about business.

Since that's the case, why even hire a CEO?

You had this vision, and you have the passion, and, without having met you, I know you are capable of doing this.

Interview: Light Iron Founder Michael Cioni

Michael Cioni and Light Iron have been one of the driving forces in digital workflow for the last 20 years. He currently leads the innovation team behind the Panavision DXL line of cameras, which combine RED camera body systems with Panavision Optics and Light Iron color science.

Charles Haine:	When did you realize first that you wanted to be an entrepreneur or that you wanted to work in entertainment?
Michael Cioni:	I would say I was always an entrepreneur, because part of it is how you see the world. I remember when I was a little kid, I started a newspaper in the neighborhood. I sort of led our little gang. We started competitions for video games, and stuff like that. All of that is entrepreneurial. You're taking a hobby, or something that's fun, and you're organizing it.

Adam Savage says, "The difference between screwing around and science, is writing it down." I kind of like that. If you're screwing around, but then you organize it, it's not screwing around anymore. It's real, and ever since I was a little kid that became a process. The other ingredient to being an entrepreneur is partially being a renegade.

I remember, I played in orchestras in high school. I loved the music we played, but I was like I don't want to play somebody else's music. For one year, I was like, "I don't want to play music that these other people who are dead wrote."

So I wrote a quartet, and we played it. Going rogue allowed it to be more satisfying. It forced me to be challenged, and forced me to try something out of the box.

Entertainment came later. When I went to college, I originally wanted to be in journalism, and then I did that for about five minutes, and I was like, "No way."

So I started getting interested in post production and I met renegades there. And we started a TV show, and we were the black sheep of the newscast. That became a club, almost a gang of kids, trying something totally that was out of the box. But then, of course, Steve Jobs was sort of back at Apple, and he became the apex figure of challenging the status quo. When I was in film school, you were not allowed to shoot digitally. You were not allowed to edit on Final Cut Pro. Of course, I said that's what we're going to do. We're going to shoot digitally and edit on Final Cut Pro. That became the secret to how we made some major success, because we were challenging the status quo.

I actually became one of the youngest Emmy winners of all time. Because we started making product that competed with professionals, that we submitted our work as students into the regional Emmys, and we were beating actual professionals in the region. I had four Emmys at 21 years old.

After being able to win those Emmys, one of the coolest things is we also won the Student Emmy. When you win that, with that renegade show we made, they brought us out to LA as part of the award. Kodak gave an award, where they sent us to the Cannes Film Festival. So I got exposure to people through the Cannes Film Festival. I got exposure to the movie business through them. I got exposure to Hollywood through the Student Emmys, because they brought us out here. I got comfortable with the city. I learned the city layout. Los Angeles is a big scary town when you're 20, but the fact that the Student Emmys helped, kind of gave us confidence.

So I moved out here right after I quit school. I didn't even graduate. I just kind of gave up, then started digital cinema. I got

really excited about digital cinema. I met a director, Christopher Coppola. He was starting to push digital cameras. I'm like, "That's what I do." I was Mr. Final Cut, Mr. Digital, Mr. HD.

My friends from college, most of us didn't graduate, came out here, and we started working on these early, early, digital cinema films. We started building technology around them. We literally did it in a garage. I've got photos of me working in a garage. We're building Macintosh computers, which of course are totally out of the box for professionals. In 2002, there weren't Macs in professional movies. Steve Jobs was trying to build up the professional use of Apple, we totally bought it hook, line, and sinker, and started not only implementing it, but inventing it and stretching our legs, and ended up starting an incredible relationship with Apple, which I still have.

We had literally an air conditioner in a garage, and no bathroom, and we built a room to edit and do graphics. We did everything in HD, uncompressed HD in 2002, using Macs.

Charles: Uncompressed? You had to have some sort of hard drive system to play that right, because the drives weren't fast enough.

Michael: We had to build RAIDs, we used RAIDs by a company that doesn't exist anymore called Rorick Data. Rorick Data made the RAIDs, but the RAIDs could only hold about 20 minutes of photographic time. We could only do it in sections. But that's what we did. We made Final Cut do this. No one in the world was doing this at the time. At that time it was all AJA, Blackmagic didn't exist yet. AJA made what they called the Kona card, the Kona 1. They had the Kona HD, and a Kona SD. The Kona HD was $16,000. We had like number six, I believe. The drivers for that product were handwritten on a CDR. We didn't even have internet in the garage, when we started that little place.

After successfully making an HD movie, uncompressed in Final Cut, we then said, "Well, what if Christopher doesn't make another movie. What are we going to do? We have all this knowledge and experience. We could offer this to other people." So we convinced Christopher and his investors to let us open up Plaster City Digital Post. Plaster City Digital Post was our entrepreneurial startup of post production for digital independent films, because, of course, studio films generally had no interest in digital. It was taboo, it was uninteresting, it was almost sacrilegious in some ways. But indies always are looking for alternatives to improve their status. So digital cinema was born through mainly independent filmmakers, and some avant garde leaders like George Lucas, and David Fincher, and Robert Rodriguez, and Michael Mann. But most of the incumbent status quo types thought "digital is for babies, and

I'm shooting film". But, of course, I was like, "NO way. This is improving at an exponential rate."

So we started Plaster City Digital Post, and for seven years we grew this thing from a garage to this company that was the premiere digital post house in town.

Charles: Were you attracted to post because you enjoyed the technical problem, or was it because you recognized that it was pain point for others that you could solve?

Michael: It is the puzzle. It's the pursuit of solving problems. I didn't choose post because I liked post. I chose post mainly because nobody else seemed to be thinking out of the box. It had the most opportunities. It was just sitting there. People didn't like digital because they didn't like how the cameras looked, and they didn't like how the post actually worked. I actually used the cameras, which were going to become superior very soon, and the post was already superior. We had the government helping us, because the government at that time was pushing HD digital transmission. So it's like everybody's going to have HD TVs, and people were saying at the time, "No one will see HD at home." It's like, "you're crazy." I'm like, "This is the opportunity." By getting good at it, we essentially cut in line.

I was able to work, and make money, and take that money away from the existing establishment of post production, simply because I embraced digital, instead of making the customer feel like they were second class citizens. We made the digital on a pedestal, where at the other companies, digital wasn't getting respect. "Those guys are amateurs. They're losers. They're just Indies." Whereas I like those. I like losers. I like misfits. I like Indies. We get along, we see eye to eye.

The answers were there. The manufacturers had a vested interest in building it and we just needed an infrastructure to productize and justify and validate. We validated with our business. We started doing TV shows and movies, and we became the digital guys. Then when RED announced their product, everyone said, "RED will never happen, they'll never make it. Those guys don't know what they are doing. No one will care." I said, "All you people are crazy." File-based 4K, remember, this was a tape world at the time. Everybody was on tape, and RED said, "No, we're gonna do this with compact flash cards. And we're gonna do it for $18,000." I said, "That's exactly what this industry needs. It needs compressed, raw, in 4K." We did it, and we became the only company that supported RED on the west coast. A few other companies in the world that supported RED, all were very successful. They are still pretty successful.

Of course, looking back it's easy to say, "Oh, yeah, RED cameras, everybody used them." Yeah, but on the day, it was taboo

and rejected. I started doing 4K in 2006. That's ancient history for most people who are just getting to it, ABC, NBC, CBS, they still haven't done 4K today. I was doing it 12 years ago. Unfortunately we were not owners, and this is where the entrepreneurial story is really important. You cannot get everything right on the first try. Entrepreneurs should not be afraid to fail. When you're going to fail, just make sure you fail up. I don't mind failing up, because you can't possibly see the horizon lines from all 360 degrees when you're building organically.

My biggest mistake, arguably, was that I was not an owner of Plaster City. By the time the company got a ton of momentum, and became somewhat famous, and internationally known, and we had a lot of fans, we didn't own it. We tried to negotiate a corporate buy-out with our owner, but our owner was just a non-technical investor. Since we hadn't had that paperwork done, we were out of luck. When I was 21, or 22, I was just happy to get a paycheck, right. The last thing I was thinking about was ownership in anything.

Money should never be the driver of your business plan. I ask people this all the time, I kind of cheat, because I sort of bait them, sort of trick them, I say, "What is the point? You've decided you want to be professionals in the motion picture industry. Why do we work in the motion picture industry?" There's always someone who says, "I'm in this to make money." Because I said, "Why did you pick this job? To make money?" I said, "No, that's not why you picked this job, because I don't know you. I hope that's not why you picked this job. Because money is a reward. Money is a result. Entrepreneurs and creators do not do things for the reward."

So, I helped them try to realize that money is a result of their efforts. It's not the objective, because if maybe money is your objective as a creator or an entrepreneur, you're not necessarily going to do very well. Because it will cost you far more money to succeed than it may ever yield.

But real entrepreneurs aren't after the money as the motive, the objective; it's the result of some success. I never spent time on the paperwork, to build the design of a company early enough, that by the time it grew, which I never expected it to, then I didn't have any paperwork to protect me. That's normal for early entrepreneurs. That's normal for inexperienced people. For young people, they don't know the paperwork. They don't know the legalese and things like that. These are things that, to this day, I struggle with. When it comes down to the paperwork, I am not put on this earth to build spreadsheets. I was not put on this earth to negotiate the terms of a deal with legal counsel. That's not what I do. I was put on this earth to focus on the horizon line. To be predictive about trends in the

future, and to solve problems so that masses of people could enjoy the results of this labor.

We had to leave Plaster City because we did not own it. After we couldn't agree to a corporate buy out, we just left. I just walked out one day. And then they sort of fired me the next day, I think. About a month later we started Light Iron. We just started over. Light Iron was founded on the same principles as Plaster City. It had basically retained 100% of its clients, and we kept almost all of the staff, because we just started over.

What changed with Light Iron is, now we had a clean slate, and we could build the paperwork correctly. So the entrepreneur failing up means we're not going to repeat the same mistakes. Mistakes are fine. Don't repeat them. Most people know that kind of edict. We essentially built it with the proper infrastructure. We're a little bit older, we're still all in our 20s, but we were building a company in our 20s, our second major company. We also had digital with some momentum. It was now 2009, it was a little bit more momentum with digital behind it, and it was less taboo. We could sort of see a little bit more down the tracks. People were starting to open up to it. Even the competition, the incumbent status quo, was starting to support digital. So we had validation through mass marketing of digital being good.

Here's what's bizarre. This is what still blows my mind. I very rarely ever mentioned this, because Panavision is supposed to be more like Switzerland. But this is really fascinating to me. When I left Plaster City in 2009, it took three years to get Light Iron to make the same amount of money, as it took seven years for Plaster City to get going. Right? Well, what's crazy is when Light Iron caught up to Plaster City, and essentially passed it, we were still ahead of the status quo in terms of technology, speed, workflow, expertise, and infrastructure. Which means Plaster City was so many years ahead. If I didn't have to start over with Light Iron, we would have skyrocketed even so much faster. Light Iron is actually a success story, and it's still behind schedule, because we had to start over back in a garage. Light Iron started in a garage again, because that was the only way we could do it when we started over, because we were still financing.

It's amazing to me, in my entrepreneur story we were so far ahead, that even when we had to reset, to get it right the second round, we were still ahead. And Light Iron became the premiere digital cinema workflow. They were like, "You're the workflow guys."

Kathleen Kennedy said, "You're the iPad guy." I'm like, "I'll take that."

We were able to put ourselves in an amazing place, even though we reset, but we got a lot right the second time. My partners are all

entrepreneurs as well, because they are all in it for the startup. We love the startup, and we love to start over. Once it gets, I don't want to say easy, once it gets stable, and predictable, that's when entrepreneurs get restless. We wrestle with routine, and I never want to be, if you're a person that's wrestling with routine, you're probably programed a little bit differently. Other people crave routing. They want predictability. They want to know everything.

Here's another trick with entrepreneurs, when really good business professionals focus on three lines. Here's a quote that I love of mine. There's three lines. There is the bottom line. There's the horizon line, and the deadline. The deadline drives a lot of people. They make all the decisions based on some sort of deadline. A deadline is basically, someone else imposes some sort of rule, some sort of boundary, so that's a deadline. Deadline followers are driven by external forces. Right? Other people say you have to do this by then. You're kind of a slave to the process. That's the deadline.

A bottom line person is someone who lets money decide all those decisions for them, and they have to follow that. Of course many businesses need deadline followers, and many businesses need bottom line followers.

The entrepreneur focuses on the horizon line. The entrepreneur is far less concerned about today. I'm not concerned about today. Stock price, I'm not concerned about today. Schedule, I'm not concerned about today's customers. A true entrepreneur is focused on tomorrow's schedule, and tomorrow's customers, and tomorrow's challenges. Once a job is achieved, we win a bid, once a project is going, once a camera starts rolling, once a client is won, once a business is open, I am so jacked, because all the things for that business to become solidified are going to come about through deadlines and bottom lines. It's all going to happen, but the deadlines and the bottom lines would never conceive of this new idea, or this new product, or this new client, or this new division. None of that drives those. Those are all required for those new ideas and products to essentially become successful in their own right. But they're not where the concept comes from. They're not where the ideas are born out of. If the idea isn't conveyed well, then it doesn't matter what the bottom line says, or the deadlines say.

The horizon line; I almost might appear to some people as insincere with existing clients, or existing products, because once a product exists or a person is signed on, I'm like, "Ah, forget it." That will just happen. We have people for that. We have infrastructure for that. We'll get through it. What about the next product? What about the next trend? What about the next problem? What do we need to do?

After Light Iron sold to Panavision, I said the problem of cinema now is not post, it's cameras. It's acquisition. It's workflow on the set. Light Iron scaled itself out. The biggest difference between Light Iron and Plaster City was the invention of mobility. We invented these things called outpost carts, and Light Iron skyrocketed ahead of incumbent major companies, that were 100 years old, and have 5,000 employees. Because we built a mobile version of a post house. All of a sudden little Light Iron, which is me and my brother, and a few friends, we are on *Pirates of the Caribbean, Underworld, Total Recall,* we are on all these huge jobs, huge movies, and *Spiderman.* We are on huge movies, and the big post houses, the big companies, aren't. Because we used a technique that they never thought of. We came up with a solution for making things mobile, giving more creative control on the set. By putting it there in compressed time. Time is the most valuable asset. Everyone was in tune with that.

By putting it on the set, we were able to invent a technology, which we patented, and we actually received the patent this year, finally, on this sort of mobile post production technique. That catapulted Light Iron forward, just like being data-centric and digital-centric catapulted Plaster City forward. We just reset it, based on emerging trend.

Now, years later, I've done that again with a camera called the DXL. The DXL is the camera I'm the product director of, and we've relaunched the camera program at Panavision. We've partnered with RED, so we pulled our RED group together. We pulled Apple into this. We pulled Panavision into this. We pulled Light Iron into this. We make the most advanced, highest quality, digital cinema solution called DXL. It's starting over again.

I have a little startup group, even though I'm in a big company now, I have a little entrepreneurial rogue group. We have our little space, and we do all the stuff rogue. That's our solution. I run the same entrepreneurial technique and I train my staff to think like entrepreneurs. We have skunk works, and we use the phrase techshop.

We practice on presentations, because you have to be able to defend your beliefs. You have to explain why you believe the way you believe, instead of what it is you believe. We explain why. We focus on the whys over the whats. It's allowed us to maintain a massive edge. It's an incredible edge. A ton of work product, and we're taking on the status quo again. Even though we're Panavision, we're still taking on the status quo, because there are things out in the market that Panavision can't control, that we want to control better. So we have to change market behavior, and it's a long process. You can't do that if you are part of the system. You have to live outside of it.

Entrepreneurs live outside of the system. They feed from it and they feed in it. There's a really cool animation, and it shows the population of New York throughout a 24-hour day, and how it's like a heartbeat. It gets big and then small, big, and small. You go in and out of the city. That's sort of like that's what an entrepreneurship does. We go in and out of the city. The city is the system. Go in and out of the system, but we live outside of the system. The incumbents and the status quo, they live within the system. They are the system. If you want to change the system, some would say, well, you have to be in it. I say, "No, you don't, you have to be outside of it." You can see clearer and you can be more resourceful, and you're less likely to be contaminated, or influenced by the system. Then you've got to be willing to get in and out of it. Independents and adventurers that live at home or what not, small groups like that, they don't live in the system. They're outside of it and they have the great ideas, but they lack the means, they lack the resources and the relationships that you need in the system to succeed. That's part of the entrepreneur process, being able to get on that train and go in and out of the city, so that you can make use of more resources and relationships within it, but you're not contaminated by it by living within it. You have to live outside.

So, that's where I will probably always work as a professional, outside of the system, traveling in and out of it, and using my relationships on the inside to bolster what's necessary to develop on the outside. Then I have fresh air. Everybody wants to live outside of Manhattan, because you have fresh air and grass and trees. That's the kind of stuff that entrepreneurs need. We need to see that horizon line, and if you're inside the system it gets clouded by today. It gets clouded by today's stock prices. There are companies that decide, is today a good day or a bad day based on what they're trading at. It's like, "No, don't let that decide, because the decisions that were made for today's stock prices are decisions that were made months ago. There's a delayed reaction." If you're going to make the stock trade better in three months, six months, or three years, you gotta make decisions today for that. What are those decisions? Don't be governed by today's stock prices, today's P&L report. Because you can't change today's report. We gotta call this client, we gotta call that, we gotta change this one thing. That's a grounding error in the grand scheme of things.

If you want to change behavior, you gotta think horizon line. You gotta think years. I've now started two companies, and now a sort of pseudo startup inside of Panavision. This is like my third entrepreneur thing as a professional. Each of these shared the same characteristics of my rule, my sort of system, in how I communicate

and talk. No offices, no closed doors, we're open. We communicate. We're all in each other's business. Everybody knows everybody, what's going on. We should all know each other's bathroom habits. Like we need to be that close and trustworthy to each other, that we can question each other's every concept, every issue. You can question each other without threatening people, without being afraid. That's how we do it.

I hate titles. Titles breed hierarchy, and they breed this work chart thing, org. charts are the worst. My brother and I at Light Iron fought for years never to make an org. chart. The staff as they got bigger and bigger, they were like, demanded, "We must have an work chart." We were like, "No org. charts, no titles, because you want to use that org. chart to impose something about yourself above someone else." That's what I know people want titles and org. charts for. They want it for external use against other colleagues, and I try to resist that as long as I can, and avoid it. All of the years, until I came to Panavision, I never had a title in my signature in my email. Never once did it say president and CEO of Light Iron, because I didn't want my staff to look at me that way. I wanted to be in the trenches. I didn't want to say, "I'm with you guys. I got your back." I actually wanted to be with them and have their back. A title creates division, and I also wanted to teach my staff that people respected me in this industry because of what I did, not what I was called. By not having a title in my address, it allowed me to show other staff, who would complain about wanting a title, say, "I don't need a title. If I don't need a title and I own the place, certainly, you don't need a title. You gotta make a really good argument to me, why you need a title, if the CEO doesn't."

"Oh, people will respect me more." I said, "They respect me because of what I do, not my title. They don't know my title." These are part of these little tricks that I think are really important, that people say they work for me, and they work for my sort of niche world in this little digital cinema world, which is microscopic in this world. Our little world. A lot of people watch movies, but very, very few people make them. It's a very tiny community compared to like medicine, or scholastic, or lawyers, or politics. There's so many people in these other infrastructures and industries, but not in movies. It's very exclusive, it's very small.

I think that's the other reason why I sort of love it, because you can make a difference in a small community really easily, if you get something right. You can almost get blacklisted, if you do something wrong. And I've certainly made many mistakes, but I have learned so much along the way, that I consistently repeated

and refined my technique of entrepreneurial leadership. That seems to be working at Panavision. I work within that system, but, like my analogy, I kind of come in and out of it. Then I quickly go to my little place, which doesn't even look or feel like Panavision when you go in it. People get lost in my space, because they're like, "Whoa, where are we?"

We're in it, but we've created a space that is physically and emotionally very, very different. Everyone realizes it in one second. That is not something that we had to work hard to achieve. That's just us being us. This is just normal. This is how we would do it. Most people would say, "Why can't we just make the whole company this way." You can. Department by department, you can change anything. If you don't exit the system, think outside of the box, you just copy, paste, what you see the next guy does. That's kind of how we get stagnant.

Charles: Can you talk to me about that moment in the history of the company when you decided to join the larger Panavision family.

Michael: Well there were actually three buyers for Light Iron. Panavision is the one we picked. The timing was right where people recognized that workflow was starting to dictate process in digital cinema. So, you needed to add workflow irons to your business. Panavision is very, very forward thinking in identifying that chain. It was very off script for Panavision, because this was not in their core competency. We decided to ultimately make the deal, because it afforded us the ability to scale faster. We were simply scaling at a predictable rate. Panavision would allow us to double or triple, or quadruple that speed. That's really powerful. Being able to have access to Panavision's infrastructure, its footprints, its address, and its capital, simply gave us a little time machine. We were able to speed things up. Panavision's history is really good, and I think entrepreneurs need to understand, there always needs to be a healthy balance between old and new, or classic and modern. Just because something is old doesn't render it useless, or something like that. Gutenberg's printing press, that whole concept, still super necessary today. We still need to print. We changed a few of the technologies, but it's basically the same process as Gutenberg did it. It's not that different. Just because something is old, it doesn't mean that it's antiquated or it's unuseful. You have to know that now.

Panavision has classic things that are near perfect. Their technique, their technology, their history, all of that. Their reputation is near perfect. What Light Iron didn't have is any history. In fact, I lost a lot of customers because "everything you guys are doing seems great, but you guys have no history. So I'm afraid that you

could go out of business in the middle of a job or something." Ironically the big companies are more likely to go out of business than me, but I get what people think.

Panavision gives us that anchor, that scale. Of course, there's a saying, "Big companies like big companies." That makes sense. Light Iron was always a small business. There were some jobs that we could never win, just because we weren't big. Not because of the work or the talent, or the location, just because of size. I get it. So we ended up really having a great opportunity with Panavision to scale quickly, and to be able to borrow a lot of the wonderful history, and integrating that into a new-found future.

Chapter 9

Portfolio and Bidding

Portfolios and Reels

In order to book jobs, you will need a portfolio or reel of work. Clients like to see that you have already done work equivalent to that which they are paying for. This is usually the first step, before you even bid for a job or do a proposal, since they need proof that you could execute on what they are going for before it's even worth it for them to spend time evaluating the bid.

Your portfolio when you start will be mostly "spec" work, meaning work not done for a client.

For some mystical reason it's always easy to spot spec work. Maybe the commercial is just too edgy for a major brand to have ever bought it. The mixing on the music is just a hair rough, and not in the good way. The motion graphics don't feel quite polished enough. There's something about demo work that always feels demo. In music videos, the absence of band members and performance can be a large flag, though of course there are "official" videos for major bands that don't have band members in them.

Even though "spec" work is easy to spot, talent can often be seen through it.

Often, for an early reel, a before and after comparison is useful. If you do special effects, show the shot before you touch it and after. If you do art department, include shots demonstrating the transition you were able to affect to the space.

But there is some lingering feeling of the amateur in before and afters. They depend on the "before" shot being terrible for your "after" to look good. Would your "after" still be impressive if you hadn't seen the "before?"

Also, the before/after assumes some ignorance on your client's part, that they don't necessarily understand the process and you need to teach it to them.

A more sophisticated artist, going after more sophisticated clients, usually only shows finished work. There are exceptions, of course, at all levels, but, as a general rule, you aren't selling the change, you are selling the final effect.

If you are a set designer, nobody shoots in the "before" set, only in the final set. That's all that matters to them. What you need to demonstrate is that you can make something wonderful, since the end result is all the audience ever sees.

Not just better than terrible, but solidly good.

It's generally accepted that you can't use work for your reel until it's publicly available. However, once the music video appears on YouTube, once the editorial appears in a magazine, it's usually yours to use. Sometimes you are allowed to privately share work pre-release, with password-protected websites or in person.

The major exception is work where you are expected to hide what you do. Beauty retouchers, for instance, whose job is designed to be invisible, often have all of their work samples password-protected, to protect the discretion of their clients.

When you are just starting out, a "sizzle" reel of clips from your work, or images from different series, is acceptable.

But to get high-level work you need complete pieces. Your ability to create 30 seconds of interesting but random and unrelated images is certainly useful, but not nearly as useful as the ability to create a consistent look or feel over 30–60 seconds on a variety of different spots. To execute on not just the easy parts of a job but the hard parts. Because you can luck in 30 seconds of cool shots, you can pull the coolest images from a variety of projects. But can you make all the shots in a given piece amazing, and tell a story while doing so?

Thus, as you grow, you'll move beyond the sizzle to complete pieces. Savvy clients will want to see them, and a lot of the top-level clients will rule you out if you have a sizzle at all.

Pricing

Pricing your work is hard.

Unions are great since they negotiate price ranges for you. But most of us aren't in unions, and the price variations in our industry can be truly massive.

There is a constant fear of over-pricing, of asking for too much.

But remember that nobody will ever pay you more than what you ask for.

You'll never know what you can actually get until you lose a few jobs to over-bidding.

Keep raising your prices until work is too slow.

Then lower them a little bit.

From time to time, try raising them up again.

When you lose a job to over-bidding, know that that is an absolutely necessary part of finding your price. It's just the cost of doing business.

If you lose out on $500 because you asked for $750, know that that $500 was worth losing for all the future jobs where you'll ask for $500 instead of $400.

If you are only asking for $500/day when you could get $1k/day you are effectively leaving money on the table. This is a hard world, you owe it to yourself to collect that money that is out there for you, if only to smooth out the long gaps between freelance gigs (there are always long gaps). Maybe you

are worth $2k? Or $2.5k? You won't know until you ask. And you won't really know until you ask too much and get turned down.

Of course, every client has a different budget, and getting turned down once doesn't mean you are consistently over-bidding. It's only once you regularly lose out on jobs that you are asking for too much.

Don't be afraid to ask your friends what they make: mostly, we're happy to talk about it.

Pricing is even harder in movies than in other markets because of the heavy distortionary effects of entertainment. This job seems "fun" to outsiders. While, yes, no one ever asks for free tacos at a taco joint, everyone knows that the taco person is working there only for the income. Filmmaking has a glamor to it that makes it seem like people should be willing to do it for free.

That makes it harder to not only convince people you should be paid for your work (and you should), but also to properly get a sense of what you should be paid.

There are three key factors in how to set your price, whether it's hourly, day-rate, or per project.

1. What You Need to Survive

Just as a production company needs to know precisely how much they need to survive, every single freelancer needs to know precisely how much they need to make to pay the bills. I personally focus on a per-day rate, so that I can always say to myself "alright, I need to make X per day, this job is going to take me X days," and do the math in my head from there about what I need to survive.

Make a spreadsheet of all your monthly expenses, including the fact that you'll need to put aside 30% of everything you bill 1099 for taxes, and that's how much you need to make a month. Divide that by 20, and that's how much you need to make every day.

This is your bare minimum rate. Anything below this and you are effectively giving money to the client. Now you might want to do that, from time to time, to make sure that you are doing interesting work and growing, but it should be rare or else you'll starve to death.

2. What Others Charge

Slightly up in the importance scale is a sense of what others charge for their labor. While there is a lot of bad information out there (one client told me they heard on Reddit that they should never pay more than $500 for a book trailer, while other clients have paid up to $50k for them happily), there are increasingly places you can start to do this research.

Nothing beats first-hand information, and one of the best ways to get it is to work for other people in the industry. While you might be determined to be a

director or an editor right away, today, and not wait, spending a year or three working for others can be tremendously enlightening as you get a front-row-seat view into how other budgets work and what the going market rates are.

Industry groups are also a great place to get this information. Many unions and guilds have rate cards, though at the start of your career this will be less useful since you'll have to climb quite a ways on the ladder to get to the place where you can earn that rate. However, there are also countless informal industry clubs now, and many do rate surveys.

In post production, the Blue Collar Post Collective does a yearly rate survey that is broken down geographically, which is tremendously helpful since the rates vary so dramatically across markets. While you might find on a random job board "never work for less than $30/hr!" if that poster is in New York and you are in St. Louis, that number might not apply.

The more research you can do into finding out what others are actually charging the better.

3. Evaluating What You Offer the Client

This is by far and hands down the most important, but most neglected, part of the process people go through when they are evaluating how to price themselves and their projects.

If it's hard for you to ask for numbers that at first feel outlandish, think about the value you are bringing to your client. If you are an actor, remember that without an actor performing a scene, there's nothing to film. If you are a DP, the production needs someone to shoot the shots. There is a budget, and it's going to be split up among the people who provide value. You don't deserve all of it, but if it's a two-person show, you are what the audience is paying for. You deserve a fair cut of it.

Always remember what value you are bringing to the client. If you decide your cashflow job is web design, and you are building a client a website that will bring them more clients, and they make $250/client (for instance, if they are headshot photographers), and you think your site will bring in dozens more clients, that can help you set a rate which is reasonable for your time and reflects the value you are providing to your client. By the same token, expecting a headshot photographer to pay $10k for a website doesn't reflect the value that website would provide for them unless you could confidently say that it would bring them at least more than 40 new clients.

Nobody will pay $10,000 for your services until they realize what that service can do for them: if you have the potential to bring in revenue for them of $100k, paying $10k for that service is much more reasonable.

If you are pursuing corporate video work and your initial client target is local restaurants, you need to identify how much value you are creating for the restaurant. No client will ever pay more for your service than you contribute to their bottom line. If you believe your ads can drive $50k more business to

a restaurant, you can easily justify charging $15k per video. If you can only prove that you'll drive $5k more traffic, you'll have trouble getting the client to do the job at all.

A good music video that properly breaks out of its box, and doesn't just play to the band's existing audience but also expands it, is of absolutely huge value to a band. This is why directors with a history of creating those videos, which still continue to get made even in our current media-saturated economy, can demand such high prices for their videos. It delivers benefit to the client, reminding the artist's fans that the artist exists and sometimes expanding the artist to new clients.

If you are an editor, remember, yes there are your financial needs, and yes there are "going rates," but if you can truly take their project from "ok" to "amazing" with your editing, that is worth far more than what another editor might bring to the table.

When you think of pricing, focus on what you offer the client. That's the way to start billing enough to survive the industry.

Raise Your Rates

Traditionally I say "no one will ever tell you to raise your rates," but that's not true. I did have one client, one time, tell me I was under-billing. They brought me back for more work at twice the previous rate.

Short of that one individual one-off client, no one will ever raise your rate for you. In fact, when you are a producer and on that side of the table, you know how much everyone you want to hire is willing to go out for, and you'll want to lower those rates as much as possible. It's the only way to survive.

Thus, every time you bid a new client, raise your rates a bit.

First off, before it even gets to that, wait as long as you can to talk about money, and make them talk first. Whoever talks about money first tends to lose out a bit in the power differential. So, when a client asks "what's your rate," a common phrase is "what is the ideal budget you are hoping to hit?" Or something like "what were you thinking this might be in terms of budget?" Get a sense of their budget as early as possible in the conversation so you can get a sense of scope and scale. Of course, if you have a standard rate, you can quote that, but you might also want to see if there is a way to get more than your normal rate, so waiting to quote your rate can give you time to figure out if now is a good time to raise the rate.

One of my favorite phrases when asked my rate is to say "I have a commercial day rate that I use for jobs like this, but I like your project so I'm happy to work out a number we're both comfortable with. Tell me what you're thinking." This is both true, I do have an hourly rate in commercials that I make pretty regularly, but it also allows me to avoid having to say a number for longer, forcing them to eventually disclose what they are hoping to spend.

Then, once you have a handle on their budget range, write a bid that is 20–30% more than that, bidding to do the job properly and with what you need

to deliver. If they want a $1k music video with explosions and exotic cars, don't bid $1,200, bid what it would actually cost and don't be disappointed if you lose the job, chances are no one is going to get it. But if their price is close to fair, come back with something slightly larger.

Then, instead of lowering your rate if they counter with a lower figure, you can consider changing the scope of work. For instance, let's say you normally get $450 a day and you are hoping to raise your rate to $500/day as an editor, and they want to do a ten-day edit on a music video and they only have $4,000 for the edit. Instead of volunteering to cut your rate down to $400, talk about reducing services and come back with something like "Well, $500 is my day rate, but how about we do it in 8 days? I'm confident I can deliver a great edit for you."

Raising your rate generally only applies to new clients. Raising your rate with existing clients is tricky, and almost impossible. It does happen, but usually only when you have demonstrated such tremendous value that they are absolutely dependent on you and know it. For the most part, once a client relationship is established at a certain rate, it sticks, and if there is going to be a change it deserves a real conversation with the client as to why. This can come off as cold in an email, so a quick phone call or in-person chat the next time you run across each other to say something like "I've been pretty busy lately so to keep up with demand I'm changing my rate a bit" goes a long way.

The Menu Approach

At the start of your career many people want to bid with a menu. "You can have this type of video for $10k, then this video for $30k, then this video for $100k."

This is a fine thought, but in creative fields it doesn't tend to work out too well. What generally happens is the client falls in love with the $100k video concept, and wants it delivered at the $10k price.

The types of things, like locations and cast and effects, that change price dramatically don't tend to mean much to a client's fascination with a job. Worse than that, even if they select the $10k job, they will always have their vision of that $100k job in the back of their mind, and it will make it harder for them to be happy with the cheapest item on the menu.

It's better to take the time to talk to the client and get a ballpark for what their ideal budget is, then write creative to fit in that budget before sending through any type of creative.

Offering a menu rarely works. Even if you book the job, it's almost never at the top budget, and the lingering dream of that top menu item sits in their head for the rest of the job.

Bartering

Assigning a price to something is an essential, but very difficult, activity for most creative types, so bartering is a common instinct.

It sometimes works out fine.

Mostly, it's disastrous, and I've seen it ruin longstanding friendships.

When you go through the practice of assigning a pure dollar value to your work, you are forced to do so not just externally to the client but also internally with yourself and you are forced to reckon with it face to face; it's rare (unless you've got a particularly resentful disposition) that you blame the world for the value that you come up with. After all, you came up with it. That's what your labor, your talent, your creativity, is worth to you.

Bartering removes you from that difficult process; you don't have to assign a cash value to the work, you will just trade it to someone else. A classic example would be something like "I'll design the logo for your business, and you'll do video for my wedding."

The problem is that neither of those activities is properly quantified. When bidding for a design job, elements like number of revisions, number of options, repurposing (letterhead design, website design, etc.), are all usually spelled out and financially listed in the bid. In a barter, this almost never happens.

More often than not, a barter ends up with both sides doing more work than they would have done for the amount of money they would have been paid for the service, and then gradually growing resentful. Since it's "among friends," round after round of revisions go on unchecked. Since you are valuing your own work against someone else's, eventually you will feel ripped off.

Additionally, there is a difficult aspect of humanity where most humans tend to value objects more when they paid more for them. It's counterintuitive, but, when given something for free, it's very hard to value it, since, after all, you got it for free. If you pay well for something, you tend to value it, since it must be worth something if you were willing to pay for it.

It's why you tend to get treated more poorly on favor-rate jobs.

Because you "traded" your service for it but never went through the process of placing an actual value on that service, it's very common that you'll be disappointed with what you got in trade, at least partially because you didn't pay for it.

Bartering is discouraged, but if you are going to do it, do a deal memo the same way you would do with any client. Place a dollar value on your work ("design services worth a value of no less than $1,000, based on an hourly rate of $25/hr," etc.) and a dollar value of the work you are trading for. Spell out all the normal terms as you would with a client. Trade checks back and forth for the value of the service.

The clarity this will force you to have, not only with your trading partner but with yourself, will leave you walking away from the barter significantly happier than you would have otherwise. Also, having traded checks for the dollar amount will make accounting and taxes easier.

Chapter 10

Marketing, Networking, and Promotion

Getting Clients

Clients are literally everywhere.

One of my first ever clients was a guy I met at a party in rural Ohio ten years earlier. We had leisurely kept in touch through a series of accidental meetings, but neither of us had tried to "keep" the other as a contact. The universe just kept occasionally pushing us together.

Finally, he had a gig he couldn't do due to schedule, and passed it my way. That job was successful, and led to five years of semi-regular clients in an entire industry I had no relationships with before; pure word of mouth.

About two years into doing that work, I sent individualized emails to the marketing departments at all the major players in that industry; that led to a little bit of work, but really, it was all just word of mouth based on doing something awesome for that first ever client.

It's important to note it was individual emails; I addressed people by name, did a little research on each company and mentioned a title or property they had that I thought I could fit in well with. Nobody reads mailing-list or blanket emails from strangers; most people barely even skim the mailing lists they actually sign up for.

I was in a coffee shop recently and overheard two people at the next table talking about the documentary they are finishing and their need for some FX; I excused myself from my friend, interrupted their conversation and gave them my card (I owned a post house at the time); a third person overheard the conversation and butted his head in to say he was also interested in some services and liked my pitch.

While my friend rolled her eyes at me, she understood. Clients are literally everywhere. Especially in New York and Los Angeles, but it's really no longer limited to just the major markets.

Sometimes really great ones come from job boards. I have indeed booked well-paying and artistically satisfying jobs on sites like craigslist, Mandy, etc.

But those boards have a major hurdle, in that they are publicly accessible. LinkedIn has a great feature that tells you how many people have already

applied for an opening, and it's not uncommon to see that hundreds or thousands of people have put their resume in the ring.

To stand out in that crowd, you need to both be extra-special amazing (and maybe you are, but, maybe you aren't), AND first. It's rare I ever post to a job board myself, but, when I do and I get hundreds of applicants, I generally hire from within the first 20; not because I necessarily want to reward their moving quickly, but because if I find a good fit in that first 20, why keep reading resumes and looking at reels?

Don't pass on the job boards; they are wonderful resources and a great way of getting yourself in the habit of putting yourself out there. But don't limit yourself to the job boards either.

There is a weird mystery to the universe that is hard to explain, that clients sometimes come from nowhere, but only, it seems, when you are looking for them.

It's like we live in a giant forest, with trees so tall that we can't see their top, but up at the top the canopy is all connected. We want fruit from those trees, but they are too tall to climb, so we shake the tree and see if we can't make fruit fall out. Sometimes fruit falls out of the tree we shake, and we book a job directly from a client we contact. But sometimes, shaking the tree shakes the whole canopy, and while no fruit falls from the tree we shake, fruit falls from another tree. Maybe that tree's fruit was so loose it was going to fall anyway and we don't need to shake trees. But that isn't how it seems to work. My experience has been that you've got to go out and shake the trees. You don't want to shake the tree so hard that you break it free from the canopy. Just a gentle shake from time to time on each tree, and you never know where fruit will come from.

Sometimes you shake a tree, and its fruit falls out years later.

But you had to shake the tree to get it started, I think.

Go out there and shake some trees.

Drag the Buffalo Back to the Cave

It matters just as much who drags the buffalo to the cave as who killed the buffalo.

Many, many, many filmmakers operate under the hope that if they can just get good enough at one thing, they don't have to self-promote. If they get good enough at sales, or good enough at editing, or good enough at directing, work will magically come to them and they won't have to "brag on themselves."

Unfortunately, that's just not true. No matter how good you get at killing buffalo, if you let someone else drag that buffalo back to the cave, the person who did the dragging will get the credit.

You have to get comfortable with promoting yourself. It goes against the grain for most of us, but when you have wins, when you do things well, it is important to see that you are properly credited for it. Advocating for yourself is actually an essential part of the process of making sure team members

understand your contribution. This is true both externally, promoting your work on social media and trying to get stories in the trade press, but also internally with the team you've built if you have built a company.

No one can avoid having to learn to advocate for their own successes.

Networking

If there's one thing I hear from students more often than "I'm not good at business" it's "I'm not good at networking."

With the exception of the heavily introverted, I think this is mostly not true, and comes from some imagined scenario where "networking" is a terrible thing that happens out in the world, in some hotel ballroom, with people wearing name tags and trading business cards, and "making valuable connections" towards closing pharmaceutical deals or buying timeshares. Or at "the club" where the really extroverted "life of the party" makes friends with all the connections they need to flourish by being a social butterfly.

This isn't networking, at least not in movies. It is, sort of, as IFP and the big festivals have networking events like this and they are useful, but they aren't the only thing that counts as networking in film, and the film-specific networking events are never as bad as we imagine.

Film has something that most other businesses don't have: glamor. Because of this glamor, this passion, this patina, there are a larger number of people trying to get in than in other industries. For every available opening, every job, every gig, there are simply more people who would like to do it, who are applying for it, who are after it, than there are in other fields.

In every area of life, if you could hire someone you already know, you would. Any hire is a risk, and hiring someone you know, or someone who is at most one level removed from you, is a way to manage that risk. You've talked to them at a party, you've maybe even worked with them on something else in the past. You know what they are like. There is some measure of safety there. Any time you go to a dentist that your cousin recommended, and use your sister's accountant for your taxes, you are living out the valuable lesson that most people hire on personal connections when it is possible to do so.

It's one of the reasons why so many professors end up hiring their students. Not only have you trained them in your way of doing things, but you've had four months to discover their strengths and weaknesses. You already know them and can evaluate them, thus lowering your risk.

Accountants on the hunt for positions at a big firm would do the same, if there were always so many accountants vying for every job that they could just hire someone in their circle. Good jobs are only publicly advertised when there isn't already a great candidate available through your personal network, which is why many jobs in film don't ever end up advertised. The DP of a major music video is seldom, if ever, going to show up as a job post on Mandy.

For every job I hire for, chances are I know someone who wants it. If not, I know someone who knows someone. And because that social network provides that safety, I go there first. I go to job sites less than 10% of the time, and generally when I don't already know someone who wants it. Word of mouth rules in film. So you absolutely positively have to network in some way, shape, or form.

All networking in the arts means is "go meet people." That's it. If you get invited to things, go. Get there a few minutes early. Stay a few minutes later. Talk to folks you don't know. It doesn't need to be about "the industry" or "how we might work together." Just, you know, what you talk about normally, sports, or politics, or real estate, or whatever it is that you like to chat about.

Go. Parties. Shows. Openings. Screenings. Festivals. Especially festivals. The one in your town, and Sundance, at minimum. Talk to people. Find the clubs and organizations that serve your industry and join them; if the fees are too high, see if you can volunteer at their events. If you have an interest in a specific area of the industry (post production, or VR, or producing) find events and meet-ups around those areas and just go (for example, NAB in Vegas for those who want to shoot or edit).

It helps if you bring a friend. Even if you don't stick with your friend, it makes you feel a little less awkward.

"Power" networking, where you "work the room like a pro," tends to turn people off. Highly successful people tend to be smart enough to be aware they are being "worked," which nobody really likes. It's a bit hollow.

Be friendly. Work hard. Exchange cards. Don't be afraid to follow up later.

Yes, physical business cards, even today. Just putting your number in someone's phone does nothing. Nobody skims their phone address book leisurely looking to see who they haven't talked to in a while. But we all, at the end of an event, pull out business cards and look at websites. Your card should look nice, list no more than a single job, and should list your website.

We are being paid for our taste. Make nice cards, whatever that means to you, whose taste reflects your own. It's an opportunity to demonstrate to your potential clients that you have taste and style. A crappy card implies you'll do a crappy job.

If you have a job description on your card (and many don't these days), you can only list one job per card. A card that says "producer, director, 2nd AC, and PA" really doesn't help you. Have a card for directing, a card for camera department, and a PA/generalist card, and give them out appropriately. There have been times in my life where I have carried four different cards with me, for the four different businesses I had going, and I made a decision with every person I met about which card to give. Everyone wants to hire a specialist. Be that specialist.

A director is never going to hire someone whose card says "director/DP" since they'll always be worried you're going to direct that job out from under them. A producer doesn't want to hire an editor/colorist, they want to hire a colorist. If, once you've booked the edit job and you are getting along, you mention that you happen to color a bit as well if they are looking, that's fine.

You've hopefully already demonstrated amazing editing skills to them. But you absolutely positively need to be selling yourself as a single specialized thing to book real well-paying work.

This will likely require multiple websites for multiple stages in your career. If you are currently working as an editor/colorist, you want to have an "editing" site and a "colorist" site, along with a resume, business cards, and email signature for both. This is non-negotiable. At all times everyone will pay more for a specialist than they will for a hybrid, so you need to sell yourself as that for the initial hiring phase.

One of the easiest ways to do this is to use the custom portfolio feature of Vimeo Pro. You can build a "collection" for each skill, and use a custom URL for each page (you can link SelinaDoeDP.com to one portfolio and SelinaDoeFilmmaker.com to another portfolio). The benefit of doing this is that it is probably the easiest way to keep your work current. The drawback is that Vimeo portfolios won't offer you the flexibility you'll get with a custom website, or even a Tumblr, Squarespace, or Wix page.

Along with this you should have a resume, the primary driver of which is to offer opportunities for overlap. A long list of the projects you've worked on and with whom you have worked on them. The goal is for the person hiring to say "Oh, woah, you worked with Jez, I worked with Jez!" And then you have overlap. They also can reach out to Jez to see how you were to work with. Listing who your supervisor was (be it the DP, post super, editor, etc.) is quite common for certain of these resumes. If you are gaffer, list the DP of all the projects you gaffed. DPs know each other, so when they look at that list they'll get a sense of your experience based on who you have worked with, and they'll know who to ask for information about your work style.

One of the biggest trade shows in our industry is NAB, held every year in Las Vegas, and popular with production and post crew. It's a great chance to meet the camera, lighting, and post companies that make the tools you use every day, to get hands-on time with new tools that are just rolling out, and to develop longer-term relationships. On a recent flight home from McCarren to JFK, I pulled out the stack of business cards I had gotten and started looking at websites, emailing follow-ups. An hour into the flight I looked down the aisle and someone else, clearly another NAB attendee, was quietly doing the same. Physical cards serve as a later prompt to check out a website, to evaluate what you see, to follow up. Putting someone's website in your phone is practically a guarantee that you'll never go see it. Make cards.

Most networking happens on a job. Once you start booking jobs (or while you are interning), be friendly. Meet people. Exchange info at the end of the job. Physical cards.

We're all on the middle of the ladder. We've all got somebody up above us, and somebody below us, and we're all trying to move up. We need things from those up the ladder (opportunities, jobs, introductions, advice, guidance), and we offer things in exchange (cheap labor, knowing what's hip). We need

to meet folks further down the ladder just as much as folks further up. It's just that there's more folks down the ladder and they are easier to meet.

With people more than a few steps up from me, I don't follow up unless I have a specific thing to say; there's no reason to fill their email inbox up with random clutter, it'll just make them annoyed. I never ask for a meeting if there isn't a concrete ask I have of them. If I have a project I really think they might be interested in, I get in touch. Otherwise, I'm content just to have met and to see if we circle back around in the future. Having met once makes the second meeting much easier, since there is the perceived familiarity of having met before and everything that has happened since to catch up on.

If they are at roughly the same level as me, within a few steps up or down, I email every few months or once a year just to see what's going on. What are they working on? I mention what I've been working on. I had a client I hadn't talked to in two years: I happened to email the day she landed a major job and lost a major vendor and desperately needed the services I could offer, starting the next day. She had forgotten I existed, and was super appreciative I emailed, and she turned into a regular client worth tens of thousands of dollars. All of that happened from one random email I sent checking in on her career.

Of course, I send hundreds of those "one random emails" a year. I aim for five a day. There are a bunch of website and software systems that can help you do this. Contactually is a good one that searches your email inbox and suggests five people every day you haven't emailed in a while.

Don't pester. You aren't there to "sell them" on you. It's just saying hello. The occasional check-in doesn't hurt. It's a balance. Social media is great for this. You need a professional Instagram and Twitter presence where you only post about work-related stuff. Once folks follow you there, you get the chance to remind them what you are working on from time to time. Want to be a director or DP? A monthly post with a set photo is a great way to remind folks that you are out there working, that you exist. Yes, it would be great if they would remember you otherwise, but a gentle nudge to remind them doesn't hurt, and that is what Instagram is great for.

SEO

Search engine optimization (SEO) doesn't quite matter to most filmmakers yet.

Search engine optimization is the tools, techniques, and tricks that help blog posts and businesses get to the top of Google ads online.

However, those techniques aren't quite relevant to filmmakers promoting themselves just yet.

The reason is that very, very few people go to Google and search for "director for feature film." Feature film directors get hired through personal relationships, through agents, very rarely through job ads, but rarely are producers so desperate to find a director that they go on a Google hunt. They have directors they know, and ways of finding new ones.

Thus, obsessing about SEO and indexing tools doesn't matter for most of us.

However, blogging is a viable way to establish your credibility as a filmmaker. Creating a blog where you write about your subject in detail, building an audience, engaging with the community, is a powerful way of making your halo. Ted Hope had Hope For Film, a prominent producing blog, before getting hired to run Amazon Studios, and it is very reasonable to assume that the blog had at least something to do with getting the job running content creation for Amazon.

Eventually there might be so much video creation work that SEO will become important, but for now the film industry remains one where most of the relationships continue to be word of mouth, and the best way to promote yourself is to just focus on doing high quality work.

Spinning Plates

When you are bidding on a job, part of the charm is giving the appearance to the client that their job is the only job in the world that matters to you.

And perhaps it is.

But generally it isn't. A good artist is constantly spinning a variety of plates to see which one sticks.

If you get overly invested in a specific project there is too much potential for devastation if it doesn't pan out.

So a good artist spins plates. As many as they can keep going. You won't book most of the jobs anyway, and, if you do, you'll either figure out how to do them all (hiring underlings for the grunt work), or you can pass on some.

It's very rare you book everything you bid on.

But you have to be in a place where you turn in a bid, and then you let it go and move on.

The best way to do that is to have another bid to work on, and one after that.

Keep as many plates spinning as you can.

It'll be easier to deal with the problems of too many jobs booking at once than too few.

Though your friends who aren't booking anything won't want to hear you complain about having to navigate too much work.

So keep those complaints to yourself, and keep spinning plates.

Own Your Own Audience

John Waters' advice to young filmmakers has always been that you need to become a personality yourself: you need to brand who you are.

You need to become the reason why people go to a movie. Most people choose a movie to go see the actors: "Hey, you want to see the new Paul Newman movie?" you might ask a friend.

If you yourself aren't a brand, you are stuck at the mercy of the actors you can't get to be in your movies. You don't have the power yourself.

You don't want people asking "Should we see the new movie at the Odeon?" You want people to say "Have you seen the new movie by John Waters, it's at the Odeon?" You want people willing to go wherever your work is, not to get prestige from where you are showing.

To do this, you need to cultivate your own audience.

Social media is a great modern way to do this. It's not the only way, but it's part of it.

You don't need to use all the social media tools. Nobody has a great email list, a great Twitter account, and a big Instagram account. It's too much work; you should be making movies, and you can't afford a social media agency yet to do it for you.

But a finely tuned social media presence that builds your audience is a great tool.

Pick one. If you are a DP, and for most directors, it's Instagram. Maybe it's participating in throwback Thursdays. Design it for the platform, hashtag it thoroughly so that strangers see it. Build your following.

If you get enough followers, clients will be interested since they hope you'll post from set and make your audience want to see the things you made for them. Sure, your 10,000 followers won't all watch the ad, but you can post about it and some will watch it. Even if none do, the brand still gets the publicity from your BTS shots.

You have something to offer: your audience, which follows you.

Maybe you aren't a visual artist. Maybe you want to write comedy television. Make jokes on Twitter. Build your following.

Find the network where your skills shine and your fans congregate.

Find the way to build your audience and cultivate it.

That way it's yours.

You can take it with you.

Movie studios are including actors' Twitter followers in their math for who to put in movies. Because that's free publicity they get as the star pushes out shots from set, the premiere, and other promotion before the release.

Free publicity that goes to targeted fans who already like that star.

Don't depend on the studio, the gallery, the record label to do it for you. Then they'll keep the fans themselves. Do it yourself (or, once you can afford it, hire your own agency) so you can keep the fans. Make sure you use a platform that lets you keep your fans: an email list is the best for this, since you have those email addresses, and the platform can't take them from you. Facebook used to show every one of your posts to your followers: now only 20% make it through, and they charge you for more reach. Reach to your fans that you worked hard to cultivate. It's very frustrating, but it's their business model.

If you do an email list, remember that no one reads long emails. Short, to the point, engaging images are best. The only purpose is to remind people that

you exist. My friend in real estate emails out a funny photo once a month. It's memorable and keeps him on my radar without overwhelming me.

If you have an email list, have an "unsubscribe" button.

The same that was true in networking is true here. If all you do is treat it as a business tool, constantly pestering people for work, you tend to turn people off. Just engage. Be yourself. Create some interesting work tailored to that format.

Because, again, your work is your best marketing tool. Social media is just another avenue for you to share that work with the world.

Also, don't just market on social media. Engage with the community as an individual. When someone's social feed turns into nothing but promotion I almost always unfollow them. Most people do.

They are your fans. Keep them.

Navigating Far Levels

Human beings do not have inherent ranked value. We are all, in the eyes of earth, or sky, or creator, equal. When standing in line at the coffee shop or sitting around a table at a wedding, we are all equal.

Within industries, however, we aren't. For individual companies there are "org charts" laying out who outranks who with military-style precision, though of course we all know the official org. chart is sometimes inaccurate in terms of who actually holds power. For celebrities, there is the IMDB Start Meter, though that mysterious ranking changes too much to be used outside anything more than anecdotal or conversational power rankings. However, between companies and in the industry as a whole, power structures clearly exist.

The best way to think about them is "who has time to meet with whom?" When you are at the start of your career, you would literally meet with anybody in "the movie business." You are at the lowest rank, desperately looking to find a way in to a complicated industry.

Once you climb a few levels, you get busier. Not too busy to have coffee with the occasional college student or 20 something you run into, but busy enough that it's not easy to do. Climb a few more levels, and you cut down on the number of truly "introductory" meetings you can do, because you are too busy having meetings with those above you, the potential clients and collaborators.

"But I might be the next big thing," the new person to the industry says, "wouldn't they want to meet with me just in case?" Theoretically, yes, but there are thousands descending on the movie business every year who might be the next big thing. You need some sort of proof that you might be the next big thing. That proof comes in terms of some work accolade and recommendations.

Once you've won a prize at a major festival (only Sundance, Slamdance, SXSW, Tribeca, and Toronto seem to matter for this, and Berlin and Cannes somewhat), you might end up with more people willing to meet with you.

Those waves tend to burn out quickly, however (you get 6–12 months of momentum from that kind of award), so most of your career meetings with new potential clients, collaborators, employers, and employees will come through recommendation. Pay attention to the recommendation and the language of your expectation is probably embedded there. Good recommenders don't always do this consciously, but they are often very aware of power status and attempt to imply how the relationship might be beneficial and next steps in the email.

If the person says "I just wanted to introduce you to each other" or "You should be on each other's radar," they are not likely implying a meeting. Thus, if you reply "Let's grab a coffee," it makes you look a little new to the industry. What is really being implied is for you to write a brief paragraph about you and your work, and perhaps include links if relevant. If the person says something like "Jose, you hire editors, and Mari is an editor, you guys should know each other," generally Mari should write a quick email and include a link to her work.

If your recommender thinks there is a meeting there, they might say something like ". . . and I think you two should meet." Of course, it almost goes without saying that sometimes people are wrong. Sometimes you can turn a lightweight email intro intended to just share work into a coffee. But, more often, by ignoring status rankings you are signaling your own low rank.

Pay attention to where you are as you climb, and it'll be more obvious if you should be trying to get face time or not. Once you are within a few ranks of someone, absolutely try to turn that into a meeting. But when you are more than a few steps down the ladder, and especially when you are eager for a job or freelance work from someone, it's better to respect their time.

This is important since most people want to hire people who already know how the system works. You learn a lot about people in your first few emails with them. Someone who wants to get too much face time too early is a flag that makes you wonder "what else am I going to have to train this person to do?" Someone who ignores your signals is a giant red flag. I once had a freelancer offer to send through a pitch book on their feature that wasn't relevant to the job; I declined. Then they offered to send me the feature scripts for their next two projects. This was an entire series of red flags that the person didn't understand how film worked or how to manage their relationship to me, and would likely be very frustrating to work with. You want to demonstrate, in those early interactions, that you are someone who already has a handle on some of how the industry works and have figured out how you want to contribute to it as you work to move up the ladder.

Once you climb to the top, of course, everyone in film is trying to meet with you. You could literally get a meal with anyone in the industry. At that point, however, you only really want to meet with people the next industry up, finance and politicians, that will help you take your business forward to the next level, the same as you did when you were first starting out.

Recommendations

Your recommendation is your reputation.

Sometimes you'll be in the opposite situation from above, and you'll have the chance to recommend people for introductions or even specific positions. Recommendations are a nearly constant part of business life. "Do you know a good accountant?" "Who do you like for recording engineer?" "Have you dealt with that stage manager?" "Who does your fabrication?" We all want to work with the best, and, while the internet is a valuable research tool, movies continue to thrive on word of mouth recommendations.

Be careful.

In an ideal world, you would be evaluated on your work alone. However, your recommendations also form a large part of how you are evaluated, since oftentimes people will spend more time interacting with the people you recommend than they will with you directly. If you have to replace yourself on a job, they will be depending on your replacement precisely as they would on you.

Are you 100% confident they will do the job that you would do, that they are as dependable, thorough, energetic, and pleasant as you are?

Then recommend them.

However, if you aren't 100% confident, you are completely welcome to say "You know, I don't have anybody I recommend right now for that. If you find somebody good, let me know."

This becomes especially complicated when you are replacing yourself, when due to schedule you aren't able to take a given job from a client that you would like to keep as your client.

Some people play a complicated game of finding someone to recommend who is good, but not so good that they will steal the client.

That is dangerous; if they aren't good enough to do what I would've done for the client, I've lost the client anyway because of the bad recommendation.

My method is to recommend the absolute best person I know for the job, even if it puts me at risk of losing the client myself. I would rather lose the client to a good recommendation, and maintain my reputation with the client for having recommended someone solid, than to lose the client by recommending a replacement who doesn't meet their needs.

Hopefully the client will come back to me because of something special I individually bring to the table.

If someone recommends you for a job, be aware that this means your performance doesn't just affect whether you get hired again, but also whether the recommender gets hired again.

Getting Press

As a freelance writer for a tech blog, I get 4–5 pitches a day from people wanting me to cover their story. I couldn't possibly reply to them all, but although some of them are super close to being press worthy, they just aren't quite.

Remember, while you want press to increase your profile, the key when seeking press is to think how it will benefit the press platform.

If you want a film technology site to cover your story, the key is to present to them, as simply as possible, how it is news. What tool or workflow did you use that is interesting or somehow brand new and engaging in a way that wasn't done before? What is the "angle" of your story. Make this as simple as possible, and put it at the top of the email so that editors can easily digest why you feel this is newsworthy.

Make creating the article as easy as possible by researching what types of articles the platform tends to run. Do they do a lot of lists? Make a demo list for them ("Five amazing camera moves achieved with the fancy new camera rig," for instance).

Have properly formatted photos easily available for them. Sourcing images is often a time-consuming part of the editorial process, and a pitch that comes with ten great photos to choose from (so that you aren't always stuck using the same header photo as your competitors) will always have an easier time getting picked up than a pitch that has either one or zero photos.

Photos are so important I'll repeat it again. It's astounding how often major brands and filmmakers want to get press without providing good quality, engaging photos that can be used. They are needed in catalogues, in headers for stories, they are the lifeblood of getting press. Have more good photos than you think you need available, to make it incredibly easy for someone to cover your story.

Andy Warhol called his publicist every day. There is no shame in wanting stories about you and your work.

Marketing

Your work is the best possible marketing you can do. Clients know other clients. They will talk about you. You might get your work featured on a blog. This will lead to more work. And you'll feel good. You're making good work.

Interview: Jon Miller, Founder of Hive Lighting

Jon Miller was a working cameraperson who wanted a new tool to solve the problem of shrinking lighting budgets. He didn't have the technical knowledge he needed to create it already, so he went out and actively pursued it, in the process learning a tremendous amount in order to create the lighting units he wanted. By the time the light hit the market, he was already absorbed enough as an entrepreneur to no longer be shooting enough to need the light units themselves.

Like many business stories, his is full of serendipitous lucky breaks combined with months and years of relentless refinement of product and non-stop marketing.

Full disclosure: I've known Jon Miller since film school, when I shot a thesis film he produced, and I was around for many of the prototypes and an early pitch for the Hive Plasma.

Charles Haine: You started in the industry wanting to be behind the camera?

Jon Miller: Before I tried to own any kind of business, yes. But filmmaking and entrepreneurship are actually the same thing. If you worked in entertainment outside of one of the major five studios, you are already a contractor, you are already a small business. It's not like "before being in business you were in film." It's the same. You are a startup. You began with a premise, which is that you are a new, exciting asset that people should invest in. And no one else knows what you're talking about.

So actually, starting a freelance career in entertainment is the same as starting a new business and being an entrepreneur. It's just the product you're selling is you. This is even true for actors. Actors and Silicon Valley apps have basically the same premise, which is a thing which has absolutely no value and is easily replaceable will suddenly become more salient. And you're both selling vaporware until the point that you prove that you're right. And it's going to be all based on likes. Snapchat and Channing Tatum have the same basic arc.

Charles: While in film school, your ambition was cinematography?

Jon: I dabbled in producing, but "I would like to be a cinematographer" was the premise going to film school. I had done photography and some film/video-making stuff, but my background had been primarily from film theory and then more of a fine art practice. I had worked on film sets for a while, starting as a teenager in New York, and all kinds of departments. You name it, I'd worked the bottom rung of basically every department. I actually applied to film school with the idea that, if I got in, that would be how I became a cinematographer, and if I didn't get in, I'd keep doing the fine art video world and see where that took me.

After school I worked as a cinematographer. I did a wide enough variety of gigs that I would say they ranged from camera operating up to actually being the director of photography on things where that title is a bit more appropriate. And everything in between.

Charles: Then how did Hive come about?

Jon: I had been working at that point on the weird collection of things that somehow people deemed me qualified for, which is a combination of I had done something like it before, so they could see that, and/or they needed somebody, and I would work the amount they would pay me.

Charles: How much of that work was word of mouth?

Jon: I had a website, and I listed myself on some of the listing services but I would say between 80% to 90% was pure word of mouth. I got a couple of cold calls and a couple of randoms based on the website, but it could be months between random cold calls.

I ended up doing a fair amount of reality and early internet content. This is first gen YouTube, before all the major players started putting any content on there. Before anyone thought an internet ad was going to have any views. I worked for some actually pretty big clients like Heineken and Pepsi but for their internet campaigns.

Charles: Before they took those seriously.

Jon: It was a weird thing because it was handled by their serious people. I was doing stuff for Pedigree and working for Chiat/Day and major advertising agencies, but they were like, "All right. We have an entire ad campaign, and we wrote in a line item called internet $5,000. And none of us know what that means."

But there wasn't a different way to produce images for the internet. There was just a different budget for it. The expectations of the client didn't change. Pedigree didn't know what an internet video looked like. They just knew what their ads looked like, and if it didn't look like their ads they didn't get it. They weren't going to YouTube to watch it for the first time, so they were watching from the same fancy monitors they screened their national ad campaign. And they went, "Why doesn't this look the same?" "What's wrong with this one?"

We were like, "Well, you gave us five grand for this one, and the other one was a half-million-dollar, two-day shoot. So that's why." We got the same dogs too, is the weird part. All of which to say I had high-end clients and low-end budgets, which actually now is just what everyone has. But at the time it was a problem that I thought needed solving. And the perspective I was looking at it from was that of the equipment.

The major driver for my costs beyond crew was equipment, and crew wasn't going to be where I got savings.

At that time camera technology was revolutionizing very quickly with the DSLR world, stuff like the 5D Mark II. My pain point then was wanting to be able to make things look good without having any kind of additional electrical power. One of the best ways for me to cut a lot of money, and actually, frankly, crew, was if I didn't have to bring in a generator.

On bigger-scale productions, that line item is relatively small, but it killed me because that was an item you can't get a deal on. No one wants to let you borrow their generator.

At the exact same time, my friend from college who had come up through the agency system and was now working at a film financing company, his family had started a new company consulting in architecture, for getting your LEED certification that a building is energy efficient.

A big portion of their consulting was recommending lighting bulb replacement. My friend (and Hive co-founder) Rob Rutherford came to me and said "I know you're an up-and-coming," which is code for struggling, "camera person. Would you be able to help us with some basic lighting consulting? Help us with our language. What is it, CRI?"

I would go in and make presentations where Rob would say "you save X number of watts per day, which equals so much off your power bill." When the ops guy says, "But it's going to look ugly," I would tell him why he's wrong, how it could look good. At the same time I was asking "Okay, you're selling all these lights. What's new in lighting?" Because I'd used some basic LED products. But this consulting work gave me access to newer lighting technology that hadn't necessarily made its way to film sets yet.

LEDs were still weird. You still had to sell people on those. Your gaffer had to have that buy-in. And they had serious issues to them. The benefits were the low power draw, but the problem that I was having at the time was they just weren't enough. They were bonus fixtures, they could not be the key light. They couldn't compare with HMIs or any significant incandescent. I still got a lot more light out of plugging a 2000-watt incandescent into any wall socket that would hold it.

Charles: So 80% of your lighting package was either lights from the '80s, HMIs and Kinos, or from the '60s, which is basically the last time tungsten units were majorly revised.

Jon: Tungsten was still standard, but they were heavy. They were big. They used a lot of power. They got really hot. And I couldn't really travel with them. I needed a new unit. They had to plug into the wall. They had to be able to travel. And I had to be able to set them up with a small team or solo.

For the vast majority of major production at the time, though, this wasn't as big an issue because there was a huge trail of infrastructure that had been built over 50 to 100 years basically to set up a system by which high-energy-consuming lights could be used with regular ease on a film set.

None of that infrastructure applied to me and my jobs.

I very much started the project that would eventually become Hive lighting as a, "How do I get a better lighting rig for myself?", and "Can I make that something unique about me? Can I

increase my rate because I got these lights? Can I get jobs no one else can do? Can I at least make my life on the jobs I have easier or better in some way?" So it was very much a specific personal problem-solving challenge that began this technology hunt.

I was thinking "How does this improve the trajectory I'm already on?" Not, "How do I start a new trajectory?" Which is a classic narrative trope, by the way, if you're writing a screenplay. To receive A, you do B, which actually takes you to C, which is why it's an interesting script.

What ended up happening was pretty much, after doing a series of DIY versions of some different technologies that I was looking into, and after learning more and more about the process, because the way I started the process was identifying the core technologies outside the film industry and then trying to find someone who's already doing it in the film industry. My first instinct was to go find the ARRI, Mole, Kino LED, or Plasma, as the case might be, in our case Plasma light, that had already been made by somebody else.

I just assumed I wasn't going to be the only one who knew about it. It didn't really dawn on me that I was going to have to make my own based on these technologies until I started doing that. Then, when making my own, I thought I was going to literally make one for me. When I began that process, it became very clear that, to make and develop the technology I wanted, I was going to have to make something that other people would want as well, because the cost of doing that was going to be too high to justify making one-offs for just myself.

The reason it started as a company, and really the first plan had even been just to build enough to rent to other people. It really was based on the idea that, once I got someone to tell me how much it costs to make these things, once I really figured out what it cost to build equipment, it became pretty clear that making one for myself was the equivalent of building very expensive motorcycles for yourself. You either have to decide you're going to do that, or you have to start getting a client base where someone else is subsidizing your habit.

Charles: That's a really common experience, that moment of "If someone can at least tell me how much it will cost to make!" So am I correct in assuming you found even that process of getting straight answers on manufacturing difficult?

Jon: It was a pretty heavy learning curve at the beginning of, "How in the world do you make this?" And also, that's not how most metal shops work. No one cold calls a metal shop and asks them how things are made.

Charles: You probably did.

Jon: I did, yeah. But for them it was not a question that they were actually ready for. They're so deep into it that they were not sure what I meant.

Charles: They're used to experienced clients who know their needs who have been hired to get something made.

Jon: They're used to people who already use their kind of services calling them because they're looking for an alternative source or a new process. They're not used to it any more than a Starbucks barista is probably incapable of explaining to you what coffee is if you walked up to them and said, "What's coffee?" Their response would be, "Do you want a large? What do you mean, 'What's coffee'?"

Charles: Do you feel like there were benefits to starting in 2010, right after the recession?

Jon: It was a blessing and a curse. On one hand capital was much more constrained. The flip version of that is there were a lot more people who were looking to do stuff, who were willing to take a chance on projects that were less stable because they had time and down machines. They were looking for new ways to create new revenue because the old ways had changed and were unavailable.

There were definitely advantages to it but I would say overall it would have actually still been easier to do it at a different time, because the damage to the economy made the economics of doing anything harder. Where we were able to get benefits from it however was that in southern California, there was a huge number of small batch manufacturing resources, primarily driven around the automotive industry, the aeronautics, and film and television, that had capacity because the volume of the work they were getting was down.

I would say at least three of the first sheet metal shops I have worked with all have gone out of business in the history of Hive. We did not save them. Our volume didn't save them. Our volume got in there because they're available, but it didn't replace what they lost. In the bigger picture, it's not a happy story.

Charles: Do you remember the first moment he introduced you to the original technology that Hive was going to launch on?

Jon: I went to Rob with what I was looking for. I ended up pretty much showing him the specs for a small HMI and said "This is what I need. We need something that replaces this because I need this for these jobs I'm doing."

He showed me a bunch of things. It was not a straight line. What he ended up showing me was this thing called a "Plasma arc bulb." An electrodeless plasma arc lamp was the catchy title. It was this very, very high quality source that was very, very energy efficient that had all kinds of design challenges that I would not realize until I started working with them much more closely. It solved two very,

very important things very, very quickly. The first one was the quality of light was fantastic. The second was it was a very energy efficient source. The amount of light you were getting out for the amount of power you were pulling was really impressive.

I literally bought a photoflood reflector from Calumet, another company that has gone out of business since I've started my company. Took the bulb, put it inside of it and shone it down the hallway in my apartment and went, "Yes. I want this on my set." 2011 is when we incorporated. That must have been fall of 2010.

Charles: Then how soon after that did you go hunting for money?

Jon: Pretty much immediately. We pretty quickly realized that we didn't have the money we needed to do anything more than cobble together some prototypes. I bought some old photofloods and chopped them up and took out the guts and put this in to show that it would work. I met a teamster who knew a guy who ran a sheet metal shop up in Newhall. I brought him the part and he's like, "Yeah, I can fab you up a box."

With that I was like, "This is as far as I can go on my meager resources. We've got to sign someone to fund this." So we entered a pitch competition at the time and in the process of the pitch competition we ended up getting to the finals of the pitch competition. It was run by a group called "The Pasadena Angels."

At the same time I actually was over working on other jobs and I was bringing the light around and showing it to people. I had a friend who worked also in film and television in New York, he has some resources for investing and stuff, some firm outside of his career that he could personally invest in things. He was interested. What he eventually said is,

> You can't get anyone else to give you some money for it, I'm happy to give you some money for it. It seems cool and I work as a director and a DP so at least I get to use it.

We did the pitch competition. We didn't technically win but we were the crowd favorite. In the process of that, we met a couple of other investors because that's obviously what these things are for. By February of 2011 we had three people lined up to invest.

One of the things that's interesting is because of our experience in film and television, we were used to the idea of going in and pitching.

Through having been in film school, through having been in meetings, going into a room of people and giving them a presentation, and trying to convince them that you're the right person to do something that they can't possibly judge whether you're the right

person to do or not, is not a foreign thing if you work in film and television long enough. Especially if you're freelance. Basically I was pitching people on a regular basis that I was the right cinematographer for them. I was pitching people on how to shoot things all the time. I would take meetings with directors at coffee shops and tell them why this is what they wanted to do. Having done a little bit of producing as well and through the process at film school, I had gone in and pitched film ideas.

Which is probably pretty unique in most people starting a company. In most of the rest of people's lives, other than some basic job interviews, you don't really go in and sell yourself. Selling yourself regularly to strangers is a job description for a very small subsection of the world. I think a vast majority of folks who are in the film and television industry are used to getting told "No" a lot. Being ready to be told "No" constantly is also a thing you have to adapt to to be in business, and it helps if you've tried to pitch a script or audition for some kind of thing.

That's actually a thing from filmmaking that I believe is unbelievably applicable to entrepreneurship. It's just this idea that you're going to have an idea and you're going to have to be completely willing to go in and tell strangers why it's a great idea. You go in expecting to be told by this complete stranger that you're an idiot, and that then you're going to have to do it again the next day is a cultural artifact that is pretty unique to entertainment and entrepreneurship. That's a normal expectation of your day-to-day existence. There's a limited group of places where that is the case.

Charles: Everything about the new economy is stuff filmmakers have been used to for 20 years. When you read an interview about the gig economy, some economist is often saying that in the future you won't have stability, and you'll be getting your paychecks from 90 different places, and it'll all be different things day to day and week to week, pitching yourself constantly and it's like "that's already movies."

Jon: You're like, "Uh-huh (affirmative)."

Charles: "This I know. This is a thing I understand. You guys are just getting here?"

Jon: Exactly. The idea that everyone was going to work for potential, not for what they earned, and that they were going to work in things and that they were going to be told that whatever they were doing was "Cool," not actually lucrative.

By February we had raised just enough money to build a set of prototypes. Our whole premise being, "Raise this money by February, get the cash in hand, and build them in time to present them. Do a mad dash and get to Cine Gear in June," the trade show in LA.

Get to Cine Gear was actually the whole entire plan. We were going to build a few of these using the people's money and get to Cine Gear and that was as far as we thought. We did that. We got these people's money. We built six units. We got to Cine Gear, we showed them. The next day we're like, "Now what happens?" We weren't incorporated. We didn't sign documents. We had sold shares of this thing. We had taken people's money and we built these things and we went to Cine Gear and people said, "That thing's cool." And we went, "Great. Now what?"

Just on pure, totally undeserving luck, at Cine Gear were the gaffer and cinematographer for the first *Think Like a Man* movie. Screen Gems had just given them the mandate that they couldn't use any non-energy-efficient lighting. Basically they had to go all LED, all fluorescent, and no incandescents and maybe HMIs. Maybe. Then they had to be below a certain wattage and limited because they didn't want to have any generators and they wanted to run it all on wall power. One of the head execs over at Screen Gems happened to be a pretty passionate environmentalist.

Charles: Lucky for you.

Jon: I've never met the person but he decided he was going to change the way film sets used power. He packaged it for Sony so that they bought into it because Screen Gems' job was to produce these things for low budgets.

Think Like a Man was in a classic comedy category where, "We're going to sell this to a demographic market share. We're going to make this much money and we'll make it for this little and we're guaranteed to make money." And it happened to be a breakout hit, but because they did it by the numbers, he also had a lot of control as long as they stayed within the numbers. No one cared. He could do crazy things like make a mandate that this environment thing was going to happen because it wasn't a big enough budget thing where anyone who was working on it had the pull with the studio to fight it, right?

It wasn't like he was telling Roger Deakins, "You have to light it a certain way," and Deakins was going to call somebody and over-rule the executive. It wasn't like he had a star on screen who was like, "I only get lit by these lights or else," kind of thing. No one's ever heard of Kevin Hart, yet, and he's the star of this film.

The lighting team had seen us at Cine Gear and they went, "This is an energy-efficient hard light, we have nothing else. Sony has nothing like that." They rented all six and used all six for the entire feature which was six weeks. We rented them for some outrageously high price which somehow got approved. So we made money the next month. We rented for all of July and August and just broke even. It was shot during hiatus basically because it's that kind of low

budget film, and we made money that entire month and everyone was like, "Clearly you're doing something right." Which was not true.

We then proceeded to not make any more money for the rest of the year on these lights, but initially it appeared like this is all working.

Charles: I would imagine when you have one client like that you can ask them a lot about, "What worked? What didn't?"

Jon: We got a huge amount of feedback. Most of it negative. Which was all very helpful and very kind of them. They put them on the job and they didn't send them back the next day and cancel the whole thing.

I don't think they have any warm memories about it. I'm pretty sure the entire electric crew found that job to be just absolutely miserable. We were just one of many pains for them.

Fast forward a bit. We took a bunch of notes from this first client and iterated. We re-tooled everything and we decided to come out with a new version. We made some hires in terms of actually getting some engineering help, getting some design help. The key to all this is because we got the Sony success and we could say literally we were just on a Sony job. Sony Pictures is using our technology. Getting our next round of investment was actually really easy comparatively.

So we were able to raise more money because, one, we were now in revenue. So we were no longer selling vaporware, in that we had built something and someone paid for it. Which makes you a different business and the person who paid for it was someone everyone in the world has heard of.

Whether accurate or not, that's a completely different pitch than, "I'm a guy, I've got an idea, and I think it will work well." And again, this goes back to the film industry, which is what everyone knows is that if you can get Sony to option your script, even if they never fucking make it and it's a terrible script, your next script will be that much easier to sell.

If you walk around saying "Sony optioned my script," it's a completely different conversation than, "I have a lot of scripts and a lot of people think they're really good."

The same rules apply in making lights. So basically it was the equivalent of a mediocre script being optioned by Sony then using that to pay for learning how to write.

Then 2014 was when we really started to introduce plasma lights you could buy and use in the form we know today, and 2014 is when we really start selling them beyond random local LA, New York rental houses and owner operators. Our products go into sort of major retailers, we started having international dealers.

Plasma remains relatively niche, which is fine at that point because we didn't have that many people working for us, but from 2014 to 2016 the revenue starts going up enough that we have employees. We

have a physical location, all that. And then in 2016 we start working on the idea that, fundamentally, we've started to introduce new products with plasma, but we're reading the tea leaves and it's clear to us that if we don't eventually introduce an LED product we're not going to be in the business of lighting, so we did a full RGB LED.

We're in the process of trying to figure out how to keep growing, and growing further. Plasma for us now is very much a sort of niche. It represents, I would say, 20–25% of our revenue now. So it's definitely shrunk down, but it's still significant. I mean, we would not want to cut that 20–25% of our revenue out. Because it's the most mature of our product lines, it's the most profitable now. There's less R&D on it and also a lot of the things that have amortized out over time in terms of tooling and up-front cost that we had to spend to get it off the ground.

We are continuing to look at expanding it. The problem for us as a company with plasma is actually not our interest in plasma, but the overall market's interest in plasma, which is a thing to remember about the entertainment industry is that it is very small. So no matter how big Hollywood is, no matter how much money you can make in the entertainment industry, it's actually one of the smaller overall industries. That is to say, no one at Sony is worried about their entertainment industry except as a way to help them sell PlayStations.

That's the business. Stupid movie picture people with their crazy ideas and their cocaine habits are fun but almost irrelevant to the big players. Sony Pictures is a vehicle for helping Sony sell Blu-ray, sell PlayStation now, sell televisions, previously sell DVD players, previously to that to sell VHS players. It's a vehicle for moving large amounts of electronics. When you're selling pickaxes to miners you make more than the miners. Film is not super small, I mean, obviously we're talking about a billion-dollar, multi-billion-dollar, industry, but it's not a multi-trillion-dollar industry and it's not a large business really.

When you look at lighting, for example, entertainment lighting is one of the smaller, most niche segments. It's up there with aquarium lighting as something people spend way too much money on, but it's cool and weird.

Look at Osram, who worry about bigger clients who buy in bigger volume. When they think of lighting for cameras, they're thinking about putting an Osram chip on your iPhone, they are not worried about what's going on on a movie set. So huge multi-billion-dollar companies that really are the R&D driving force behind lighting technology decide what the entertainment industry is allowed to build.

Macroeconomic forces will always limit what a niche company can actually work on. Right now the macroeconomic forces of lighting have chosen LED as the way forward for all forms of light. And so as long as those are the macroeconomic forces, we're able to nibble at the edges in terms of R&D and innovation, but all we can really do is tweak what has been made for something else. We do not have the resources or power to get custom-made units from scratch. Which is as true for a major player like Arri as it is for us.

Even the largest lighting companies are still primarily only able to make a special blend of what they want from combining things that are available. They're not able to make their own from scratch. In the same way that camera sensors are primarily only a result of what Sony and Canon decide to develop, not only for the prosumer market and their consumer market, but also for their large, major industrial clients and then can be tweaked to make a cinema sensor.

Charles: So that means outside industry forces are not excited about bigger plasma, no matter how many gaffers say "Give me the biggest plasma I can plug into a wall circuit. Give me a 2k plasma." There's just really not that many gaffers in the universe when compared to, say, companies that are buying thousands of light bulbs at a go.

Jon: You have to also remember that what people forget is that the 18k HMI came almost 20 years into the history of metal halide. So you had metal halide that weren't even usable for entertainment up from the '50s and '60s. Then in the '70s you had metal halides get called "HMI" for the purposes of their entertainment industry and used at the Munich Olympics. We would consider them unusable right now.

Over the course of the '80s, you got slightly better blends of color. You had relatively limited wattages. They were almost all magnetic ballasts. Then over the course of the '90s, you get non-magnetic ballasts and a broad range of different sized bulbs, and that's because, at that point, Osram and Ushio had already paid off all the tech on how to make these bulbs, had already made a ton of them and could indulge small-volume, high-end projects like making a 12,000-watt version, making an 18,000-watt version.

It wasn't really until the 2000s that you had 18ks regularly on anyone's film set. Before then you still had movies like *The Rock* that was shot with carbon-arcs for the daylight exteriors. The idea that there's an ARRIMAX everywhere is still pretty much an under 15-year concept. And if you read most *American Cinematographer* magazine articles sort of in the '90s, they just start suddenly popping up in the late '90s, kind of like a thing that someone got their hands on and, "How incredible is this thing?" We have a very short memory and attention span.

Charles: How much of your market is entertainment?

Jon: The majority of our plasma clients are non-entertainment clients. Interestingly enough, I would say 60–80% of our plasma sales are really actually now to what I would call technical and industrial lighting. They're all for image capture. They're all for someone with a camera. They're just not for then being used in classic entertainment uses. Testing facilities, crash test facilities, sensor testing. We sell more plasma to northern California than we do to southern California. Facebook, Google, and Apple are better clients of mine than Netflix, Amazon, and Hulu when it comes to plasma.

It's quite the opposite with LEDs, and there's a variety of reasons for that. The primary being with all those situations, those tech companies have the ability to choose something based on the technology and have the purchasing power to then make that decision, because they want the best technology for each situation. In the entertainment industry, you are choosing a general overall solution and the access to the solution is almost as important as what the solution is. If you're on a film shoot, if you can't get what you want, you get what you can get, and you move on. If you're working in a lab at a major tech company, you put in a purchase order for what you want and you wait a few months until your budget's approved. It's a completely different purchasing cycle and attitude. So new technologies are much harder to gain a foothold in entertainment. For as innovative as the entertainment industry sometimes is, so much of the lie we tell ourselves where entertainment is a big deal, the other lie we tell ourselves is that entertainment is innovative. Entertainment is conservative, it's wildly conservative. In fact, it's one of the most conservative industries.

On the technology side, the idea that there is a still ongoing debate about film versus digital at all is insane. If you were to ask any other industry that has converted from analog to digital, there's no one out there fighting for analogue. Some weird people own typewriters. No one's out there yelling about Word ruining the novel, and definitely no one at major publishing companies is trying to use Linotype printing for major products.

Our obsession with how we've done it over and over again and that's the way it should be, it's an incredibly conservative industry in that way. Where it's incredibly innovative is in its willingness to do whatever it takes to get a problem solved. Which is what led to Hive.

Chapter 11

Clients and Creative

Managing Clients

Under-promise and over-deliver.

A client's experience of your work is inevitably tied to their expectations.

Sometimes you'll be lucky and the client will have little expectation; they really will give you free rein to do interesting work, and they'll be happy with what they get.

More often than not, that isn't going to be the case. They are going to have very concrete expectations, based on your previous work, based on other work they liked, based on their own imagination, that your work will be judged against.

The worst-case scenario is a client who claims to have no expectations but actually has very concrete expectations: they just don't know it.

A friend was playing music for another friend's wedding. The groom would only say he wanted "simple and classic" to any questions about the setlist. "Whatever you want," he kept saying to the musicians. But any song proposed by the musicians was vetoed. It was a setup destined for failure: the groom had a clear idea of what he was looking for, but no way of articulating it. The musicians had to find a way to find out the real parameters, and also to do a bit of magic, to sell the groom on what they were proposing, to ensure the couple walked away happy.

Clients by their very nature aren't great at articulating what they want. If they could articulate it, and execute on it, they wouldn't need you. Frequently filmmaker friends are frustrated at how much time they spend educating clients on filmmaking, but that is why they are a client at all. They need someone to teach them about the filmmaking process. With "green" clients more than half your effort will be educational, and even as you climb the ladder you'll still be educating your clients at least 10% of the time.

It's your job to manage that experience as much as possible, so that when the final product delivers they are happy. They love what you made for them. They see all the work that went into it and are appreciative.

A major problem with this is that there is an increasing perspective that this is "easy." Everyone has a great camera in their phone, makes videos on it with

their friends, and might have even lucked into a few attractive shots. Everyone writes emails from time to time and thinks that "writing" is an easy thing to do.

Being able to accidentally create a few striking images, write the long memo at work, or use a template to make a website, is very different from the discipline of being able to consistently deliver exceptional material day in and day out in a variety of circumstances. To craft not just a random nice image of a sunset, but the right images that serve the story being told.

You have worked hard to master a set of skills for creating your work.

Clients might not always appreciate that. They might think it's easy, that it shouldn't cost too much to just "you know, change it a little bit."

From as early as possible in the process you need to be asking educated questions that are designed to find out what they are expecting. And you need to be delivering educational information to help them understand what the process will be like.

If their expectations are in line with what you want to create for them, and you can pull it off, or it's outside your comfort zone just a bit, wonderful. It's good to keep putting yourself in situations where things are 10–20% harder than you have done before.

If you are not in alignment, it's better to walk away.

Showing unfinished work to clients is risky. Many clients tend to imagine the worst possible scenario when shown unfinished work; when you look at it, you see what it's about to be, how good its potential is, but, especially when a lot of money is at stake, many clients see the opposite. I had a green screen job once where we had one shot with no composite yet: it was just an actress against a green background, but the shots before and after were test-comped so it was easy to see what would go in that middle shot. Despite my preparing them by saying that one of the shots wasn't comped yet but would be soon and was being included for narrative reference, the client had a mini meltdown about how terrible the project was going to be with that "shot with the green set" in it: "can we cut it out and still have it make sense?" they asked in a panic. This was something that any filmmaker could easily imagine their way through, and that we extensively explained when delivering, but it just wasn't possible for the client to imagine.

On the flip side you often have to send through rough cuts and test comps as you need to do reviews as the project evolves to be sure you are in sync; make those as good as you possible can. Showing work before it's ready for outside view can end up souring an entire working relationship, since clients usually don't actually want to see how the sausage is made. Even if the project turns out to be wonderful in the end, they remember that rough mock-up and think of the final result as a "salvage" you made, not a project that fully delivered on expectations.

The rough cuts you show your friends, your film school professor, and your collaborators at the production company are generally much rougher than what you would first show a client. Doing daily tests in your office for several days on an edit before sending it out to a client is a wise move.

Sometimes you don't have a single client but, instead, a group, the marketing department, the board of directors, the head of the company, and it's difficult to tell who is the boss. This is especially frustrating on a phone call; in person it's generally easy to spot who everyone else listens to, but, on a call, the dynamics can be less obvious. If you can't get in the room with them, at least see if you can get on a video chat so you can watch their dynamic as they interact with each other and see who actually has the power.

If you get caught in a difference of opinion, where the marketing department and the board have differing visions, you'll almost never win. A divided client is impossible to please. Since you are the outside vendor, and they are often spending a large chunk of money on you, you end up taking the blame for not creating something that magically pleased people with different needs.

This sucks.

Sorry.

See if you can't spot it earlier in the process next time, and pass on the job, or subtly push your clients to get on the same page with each other.

But it's going to happen.

Be sure, in your expectation-setting process, that you set deadlines not just for your side of the work ("we'll deliver rough cut by April 15th," etc.) but also include how long they have to respond ("client will have four days to review and return notes"). I've delivered projects on deadline only to get notes six weeks later because it turned out the client was going to be on sabbatical. I've had it turn out that the client was spending two weeks on an island in the Caribbean with no internet during the time they were supposed to be giving final approval for delivery to network. I've had clients deliberately slow down the process in order to avoid having to pay their final delivery payment. Once you've put the project to sleep for six weeks waiting on client notes it's very hard to get momentum going again, get the team interested again, and keep going with the same quality you had before. When in the middle of a project, it's awake in the mind of you and your collaborators in a way that is creatively fertile. Once the project "goes to sleep," and leaves your mind space, it's hard to get it awake again.

You will be disappointed, they will be disappointed, everyone will be unhappy if you don't manage expectations properly from the start.

Communicate Like a Professional

This should go without saying, but you should communicate professionally with all your contacts in the film industry. This includes your peers in film school programs, your contacts from set, your professors, your clients, basically anyone you meet connected to film.

Complete sentences made up of complete words giving complete information.

Keep information in a single email thread, to make it easier to search later, with an understandable subject line to make it easier to find. "Delivery" or

"finals" isn't a subject line. "Final Delivery of Project SuperSpud October 21, 2022" is a subject line.

Don't hijack threads. If you are working with a single client on multiple projects, keep your questions/comments about each project in that thread. It makes it easier for them, and you, to reference later.

There is one exception, and that is smileys and emoticons. Text can sometimes read as cold and harsh. If the client starts doing it first, adding smiles or animated gifs can "take the edge off" cold hard text and are acceptable, but it's important here to follow the client's lead. There are emails I've sent clients that had two words and four animated gifs, but that would never be my first email to a client.

Creative vs Accounts

One of the first things you need is a "Head of Accounts."

Whoever this person is, it can't be you.

It can't be you because you need to talk creatively with the client. You need the client to know, 100% beyond a shadow of a doubt, that all you think about, care about, dream about, is making their thing the coolest it could possibly be. Money doesn't exist for you. It's not a real thing. You live in the world of pure creation, where you marshal Goethe's angels of inspiration to your aid.

But before you can agree to anything, you need to check with "Piotr from accounts, because whenever I agree to stuff without checking with him he gets unhappy."

Then accounts gets to be the hammer, which says what you can and cannot afford to do, that talks the client into spending more money, and paying more upfront.

Otherwise the relationship gets diluted. If you go out to ping pong with a client and talk them into a project twice as cool as they were asking for, and then also ask them to double their budget, it starts to feel like you were pitching the idea because you wanted the money, not because you wanted the cool thing to exist.

But if you and the client come up together with the best idea ever in between rounds of table tennis, then you end the night saying "lemme talk to Piotr and see," and then Piotr asks for more money, it goes down a little easier.

I have a friend who is doing very well, but when he started it was him alone in his living room, so he invented an accounts person, made them an email address, created a personality for his "head of accounts." In this day and age, you'll probably have to make them a LinkedIn page for all your clients who use Rapportive.

This way, the bid was coming from someone else. When a check was slow to come from the client, he didn't have to get involved personally, his accounts person could be the asshole who says "if I don't see the money in my

account today this project isn't happening." He didn't have to hold assets until final payment arrived, his "accounts" person could.

This is obviously only possible with remote clients; if your work involves clients coming into the office, they are going to want to meet your head of accounts. Sometimes you are going to want the head of accounts to stick their head in the room while you are working with a client and keep track of how things are going; this is vital if you bill hourly. If you bill hourly, the accounts person should stick their head in to every session to see if you are going to be able to fit in the time you estimated, or if it's going to take longer.

The artist can never do this; if they do, the client will start to suspect the artist is being deliberately slow in order to bill more. Dragging their feet. Sandbagging. It's important that it feels like the artist is only there to serve the muse.

But Piotr, from accounts, needs to make sure the rent stays paid.

In the beginning, before you are earning enough to afford a real head of accounts, it's common for this person to play double duty with office manager, answering phones, greeting clients. If you are really starting out, sometimes it's useful for multiple people to play this role together with others you share office or studio space with; I'll be your "head of accounts" if you'll be my "head of accounts."

It's also possible to outsource this to a firm who handles bookkeeping, though it can be hard to find someone who strikes the right balance of aggressive and friendly that you are looking for. Other industries have different norms, and you really want someone who understands something about film playing this part.

This is just a role to be played in the world. When I'm a client, I watch it being played, and I appreciate it. It helps the world operate. And it lets you just focus on the artistic work with the artist, knowing that the money is being worried about elsewhere.

Good Client, Bad Client

Clients never know what they want. It's your job to tell them.

So, a "bad client" isn't someone who doesn't know what they want. A bad client isn't able to appreciate good work when they get it.

All clients are unpredictable with payment. A bad client doesn't communicate with you about it: even if the check isn't coming, they or their accounts team should be responsive to your contact and give the best estimates they can. I've had clients for years who were very slow to pay, but they've always responded to my questions about it.

Clients will usually take credit for your work. They have the money, they get to do that. But bad clients are rude about it.

If you can, get the client to an in-person meeting, or a Skype, if possible. Conference calls are terrible. You can't read people's facial expressions, you can't see the interpersonal dynamics between the team. The most important

person might never say anything at all, but you can tell they hold the power by how everyone else looks at them before they speak.

A bad client doesn't have a handle on their own team. You need feedback from a client, you send your work along, and get notes, but they don't tell you that they didn't show the boss. They are guessing at what the boss might like. You make changes, they love it, show the boss, who hates it. All of that work was wasted because the boss never saw the earlier edits.

Or, worse, there are two centers of power, and the client isn't able to reconcile them and puts you in the middle.

This is a client you'll never please.

It should go without saying, but this is movies so it bears repeating, if a client is ever offensive, threatening, harassing, or pushing you to engage in illegal activity, this is a bad client. You are free at any time to stop responding to their emails and phone calls. The industry is big, there is plenty of work, there is never a reason to work for a harassing client.

We had a client bring out a bag of cocaine in a post suite, and we had to politely inform him it wasn't the 1980s anymore and that doesn't fly these days.

I had a client leave me a threatening voicemail in which he encouraged me to literally, not figuratively, but literally go to hell.

I cut those clients loose.

Life is too short.

Chapter 12

Representation

In all forms of film there are methods of representation. Actors, writers, and directors get managers and agents. Production companies get sales agents.

Everyone would like to be "represented" in some way. It's a form of external approval. It means you are professional, a real artist, because somebody else says you are.

For a long time it was absolutely necessary. All the work flowed through representatives. You couldn't sell without them.

Increasingly, they aren't an absolute necessity, though they are absolutely useful in their time and place.

You can decide for yourself that you are a filmmaker. External validation is irrelevant if you give yourself internal validation.

In the current landscape there are a wide variety of ways for you to find your clients, to sell your work, to make a living.

Representatives are going to take between 10–20% of your revenue, and in exchange the promise they make is that you are going to make so much more money that it's worth giving up a portion of it. They are going to introduce you to people, guide you, help you navigate.

Sometimes it's worth it, but it isn't always.

You can, and many do, survive and thrive without it.

If you do want to pursue representation, there is no guaranteed "path" to getting represented. Cold submissions usually don't work (they get dozens of cold submissions a day), but sometimes they do. Your best bet is a personal introduction from one of their clients that is currently earning them money; that intro will at least get your work considered, possibly a meeting to talk about scenarios for working together. Hands down the best way to get representation is to write a script so good that folks are competing to represent you.

Sometimes you end up in a situation where you are "hip pocketed," which means you are informally represented. They'll look at your work, maybe show it to a few clients, push you gently and see if anything happens. If they discover they can sell you, they'll pursue a more permanent relationship. If they push you a little bit and can't sell you, it'll fizzle.

But always remember, while representation is nice, it's not necessary. It doesn't make you a "real" filmmaker, only you can do that for yourself.

For reasons of tradition and contract negotiations they all take different percentages of your income in exchange for connecting you to better clients. An agent takes 10%, a manager 15%. Sales agents take 2–5%, often on a sliding scale based on the size of the job.

Some major Hollywood stars have an agent (10%), a manager (15%), a business manager (5%), and a lawyer (5%). That's 35% of their income eaten before they see a dime.

Agents are licensed by the state and are legally allowed to negotiate contracts, while managers aren't. Agents tend to be focused more on short-term revenue, and frequently work at large agencies where they are in competition with each other. Managers are often single-person shops or part of small companies, and they take a longer-term view of your career.

One joke runs "what's the difference between a manager and an agent? 5%." On top of that managers are also allowed to produce, which agents aren't allowed to do. However, many agencies will "package" projects, which involves putting together a project in a fashion that is not dissimilar from producing. To do so they must give up their agency fee for their clients, but a well-packaged project can be much more lucrative for the agency, though not always for the client.

Everyone wants representation. It's a natural part of your growth process as a filmmaker, since having representation forms a very powerful mark of outside approval of your work. There's even a joke about it in *Swingers*; Jon Favreau's character is unrepresented and it ruins his ability to flirt.

Many of the successful filmmakers I know are represented.

Some aren't.

Some aren't now and used to be. Some never were.

A better way to think about it is that agents tend to focus more on shorter-term goals, while managers think about longer-term careers. This isn't always the case, but it is the general trend. Many managers are also lawyers, and can negotiate your contract, and aren't barred from producing. Agents tend to work for larger agencies (dominated by acronymonious firms like CAA, WME, APA, UTA, the defunct AMG, along with Gersh, and Paradigm ("the 'digm")), and are incentivized to get the largest short-term deal possible. That 10% goes to the overall agency, with your agent getting a bonus for a larger or more impressive negotiation.

Managers tend to (and this is a tendency but not a rule) work for smaller firms where there is a larger focus on long-term strategic thinking about your career. Since the firm has less overhead (their offices are generally less terrifyingly opulent), they see more of that 15% themselves. They are usually, but not always, aiming for decades-long relationships with the talent they represent.

While there are no hard and fast rules, it is not uncommon to work with a manager first, who will often work to develop your projects until you are ready to work with an agent, and then who will shop you to agents. It's not unheard of for a manager to decide it's time for you to have new agents and to take you out to meet new people mid-career.

There are also many who survive without having both, or even either. Some top-of-the-line cinematographers I know have built their entire careers on word of mouth and having a good lawyer for contracts, and never had an agent once. Some tried an agent for a year or two, discovered they still got most of their work on their own, and got tired of giving up their percentage.

Though if you think the fees are high in entertainment, in the art world gallerists typically take a 50% cut.

Getting Repped Too Early

It is possible to get representation off a single good feature or pilot screenplay. It happens all the time. However, one danger in getting repped too early is that if you haven't developed the robust skillset to make work on a regular basis, you might not "earn" anything anytime soon. If that script doesn't sell, or get made, and your rep doesn't make any money from you in the short term, they will eventually move on.

Many young filmmakers are very focused on getting an agent as soon as physically possible, but the truth is that an agent can only work with what they are given. If your skills, relationship, and track record aren't yet saleable, having an agent isn't going to help that much. The better, smarter move is to focus on getting so good that you have your pick of agents.

If you write a script every year until you feel confident you can knock out an amazing script every single year, you're going to be an asset to an agent, a reliable client who can deliver, and you'll be in a situation where you could potentially get to pick and choose between a wide variety of agents.

If you are a busy working DP who has climbed up the ladder the hard way, making a wide variety of connections on your own, an agent or a manager will be able to take that robust reel you have built and use it to get you in fresh new rooms.

You need to have something you give your representative to sell.

I had two friends from film school and one went to work for an agent that, coincidentally, signed the other. For several years, my "signed" friend would regularly be on calls with our "assistant" friend listening in, taking notes, following along. It was awkward, but not that awkward. Of course, my "signed" friend never sold a major script and eventually the reps moved on, but our "assistant" friend, who kept writing every morning before going to work for the agents, eventually signed with those agents when his work was ready. They read drafts along the way, and gave feedback, and helped him grow to be the working screenwriter he is.

If you are thinking "writing" might be your path to "directing," going to work for an agent is one of the smartest moves you could make, whether you've just finished college or gotten an MFA.

For a Business, a Sales Agent

If you decide to launch a production company, you will eventually go hunting for a sales agent.

Sales agents take between 2% and 5% (generally on a sliding scale based on the size of the job) for connecting you with potential clients. This can be tremendously beneficial, but it is important to have the work ready for them to sell.

You won't be able to land a sales agent very early in your company's existence, at least not a very good one, since when you are really new you don't have the track record to book the really high budget jobs the sales agent needs to make a worthwhile fee (remember, their percentage is relatively low). Five percent of a $10,000 job is only $500, so they aren't going to spend a week of full-time work trying to help you land that job. Their focus is on bigger fish.

To land those bigger fish, however, requires a lot of work on your part. You need a deep bench of high-end work and talent on your roster to get considered by the higher-end clients, since clients tend to be incredibly conservative in their hiring.

Thus, a sales agent isn't something you need to obsess about when launching your company. As you launch a business, focus on building really good work that someone could go out and sell, and then worry about finding a sales agent to help you sell it.

Never forget, they are only out there to help you sell it. If you have a production company, your job will never stop being sales.

The purpose of representation is to connect you to the people you need to know to flourish. The gallerist takes 50% because they can get your work in front of the major art buyers. They have their own group of clients that pay big money and they will show your work to them. And they need to have a fancy space to do it in, leading to high overhead, leading to their large cut.

Maybe you need it. Maybe you don't. It's your choice. There are other avenues for finding clients.

Representatives also frequently represent many people. Usually, the only way to get their attention is to earn for them; you book a job, whether through them or through your own means, and start earning them money, and they see that they can earn more through you so they start selling you harder.

The beginning of any representation period is always a tryout, to see if they can earn money from you or not.

If they can't, they'll move along.

One of the benefits of representation is that payment often flows through them. And if they represent a lot of clients, that means that they are a big line item on a client's accounts payable. They can be the hammer to get you paid faster than you would be if you were a little fish. It's a benefit.

For the most part, the days of representatives as tastemakers is changing. A small coterie of agents don't control all of Hollywood casting. New technology allows people to find each other without representatives, so the power is more dispersed.

Fundamentally, external approval from someone else will never replace the internal approval you can give yourself.

Go, do the work you want to do.

Then, once you are successful, all the big representatives will come knocking and try and poach you.

But you'll always be secure in knowing that you can take them or leave them. That you got where you are without them, and if they move on to someone else you can survive.

You Get to Stop Growing Whenever You Like

There is a bias towards growth in this book. Towards "leveling up." Taking it to the "top."

It's important to remember that you can also slow down, or even stop, whenever you like.

I had one client for several years who lived down the street from our office. They always brought in interesting projects, properly budgeted and scheduled, and we did good work together. Nothing that was going to "level up," but solid projects.

After I left my company, I was at the monthly art walk in our neighborhood and saw him there and said hello. "How often do you come to this thing?" I asked.

"Every month!" He said. "It's so much fun, why would you miss it?"

I, of course, had never been. In my years in that neighborhood most Friday nights had been in the office getting projects ready to deliver. I didn't even know we had an art walk.

We talked for a while and I realized that he had found a level where he was proud of his work and wanted to enjoy the art walk.

Little Failures

"If you're batting a thousand, you're in the wrong league."

That came from a writer friend of mine who is among the most successful people I know. He's also one of the most fun; if there is a fun event going on, you can guarantee he'll be there.

What he means is that one of the reasons we get into the arts is to stretch ourselves, to grow, to keep moving, and stay awake. That's what we want from this field. Otherwise, we'd go do something else. If you are literally hitting every job out of the ballpark, you are taking jobs that are too easy for you. You're a professional ballplayer playing against children. You need to play against equals.

Batting a thousand, or 1.000, in baseball parlance means you are hitting everything that's tossed at you. Nobody in the major leagues bats 1,000 because they are up against professional pitchers. It's a balanced competition. Sometimes you miss.

To do interesting, engaging work, you have to take big swings. You've got to push yourself outside your comfort zone.

Sometimes, when you do that, you miss. You fail.

The arts are unpredictable.

I want desperately to tell you that you're always going to take big swings and pull it off. But that just isn't possible.

Sometimes you'll bite off more than you can chew, and you'll choke. The project will fail.

It's part of the game.

You have to create a space for yourself where that is acceptable. You don't have to be happy about it, but you can't walk off the field because you miss the ball occasionally, and you should remember that it's a good thing to occasionally miss.

It means you are pushing yourself. It means you are stretching.

With client work, it's wildly uncomfortable.

The best way to cover yourself is to be 100% sure you did everything you possibly could to make the project succeed.

You do that, and then you let it go.

You have to occasionally bite off more than you can chew.

That means occasionally you are going to whiff.

Bigger Failures

Businesses fail.

Most do.

Over the really longer term, almost all do. Even Pan Am, once king of the skies.

The primary sign that your business has failed is that you are out of money and can't afford to pay your debts.

It's sometimes hard to tell this has happened, since small businesses always feel like they are about to run out of cash, and somehow you keep figuring it out. Cash is low then a new client, or job, or check, comes in and you survive another few weeks or months. Small business often feels like constant crisis.

Then, one day, you can't figure it out, and the business goes under.

Generally, this is because the will of management is done figuring out how to keep it going. The effort of figuring out this current crisis isn't worth the benefit of keeping the company going.

If you put any money into it, it's usually lost; you've got to keep the business going to have any hope of the business paying you back, and, if the business fails, you've lost that initial chunk.

It's one of the reasons why it's good to have that initial chunk you put in in the first place, it's called "skin in the game," and it often motivates managers to keep pushing the business forward when others might quit. Because if you have no skin in the game, you can just walk away to the next thing. But if the company owes you $50k, you have to figure out how to save the company, how to grow it, how to survive, or else you lose your investment.

Be wary of top level management who aren't willing to put skin in the game. They should want skin in the game, since it means if they really take the company forward, they benefit too, since putting skin in the game usually gives them more ownership. Hiring a business manager and giving them a percentage that grows with billing over time will motivate them to keep growing the business.

Most studies point to a business crack up being as stressful as a divorce. In addition to losing the business, it also usually means you lose your job if you work for the business. This is going to be incredibly difficult.

Businesses will also crack up when the original founding partners no longer share the same vision of where the company is going to go. Maybe a company founded to pursue narrative features has a partner that wants to keep going, and another partner who wants to pivot to reality television. When the partners no longer share a vision it isn't sustainable and the founding partnership will split, even if the company keeps going.

Once you've been around a while, this will happen to you, since careers evolve. You won't be with every business you work with forever. But it is stressful. Others you know have gone through it. Find them and buy them lunch. They'll be happy to talk about it.

Spend a few days out of town.

If you live in LA, I highly recommend spending a few days at a Korean spa.

If at all possible, be nice to yourself.

Everyone in the arts wonders if they should keep going.

Everyone in small business wonders if they should keep going.

Both activities are hard.

Being in a film business, which your career is, is hard squared.

Yes, you should keep going.

The doubt is good. It keeps you focused. It helps you reevaluate your priorities, what you want from life.

Maybe, some day, you will stop.

Maybe that day is today.

But probably not.

Don't be so hard on yourself for the doubts. We've all got them. It's how we move through them that counts.

We feel driven to do these things.

But sometimes it's terrifying to do them.

We sit down at the blank canvas, the blank page, and it seems nearly impossible that we'll be able to do what we want to do.

Fear and doubt dog all of us.

You just have to start.

Keep going, doing it every day, no matter what.

Put it at the top of your daily to do list. Everything else can come later. Do it before anything else.

Because "everything else" will expand to fill the time you give it. If it's last on your list, or even only second on your list, you'll never get to it.

Life will happen and get in the way.
Don't let it.
Put it at the top.
Punch through the fear.
It's a daily struggle.

Only for the Money

Never do anything only for the money.

If you are going to do something purely for money, go be a lawyer for an oil company. The money will be better, or more regular at least.

Yes, you'll do client work, and part of doing client work is doing things for other people.

But you have to find something of yourself to invest in the gig. Something you find exciting. Something that challenges you or makes you grow. Something about the story being told or the project being completed that you believe in.

That belief doesn't mean you should work for free: you should still get paid a fair wage for your skills and time.

But that belief in the project, that you are going to make something good, that's what matters.

If you are debating taking a job, or staying with a job that hasn't happened yet (you'll often be attached to a project for months or years while it's working its way through getting made), be sure to ask yourself this question: "is the only reason I'm doing this is for the money?"

If the answer is yes, and if you can afford to walk away, you should.

If you can't walk away, if you need the money, you need to work your ass off to find something you actually believe in in the project. You need to fight like hell to add it to the project, if it isn't already there.

Because if you don't really care, it'll always show in the work.

And your name is going to be on it, for all time.

This is even true with your "cashflow" job. Find a way to bring some joy, or energy, or fun, to the process of earning a living while pursuing your ambition job and you'll be happier along the way.

Business

After reading this book I hope you never use the phrase "I don't understand business" again. Nobody fully masters business, since it keeps changing, keeps moving, keeps shaking. But you owe it to yourself to dive into it, to take care of your own career, to get involved in that half of the enterprise.

If you do, it's likely you'll find yourself among the lucky many who find a way to keep doing your creative work and paying rent, and that you remember that one of the biggest choices we get to make is what we do with our time.

Not just "what we do for money," but "what we do with the gift that is our life." Hopefully the information in this book will save you some headaches and make your journey of creating things easier.

Interview: Elliot Silverstein, Film Director

One of the hardest battles many artists face is the battle to protect the vision they have for the project against the unrelenting force of compromise that comes with doing collaborative projects. This is compounded even further in film, where the financial support often comes with strings, and opinions, attached.

In the television industry, one of the biggest warriors for the right of a filmmaker to have a creative vision is director Elliot Silverstein. I sat down to interview him specifically around issues of director's cut and his efforts to put forward creative rights for filmmakers from within a commerce-driven industry.

Among the many other things to take away from this interview, one vital one is to remember that contracts can evolve. Just because something "has always been this way" doesn't mean you can't change it for the next go round. The director's contract didn't give the director input into post, so Silverstein worked with the DGA to get that right.

Before Silverstein, by default the director was expected to simply leave the production after a shoot and move on to further jobs. Because of his personal commitment to seeing his work appear on screen the way he had intended it, Silverstein ended up dramatically changing the way in which creators interact with their financiers, be they studios, networks, or simple clients.

This interview was originally published on the online blog NoFilmSchool and is used with permission.

Charles Haine: When you look back at your career, where do you put the Creator's Bill of Rights now? When you think about it, is it one of the most important things you did?

Elliot Silverstein: I'm very proud of the legacy. I think it really defined, to a very large extent, what the Director's Guild of America is, apart from its role as a trade union. I am proud of having left the creative rights concept and the specifics associated with it. I'm very proud of that.

I don't know how to describe it, but early on, the corporate influence on a given piece of work was much stronger than it is now. Directors had very few defined rights to protect the work. For instance, the initial version of the contract between directors and producers read something like this, "The director shall have the right to view," the word "view" was important, "the first rough cut," whatever that was, "and to make any suggestions he had to the associate producer," whoever that was. The roles have changed since those days. That tells you that it was further down the line. They didn't have firsthand control.

My first task was to establish what suggestions meant and who the associate producer was and why it'd have to be the associate producer instead of the producer and why the director didn't have primary influence over the material that they directed, subject only to the labor laws, which gave the corporation ultimate control.

Haine: The whole movement grew out of your time on "The Obsolete Man" episode of *The Twilight Zone*.

Silverstein: There was one sequence where there was some dispute between me and the editor. I had an expressionistic view of that piece, and he had a more literal view. There was a sequence in which a chorus of SS-type people were advancing on one of the other characters, a whole chorus, and they were just going, "Grr," getting louder and louder and louder as they advanced, and eventually converged on him and attacked in an unseen way because they were in a football huddle.

He cut that rather literally. I wanted to delay the advance to create a greater tension as the growl they uttered in chorus increased in volume and they advanced slowly to it. He wanted to get the advance over with. There was a big to-do about it.

Haine: You had this conflict, but it didn't transcend into the personal?

Silverstein: No no, it was just simply with the editor. By the time we resolved it, the cut had been made and they were ready to go on the air, and I couldn't really do what I wanted to do. At that point, I consulted Joe Youngerman, who was the secretary in charge of the Director's Guild, and found out what rights a director had. He pointed out to me the quote that I made to you a few minutes ago, and I said, "What do we do about that?" Joey said, "What do you want to do?" I said, "I want to change it." He said, "You have to negotiate with the company. Let's do it." We did it under the initial leadership of Frank Capra. After that, he moved on and I took over and led the so-called creative rights movement for about 27 years.

Haine: That's a long run.

Silverstein: It is. A lot was established because it was influential all over the world. Short of substituting a director for the corporation, it defined what rights a director had as an artist.

Haine: With things like Marvel Studios taking off, do you feel like the director is losing some of that ground as an individual creative force? For instance, *Star Wars* fired Colin Trevorrow, and then they fired Chris Lord and Phil Miller, and Marvel fired the great English director Edgar Wright from *Ant-Man*.

Silverstein: You say "they." You see, the minute "they" or "we" comes up, it's inevitably a corporation. I'm more interested in the individual fortunes, the individual visions. I'm aware of what you're

talking about. The corporation was not happy with what the individual was doing, so they had to find an individual that they approved of.

When I first came aboard the Director's Guild, the influence the directors had was based on the power of those that had preceded us, the really great motion picture directors, because film for television was relatively new. One had to substitute rights for power. That's really what it was all about.

I'll give you an example going from the sublime to the ridiculous. When Frank Capra headed the Creative Rights Committee, which came about because of my interest and insistence that there had to be some rights for directors, we met with labor relations people who didn't understand the first thing about moviemaking. They were labor union people. Their job was to hold the line on costs. They would not budge.

The issue at that time was to make a director's cut. That is, to give the rights to a director to cut the film or to instruct the editor to cut the film the way they saw it, the way the director saw it, not the way anybody else saw it, and a limited amount of time in which to do that. Now these people said, "No. That's holding up production, or the director will use that right to blackmail us, to delay the orderly production of a television show."

They were afraid the directors would push for more power, and eventually that, of course, translates into money. They refused. I remember the conference that the directors on that committee had with Capra. He made the following proposal:

> The Director's Guild will agree to a list of 12 names of any directors we mutually agree on, beginning with David Lean, and we will transport them from wherever they are, at no expense to the companies, to complete the work of a director in post-production, if the companies in their unilateral view feel that that director is malingering.

Now that's pretty broad. It embarrassed the labor relations people, because they were not used to a union saying, "We want you to believe that we're really interested in the quality of the result, the individual vision of the result. We're not looking to do anything. We're gonna give you everything. Just give us a break."

They asked us for 15 minutes, and when we came back they said, actually the quote was, "We see how much you care, and so we will grant your request for a director's cut." That's where the director's cut came from.

Haine: Now is that list still in effect at the DGA?

Silverstein: Never been used. It was a tactic, but if we had been called on it, we would have followed through. Now that's the sublime.

I was scheduled to do a television show at a major company, and I showed up with my script to the little dormitories where the producers lived and worked. In the corridor outside a number of offices, there were a number of other directors walking around the corridor with scripts in their hands. I couldn't really figure what that was.

I went in and spoke to one of the producers and I said, "Where do I go to work? I don't have an office." He said, "Out there with them." I realized that's what they thought of directors. They had no office, no place to sit down, no desk. They were to wander the corridors or sit on the stairways and do their work.

I said, "All right, I know how to handle this." I went outside. I asked the assistant director aside and the production manager aside, to meet me on the street. I sat down on the street and we had a conference, with everybody laughing, of course, secretaries putting their heads out the window and laughing at what we were doing. I had a production conference right there on the street, holding up traffic.

You would think that somebody who's responsible for the expenditure of all of the money that it takes to produce a show would be treated with more courtesy than they treated us at the time.

Eventually one of the executives came along in a big black limousine and said, "What's going on?" I replied, "Nothing, sir. We're preparing a television show." He asked, "Why are you out here?" Without hesitating I answered: "This is clearly where the company wants us to be, because they won't allow us any place to sit down or to work inside, so the natural conclusion is they want us to work in the street, which is what we're doing." He said, "Just a minute," and he went inside.

Five minutes later we had a desk. I had a desk and a place to sit down.

That extended the clause that says we have to have a desk with a door that can be closed and a telephone, near facilities, and a parking space. That's the ridiculous part. You would think that somebody who's responsible for the expenditure of all of the money that it takes to produce a show would be treated with more courtesy than they treated us at the time. I had to pull some kind of a stunt like this in order to call their attention to the absurdity of their practice.

Everything between those two points, consultation, and the things that flow from consultation with the producer are part of what filled in the blank between those two poles.

Haine: One thing I wanted to ask about was, in some of your interviews over the years, it's clear you've paid a lot of attention to the way technology impacts director's rights, colorization in the 1980s, director's cuts on DVD in the 1990s.

Silverstein: Yes, but all of those are subsequent. The main thrust does not change, the director's right, the director as an artist. Everything else changes and technology just follows. There will always be changes in technology. There will always be changes in practice. There'll always be changes in financing. The core is that the right of an individual human being who is assigned the job of translating this material into a movie has not changed.

I think most directors have a vision and want to see it executed. That's where the problem arises, because very often, producers, whether or not they have artistic instincts, also have visions, and those sometimes collide.

Haine: You once said you used to hold up a piece of paper over the lens for parts of the shots you didn't want them to use.

Silverstein: Yes, and this has to do with editing rights. What would happen was the cameras would roll, and before you'd call "action," the actors might be unprepared. They would just be ready and the cameras would roll and there would be a period perhaps of five or ten seconds, which would provide mischievous producers with pieces of film that I didn't want used. I realized the only way to do this was to block the lens until I said "Action," and then take the paper away from the lens, so that "Action really meant Action" and not a delayed cue to begin. I wrote something on the paper, I think, which was, "Actors not up to speed." When they were up to speed, I'd take it away.

Haine: When people talk about the history of directors taking that kind of power, for you it was a practical battle, and theory didn't seem to be a big influence.

Silverstein: If you hire somebody to create something, you let that individual create it, and that creation is part of an imagination, an imaginative process. The development of corporate influence over this interrupts that process very often and substitutes corporate views for individual views, which may be a larger comment on American life, including political life, though that's too big to go into at this point.

Haine: Do you feel like it hurt your career to fight as hard as you did for creator's rights?

Silverstein: Yes.

Haine: Do you regret it?

Silverstein: No.

Haine: Were there moments where you felt like your powerful advocacy
 for director's rights hurt you getting later projects off the ground?

Silverstein: No question about it. No question. I was thought of as the vil-
 lain by some of the corporations because what I was doing was
 decreasing their power. If there's anything that they resent more
 than anything else, it's reduction in power. I was saying the direc-
 tors had the rights – not the privilege, but the rights – to do this, or
 that, or something else, whatever the specific happened to be.

 It was difficult to them, although I must say when we started
 to negotiate with the executives, which was the second meeting
 we had, I found that the top executives really were quite reason-
 able and understood what we wanted and why. They felt that we
 eliminated some of the difficulties further down the corporate
 line, as to why things were delayed and why they weren't deliv-
 ered on time, etc., etc. Our efforts did in some respect help them
 streamline their own process.

Appendix
Teaching and Recommended Reading

Teaching

"What about teaching?" is a question I often get from students, and it deserves some consideration.

If you have either an MFA or significant professional work, you are qualified to teach. If your work is significant enough you don't even need a bachelor's degree to teach; there are many college professors in film who never even started undergrad but went right into the industry. However, their work is usually strong enough that they were able to get hired on that. They also tend to skew older, from a time when there were fewer film schools and fewer people from their cohort with MFAs. With the explosion of MFA programs, if you are on the younger end of the spectrum you'll need an MFA to compete for academic jobs, especially full-time positions.

If you chose to attend film school and received an MFA, you are now qualified within the eyes of higher education to be a college professor.

Should you?

The first thing to understand is the distinction between adjunct teaching and full-time teaching. "Adjunct" positions are designed for someone working a full-time job to come to campus once a week and teach a class. The pay is usually designed as a supplement; an hourly salary for the hours you are in class, and maybe some small pay for "course prep" or "office hours," but sometimes not. The positions were originally intended to be a small portion of the faculty bringing up-to-date field knowledge to campus, with the bulk of courses offered by full-time professors.

However, higher education administrators quickly realized that adjuncts are far more affordable than full-time faculty, and over the last few decades we've faced the "adjunctification" of higher education. Chances are if you went to film school you had the majority of your classes taught by adjuncts, as some programs have more than 60–70% of their coursework delivered by adjunct professors.

Film is one of the few areas where this actually makes some sense. It's a fast-moving industry, and having an editing, color grading, sound design, or cinematography class taught by a working professional, who spends 50 hours a week

doing the job, today, the way it's being done right now, and then comes in one night a week or on Saturdays to share that knowledge, is invaluable. Technology is changing our industry so rapidly that keeping your knowledge current is vital.

A good film program will likely always have some load of adjuncts as an essential part of keeping their curriculum current. On top of that, student relationships with adjuncts can be a great professional launching point for those students, as, for instance, the busy editor identifies a new assistant in their class and brings them in to intern at the post house where they work.

If you are a recent film school graduate, however, considering adjuncting can be tricky since the pay is typically frustratingly low. What often happens if teaching is your goal is that you become a "freeway adjunct," traveling between multiple campuses adjuncting one or two classes a week at each. I had a friend in LA who taught seven classes at five campuses one semester, getting around by motorcycle to beat traffic, in order to survive. This was never the goal of adjuncting when it was first designed.

There are full-time teaching jobs available in film, but the competition for those jobs in the big film markets of New York and LA is fierce. The beauty of a full-time teaching position is that you get paid year round in order to teach fall and spring, and have summers off. You will meet many working filmmakers who have a full-time teaching job for stability and then produce their work over the summer. Especially considering how unstable freelance directing can be, the competition for a full-time teaching job will be intense.

One option to make yourself more attractive is to have another teaching skill. While many, many people want to teach directing, including folks with recognizable work on their resume, if you can teach editing, cinematography, color grading, or producing, there are more options available to you. It's very difficult to work full time as an editor and also have time to teach, but "editing adjunct" can be a good cashflow situation while pursuing other ambition goals.

The exception here is screenwriting. Of all the film skills, screenwriting is the one where it is easiest to be a working professional and teach a class a week, so the competition for writing positions is also very tough.

This opens up quite a bit if you are willing to leave the major markets. First-year graduates from MFA programs will regularly see themselves getting interviews for full-time teaching programs in smaller markets, even at big schools with robust programs, and if you had some success with your thesis project all the better.

However, the days where full-time teaching was a job you could get without an MFA are rapidly disappearing as film MFA programs proliferate. It still happens, but such jobs are harder and harder to find.

If you are ever thinking you might want to give full-time teaching a go, you should start adjuncting wherever you can right away. The more robust your teaching resume, the better it will look when going up for a full-time job.

Teaching, if you have the skill, is a great way to provide for supplemental income while also continuing to grow your skills. You can't help but learn new

things as you teach, and you will also continue to build and grow your professional network. Former students of yours will go on to have careers and will often go on to be collaborators.

If you want to develop a long-term teaching relationship with a school, it is sometimes beneficial to show up at other school events. While no one expects adjuncts to attend faculty meetings, if there are end-of-semester or end-of-year screenings, it is always noticed when adjuncts attend to "support the community."

There are always many available working professionals in film who are interested in every adjunct position, so be sure to be conscious of keeping your skills current, focusing on student learning and outcomes, and being pleasant to work with, and you should be brought back semester after semester.

Adjunct positions at bigger, generally public, institutions can even eventually, after a few semesters, lead to benefits including retirement and health insurance. You might not imagine you'll teach somewhere for a decade when you start, but after you get a handle on a course and find a way to balance it with your other professional obligations, it's good to check in with HR to see what benefits might be available if you continue to teach year on year.

There are some schools where it is easier to get teaching jobs, generally in for-profit educational institutions. You'll know them by the sheer volume of advertising they do in your market. It's perfectly OK to get your feet wet teaching here, but generally it's considered best not to spend too long teaching in the for-profit arena if it can be avoided. For-profit schools tend to, with a few exceptions, have lower standards for student learning outcomes and a greater focus on just getting butts in seats. If you have no teaching on your resume this can be a great first position, but move along when you can.

Full-time teaching positions are referred to as "lines." You'll hear them discussed in terms of "we haven't gotten new lines in years," meaning that the school hasn't hired a new full-time professor in a while, or "they aren't replacing lines," meaning after someone retires the administration isn't replacing the position with a new hire.

Lines fall broadly into "lecturer" categories, which tend to teach more and have fewer service obligations, and then "tenure track" lines that come with a slightly reduced teaching load and greater job security. Tenure track lines are fiercely competitive, especially in the major markets, and you should be prepared with a resume of robust teaching and professional work to be in the running for one. Once you achieve tenure (generally a six-year process), you can't be fired and have a job for life. Unless, of course, they close your program, but, with the popularity of film and television in higher education, that is less likely.

Many software and hardware vendors offer "certifications," such as Blackmagic Resolve, Avid Media Composer, or Arri, for their camera and lighting tools. While certifications are not necessary for most freelance jobs (clients will care more about what you do than what tool you use to do it with; the exception being if you are pursuing assistant editing work in Media

Composer, where some major networks like certification), they are useful in academics. If teaching is something on your radar, gaining credentials can help build a more robust application.

Recommended Reading

Every single freelancer, small business owner, or person struggling to manage cashflow should read *Simple Numbers, Straight Talk, Big Profits!* by Greg Crabtree (MJ Lane Publishing, 2011). The realization that the problems of a freelance or production company business are the same as those faced by all small businesses in incredibly comforting, and it's full of useful information to help you survive.

Index